Picture-Perfect Techniques for Magical Image Manipulation

Digital Retouching and Compositing:
Photographers' Guide

David D. Busch

D1509425

Digital Retouching and Compositing: Photographers' Guide

Credits: Senior Editor, Mark Garvey; Production Editor, Megan Belanger; Senior Manufacturing Coordinator, Laura Burns; Copyeditor and Proofreader, Karen Annett; Cover Design, Chad Planner; Interior Design and Layout, *GEX Publishing Services*; Indexer, Kevin Broccoli, *Broccoli Information Management*

Publisher: Andy Shafran

Technology and the Internet are constantly changing; due to the lapse of time between the writing and distribution of this book, some aspects might be out of date. Accordingly, the author and publisher assume no responsibility for actions taken by readers based upon the contents of this book.

Photograph of KODAK PROFESSIONAL DCS Pro 14n Digital Camera courtesy of Eastman Kodak Company

Library of Congress Catalog Number: 2002117411
ISBN 1-932094-19-9
5 4 3 2 1

Educational facilities, companies, and organizations interested in multiple copies or licensing of this book should contact the publisher for quantity discount information. Training manuals, CD-ROMs, and portions of this book are also available individually or can be tailored for specific needs.

MUSKA&LIPMAN

Muska & Lipman Publishing
25 Thomson Place
Boston, MA 02210
www.muskalipman.com
publisher@muskalipman.com

Dedication

As always, for Cathy.

Acknowledgments

Once again, thanks to Andy Shafran, who realizes that a book about editing color images deserves nothing less than a full-color treatment, and who knows how to publish such a book at a price that everyone can afford. It's refreshing to work for a publisher who has *actually written* best-selling books on the topic, too. Also, thanks to senior editor Mark Garvey for valuable advice as the book progressed, as well as copyeditor Karen Annett, production editor Megan Belanger, and book/cover designer Chad Planner. Due credit also must go to several of the behind-the-scenes masterminds like Kathy O'Hara and Sherri Schwartz, who were instrumental in getting this book packaged and out on the shelves.

Thanks also to my family and the countries of Spain, Ireland, and Italy, without whom there would have been a lot of blank spaces in this book where the illustrations were supposed to be; and to historian/photographer Candace Wellman for her gorgeous photos of places I haven't had the chance to visit. Who says Samoa isn't historical?

Special thanks to my agent, Carole McClendon, who has the amazing ability to keep both publishers and authors happy.

Preface

Don't just learn the tricks of the trade; learn the trade.

If you've been using Photoshop for awhile, you've found tricky techniques make great shortcuts—until the first time you run into a situation that doesn't fit one of those prefabricated solutions the "experts" spoon-fed you. That's when you discover that knowing what you're doing is not nearly as important as knowing *why* you're doing it.

Anyone who wants to learn how to transform lackluster images into compelling masterpieces needs this book. If you suspect you have a triumphant prize-winning photograph hiding away in a shoebox, or have been harboring a powerful desire to retouch, restore, revamp, or refurbish your pictures, the secrets you need are within these pages.

Great pictures are *made*, not discovered through some happy accident of timing, framing, and exposure. This is the book that will show you how to *make* great pictures from the raw material at hand, whether your needs involve retouching minor defects, fixing major errors, or creating entirely new images that grab the eye and command attention. Certainly, there are lots of tricks and tips here. But, more importantly, you'll discover *how* and *why* these techniques work so you can apply them in ways that you never dreamed possible. If you like the ideas you find in this book, you'll discover that many of them will spark the best and most useful ideas of all—your own.

Introduction

Retouching and compositing are two very different, yet closely related sides of the same image-manipulation coin. Retouching generally involves fixing problems with existing photographs: removing dust spots, stains, and artifacts generated by a digital camera; correcting lighting problems; recomposing poorly composed images; or even deleting the tracks of roving organisms that find the emulsion of your conventional photographs tasty.

Although compositing can help you fix errors, this tool also opens doors to other types of image manipulation. With compositing, you can *combine* one or more images, or portions of images, to create an entirely new picture that never existed in that form in reality. Photoshop has enabled us to flip the old saying, "Seeing is believing" on its head. Today, if you *believe* in an image and have the requisite image editing skills, after a little bit of work you can *see* it, too.

Digital Retouching and Compositing is aimed squarely at those who want to use Photoshop creatively to mend defective images, produce enthralling new images, and become proficient with all the tools available to them. The emphasis in this book is on mastering the tools Photoshop has for editing and assembling images. You'll learn more than you expected about methods for retouching and compositing, and as much as you dreamed about how to apply them. Other books may show you some quickie self-defense tricks that work in an emergency; this one gives you a black-belt's grounding that can handle just about every conceivable situation.

The seed for this book was planted while I was writing my last image editing effort, *Photoshop 7: Photographer's Guide.* Tucked away in that book were three concise chapters covering Photoshop's basic tools, image retouching, and image compositing. Although the chapters were full of helpful information and fun to write, I realized that a great deal more could be said about each of those topics. The focus of each of those individual chapters became the subject of the three parts of this book. Part I provides an introduction to each of the most important tools Photoshop offers for retouching and compositing images. Part II explores all the different ways you can fix goofs through

skillful retouching. Part III takes off for the exhilarating thrills possible when you begin creating brand-new images from old ones using compositing skills.

You don't need to be a Photoshop guru to apply the techniques explained in this book, although basic familiarity with Adobe's flagship image editor is a tremendous help. After you've honed your expertise through the material in Part I, you'll be ready to tackle Photoshop's most misunderstood, but easily applied tools using the step-by-step examples, helpful background information, and advice that will spark your own creativity.

Why This Book?

There are hundreds of books available on how to use Photoshop, including more than a few that cover retouching and compositing techniques, at least in passing. Some are dumbed-down or padded with a half-dozen chapters that tell you how to use the Brush tool, or where to find each of the ten billion Photoshop commands and features tucked away in menus, palettes, and toolboxes. Others have pretty pictures (often taken by someone other than the author) and somewhat useful techniques, assuming you only work with the same pictures the author used.

This book was written for those who already know where to find the Eraser in the Tool palette, and want to learn how to apply their basic Photoshop knowledge to performing useful tasks. You want to solve problems without creating new ones, and learn how to handle any image manipulation situation that comes along. You'll probably find yourself in one of these categories:

▶ You're someone who takes good pictures, perhaps as a hobby or as an artistic outlet, and want to learn to use Photoshop to make your photographs the absolute best they can be.

▶ You need creative images to dress up your personal Web site, or to add a professional touch to your own or your company's pages on the Web.

▶ You're a small business owner who wants to document your business, promote it with effective visuals in advertising or publicity, or create pictures that are salable in their own right.

▶ You're a corporate worker slaving away in a cubicle who wants to enhance your value to your current employer (or your next one) by adding impressive graphics skills to your résumé. The ability to produce professional-looking images for reports, presentations, or other applications is highly marketable.

▶ You're a hustling Webmaster who understands programming in XML, Java, JavaScript, Perl, or even plain old HTML, and you want to expand your graphics capabilities.

▶ You're an apprentice graphic artist who already has some expertise with Photoshop, but wants to learn more about retouching and compositing.

▶ You're a trainer who needs a nonthreatening textbook for an advanced Photoshop class.

Who Am I?

You probably don't buy many Photoshop books because the author is famous, so you'll probably take comfort in the fact that I'm probably the world's most successful unknown author. As much as I'd like to think you picked this book off the shelf and are reading this because you really, really loved my last book, odds are greater that you grabbed the book because the title interested you, and, as you flipped through, you found all those gorgeous color pages and eye-popping images interesting. You were looking for cool ideas and useful techniques. Perhaps you've enjoyed one of those meaty books that Course Technology/Muska & Lipman lovingly turned out in the past and were looking for more of the same. I figure that the content will hook you more easily than this introduction, so I'm content to let the pictures and text speak for themselves.

However, a little background on the one who presumes to instruct you in this arcane technology may help you understand exactly where this book is coming from. In each of the chapters that follow, I don't plan to melt into the background and let Photoshop take center stage alone. I'm going to poke my nose into everything, offering up my experiences, advice, tips, and goofs as examples to help you learn retouching and compositing as you deftly avoid making the same mistakes I did.

My original training and experience were heavily steeped in photography. I've operated a commercial photographic studio, worked as a photojournalist for magazines and newspapers, and written hundreds of articles for the major professional photographic publications. I've made my living as a sports photographer for an Ohio newspaper and an upstate New York college; I've slaved in my own photo lab; and served as photo-posing instructor for a modeling agency. People have actually paid me to shoot their weddings and immortalize them with portraits. Eventually, I was seduced by the dark side of technology, and combined dual interests in photography and computers to author more than 70 books on computers, graphics, photography, and Photoshop.

Like you, I'm trying to do what I love, and have been lucky enough to have been doing it longer than most. When I utterly trash a photograph, either in the camera or after uploading it to my computer, I can usually offer exceedingly technical explanations of what I did wrong. I'm more than happy to let you learn from my mistakes, and travel to Photoshop and image manipulation proficiency on a more comfortable gain-without-pain route than I took.

How to Use This Book

Some books are intentionally written so you can start anywhere and begin working without having read any of the previous text. When writing in that mode, the author has to include cross-references to other parts of the book virtually every other paragraph so that, when you're instructed to make a selection but haven't the faintest idea of what the selection tools are, you can jump back to the part that gives you those basics.

Some Photoshop books sprinkle four or five icons on every page, advising you of Warnings, Tips, Technical Stuff, Potential Bombs, and Alerts, with perhaps a special icon to remind you that if you want to use a file that's on the CD-ROM, you should look for it on the CD-ROM. The true value of these icons is that they usually highlight the only parts of the book really worth reading.

This book doesn't use thousands of icons as a substitute for content (although you'll find a few where they are actually helpful), and it's not the sort of book that can be read odd-numbered pages first (although it is entirely possible to skim through parts that you already understand and concentrate on the areas that most interest you). You'll get the most value from what I have to say if you start at the beginning and work your way through. Many of the techniques build on those that were explained before. For example, you'll find the sections that explain how an image's tonal values work helpful when you begin studying color, or the sections on making simple selections when it comes time to jump into the really hairy stuff.

Feel free to read quickly the sections that you already understand well, or ignore some of the background on how things work. However, I've tried to chuck all the boring parts of this book into the bit-bin long before this book reached the printing press. That's why you're not holding an 800 page book in your hands. All you need is this book, the photos on the CD-ROM (or your own pictures), and a copy of Photoshop. Here's a summary of the essentials.

▶ You'll need a Windows PC or Macintosh OS system with enough RAM to run Photoshop comfortably (that is, from 256 to a gazillion megabytes of RAM). I use both a Pentium 4-based PC and a G3-based Macintosh, so I've tried to make this book a cross-platform experience. The instructions generally tell you to use the Alt/Option key, Ctrl/Command key, or right-click/Control-click to access particular functions. (Remember that the PC's Ctrl key is *not* the same as the Control key on the Mac.)

▶ You'll make things easier on yourself if you've upgraded to Photoshop 7. Many of the menu items have been moved since Photoshop 6.x, and Photoshop 7 includes cool new features, such as the Healing Brush and Patch tool (which are useful for retouching and compositing) and the File Browser (which is less useful). Most of this book can be meaningful for those who haven't upgraded yet, if you're willing to make a few adjustments.

▶ The more photos in digital form you have available, the better. I'm providing the same images I used to prepare the exercises in this book on the CD-ROM, but you'll get the most from this book if you immediately follow up each exercise by tackling one of your own photos using the same technique. It doesn't matter if the pictures derive from a digital camera or were scanned in. The important thing is that you work with images that need fixing, or which can be improved by compositing techniques.

▶ Don't lose the CD-ROM that's bound into the back of this book. It's a dual-mode CD that should work with any Macintosh or Windows PC, and contains all working files you'll need to complete every exercise in this book. The CD includes folders given the same names as the chapters (Chapter 1, Chapter 2, and so forth) and inside each chapter's folder are two other folders labeled Figures and Working Files. You can view the figure files to get a close-up look at any of the color illustrations in this book. The working files are what you need to complete the exercises. If you have a lot of free space on your hard disk, you can copy all the working files to your disk so you don't have to keep the CD-ROM inserted all the time.

Your Next Stop

I'm not your one-stop source for toll-free technical support, and almost certainly can't help you with questions about Paint Shop Pro, Corel Draw, or JavaScript programming (although I get these from time to time). On the other hand, I'm always glad to answer reader questions that relate directly to this book, or to my other area of expertise, photography. Even if I can't answer a question, I can sometimes get you pointed in the right direction. You can write to me at *photoguru@dbusch.com*. You'll also find more information at my Web site at *http://www.dbusch.com*. Should you discover the one or two typos I've planted in this book to test your reading comprehension, I'll erect an errata page on the Web site, as well, along with an offer of a free copy of the next edition to the first reader to report anything that, on first glance, might appear to be a goof.

A final warning: I first came to national attention for a book called *Sorry About the Explosion!* This book earned the first (and only) Computer Press Association award presented to a book of computer humor. Since then, my rise from oblivion to obscurity has been truly meteoric—a big flash, followed by a fiery swan dive into the horizon. So, each of my books also includes a sprinkling of flippancy scattered among all the dry, factual stuff. You aren't required to actually be amused, and you can consider yourself duly cautioned.

Chapter Outline

This section is a brief outline of the chapters in this book. If you want to know exactly where to find a topic that interests you, consult the table of contents or index.

Part I: Mastering the Basics

This first part of the book has five chapters that serve as an introduction to each of the most important components of Photoshop that you'll use for retouching and compositing. These topics are all explored in greater depth in Parts II and III.

1. Retouching and Compositing from 50,000 Feet

In this overview, you'll learn about retouching and compositing, what they are, and how they are used. You'll also find a discussion of pre-Photoshop image enhancement and manipulation techniques, and an overview of your image editing toolbox.

2. Selecting Objects and Backgrounds

Learn the exciting origins of masking in conventional photography, and refresh your knowledge of Photoshop's selection tools, including the Marquees, Lasso, Polygonal Lasso, Magnetic Lasso, Magic Wand, use of Channels, and clever ways to manipulate selections.

3. Cloning, Patching, and Healing

Here, you'll learn how to use the versatile Clone Stamp tool, clone from the same layer or different layers, use the Healing Brush and work with the Patch tool. These tools are all basic implements for retouching that you'll want to master early.

4. Tools for Adjusting Tones

Many Photoshop users don't really understand tonal values, which is why they find essential tools such as the Levels command and Curves feature so difficult to fathom. This chapter gives you the information you need to increase detail in highlights and shadows and manipulate gray tones effectively.

5. Adjusting Color

Color's another realm that causes confusion. This chapter helps you master Photoshop's color controls, understand the various color models it uses, and make color corrections quickly and easily.

Part II: Practical Retouching

The second part of the book shows you how to fix faulty photos using increasingly complex retouching techniques. By the time you finish this part, you'll be adept at repairing the most errant image.

6. Simple Retouching Techniques

Part II kicks off with this chapter that eases you into retouching using simple techniques. You'll learn to remove small objects, erase dust and scratches, use sharpening and blurring effectively, and make light work for yourself.

7. Retouching Portraits

Learn the challenges of retouching photos of people, including removing wrinkles around the eyes, mouth, and forehead, fixing and brightening teeth, removing braces, erasing red-eye, and performing digital plastic surgery on noses and other features.

8. Creating Great Grayscale Photos from Color

It takes only seconds to transform a great color image into an inaccurate black-and-white picture. Creating a great grayscale photo from a color picture takes only a few minutes more, but you have to understand exactly how Photoshop works to do this effectively. This chapter shows you some little-known secrets for performing this magic.

9. Creating Duotones, Tritones, *n*-tones, and Colorizations

Here, you'll learn how to add color to grayscale images. You may think you understand duotones, but you're in for a few surprises in this chapter. You can also learn how to mix color and grayscale images, and mimic hand-coloring, even if you're not an artist.

10. Photo Restorations

When terminally ill photographs hit your Photoshop ER, you'll want to use the techniques in this chapter to revive them. Learn to fix tears, camouflage cracks, minimize stains, remove undesirable patterns, or create whole new backgrounds.

Part III: Compositing Magic

The fun hits full throttle in this part of the book, where you'll learn to create seamless composites, remove or relocate objects, or build fantasy landscapes from parts of many different photos. You can let your imagination run free using the tips and techniques provided here.

11. Simple Cropping and Fix-up Techniques

Learn to improve compositions with cropping, straighten images, improve perspective, or stitch several images into one to create a panorama.

12. Compositing to Improve a Picture

Every picture tells a story, but some of those stories need editing. This chapter shows you how to remove large objects, replace objects, or add entirely new objects to a photo. You'll discover the basics of merging images.

13. Invisible Compositing

This chapter explores the essentials of creating seamless composites by matching colors, making lighting and textures consistent, using scale and angles, and blending layers.

14. Fantasy Compositing

Creating your own fantasy world, manipulate scales to create outrageous effects, and add wild colors. Work with filters to fashion incredible looks and textures, or use shadows to add a three-dimensional effect.

15. Compositing and Retouching for Print and Advertising

The rules are different when you're compositing for publication. Learn the rules, and learn some techniques for making products and people look their best. Anyone using Photoshop in business will find something helpful in this chapter.

Glossary

This illustrated glossary defines all the terms you'll find in this book, or which you may encounter when working with Photoshop, retouching, compositing, or digital photography.

Part I:

Mastering the Basics

You've probably heard the phrase, "Carpenters know their tools." That aphorism applies just as well to the art and craft of retouching and compositing. Simple knowledge of the mechanics of accomplishing something isn't enough. You must also have the right tools and know how to use them. If not, your understanding of the mechanism behind image manipulation is just so much theory. Just as carpenters buy the best tools available, and spend many hours mastering their use during a lengthy apprenticeship, you need a high-quality, versatile set of tools (Photoshop) and should plan on spending time learning to use them proficiently.

Part I of this book is your apprenticeship with the toolbox of Adobe's flagship image editor. The five chapters that follow explain the basics of retouching and compositing and show you how to use selection, cloning, tonal, and color tools, along with other essential capabilities such as working with layers. Then, we tackle more complex retouching and compositing projects in Parts II and III.

1

Retouching and Compositing from 50,000 Feet

One of the most important and often overlooked developments of the computer age is the ability of Photoshop, and image editing tools like it, to subtly (or dramatically) alter the appearance of images we view. Today, we're so accustomed to assuming that a startling image may have been "photoshopped" that we sometimes forget that sayings like "Seeing is believing!" once held a solid grain of truth. Photographs in supermarket tabloids of farmers wrestling with pig-sized grasshoppers and images of the Great Pyramid of Giza relocated slightly to create a better composition on the cover of National Geographic remind us that our eyes and brains are easily tricked.

Until recently, realistic image fakery required either a great deal of planning or monstrous expense. National Geographic, for example, employed a gazillion-dollar Scitex laser scanner to nudge two pyramids closer together into a vertical composition for its controversial February 1982 cover. Today, anyone with a $50 scanner and a copy of Photoshop can do the same thing, and probably do a better job of it—if they've read this book!

In general, these newfound capabilities are good things. Most of us aren't interested in assembling a photograph that shows George Bush having a conference with Mohandas Gandhi, for nefarious purposes or otherwise. We're more interested in removing bags under the eyes in a portrait of a loved one, or banishing an ex-brother-in-law from a family portrait. We'd like to disguise dust spots, bring back vibrant color to a faded 50's-era snapshot, or remove a telephone pole that seems to be growing out of someone's head.

These are all things you can easily accomplish with Photoshop, if you know how. This book shows you the secrets of retouching images and how to create new ones through seamless compositing techniques. This chapter provides a little background on both, and lists the skills you'll need to master to become a proficient image manipulator.

Photography has always been part craft, part science, and part fine art, with a little alchemy and magic mixed in. Early photographers were often skilled artisans who built their own cameras, amateur chemists who sensitized photographic plates, as well as artists. Digital imaging cranks up the science component several notches, giving the artist in all of us more powerful brushes and an infinite palette of colors, tools, and effects.

The Origins of Retouching and Compositing?

You never really believe a picture is worth 1000 words until somebody starts critiquing one of your beloved photos. Then, the words really seem to pour out! Your problems may involve dust spots on a scanned image, defects in your original subject (such as skin blemishes or bags under the eyes), like those shown in Figure 1.1, or simply something that appears in a photo that you wish weren't there.

Figure 1.1

Bags under the eyes, multiple catchlights in the pupils, or a washed-out eyebrow are all things that can be fixed with simple retouching techniques

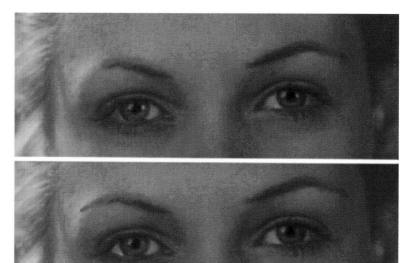

Retouching

Retouching is the "touch up" of images to make them look better, but without creating a whole new image. The goal of simple retouching is often to remove defects from a photograph. Of course, a defect is often in the eye of the beholder (if not in the bags underneath). A high school senior portrait (male or female) showing less than silky-smooth skin is sometimes viewed as a disaster by those who have just traversed the rocky roads of puberty. On the other hand, removing the character lines from the face of a 60-year-old corporate chief executive would provoke outrage. Emphasizing that steely glint in the eye may be much more important. In advertising photography, the product must be presented just so, and 20 hours of retouching can be a lot less expensive than reshooting a photo when locations, props, models, and well-paid photographers are involved.

Retouching and compositing are a pair of related tools that have been available for most of the history of photography, but only were wielded by those who could become adept in the intricate skills needed to apply them.

Retouching is generally thought of as the process of making modifications to an image by applying dyes or pigments to original negatives and transparencies (or copies of them) or photographic prints to disguise certain features or create new ones. Covering up blemishes, removing dust spots, filling in a bald spot in a portrait, or reconstructing part of an image that has been damaged all fall under the purview of retouching. When done well, the effects of retouching may be difficult to see, unless you make a side-by-side comparison with the original image.

Compositing

Compositing is a more involved process that makes significant changes in an image. Compositing involves combining two or more images, or portions thereof, to create a new image that didn't exist in that form previously. You may want to create a composite that combines the best poses of two family members into a single double portrait. Perhaps you don't like the background in another image, and want to replace it with a more attractive setting. If you have a touch of whimsy in your soul, you may even harbor a secret desire to transplant the Eiffel Tower to London. Composites can be realistic or outrageous, however you prefer, like the one in Figure 1.2.

Photographic Origins of Image Enhancement

In ancient times (prior to 1995), both retouching and compositing required a great deal of manual labor as well as considerable talents as an artist and technician. As a result, retouching and compositing were reserved for images in which the stakes were high, such as commercial portraits or advertising. These endeavors involve considerable investments of time and money, so an additional expenditure for lovingly making an image *just so* was justified.

Consider an image destined for a multimillion dollar advertising campaign. The original might have been shot in a studio staffed with a professional photographer, stylist or other helpers, mucho expensive equipment, and, perhaps, an advertising director hovering over the photographer's shoulder. Prior to the advent of digital photography, the final result of this effort might have been a rich, detail-filled transparency measuring 4 × 5 to 8 × 10 inches.

Even the most painstakingly-produced "chrome" (short for Kodachrome, Ektachrome, Fujichrome, etc. among the pros) will rarely be perfect. So, it was common to retouch these transparencies (or duplicates) using bleaching (to remove color) followed by application of dyes, or, often, simply dyeing alone. The process is extremely complicated from a technical standpoint. There are separate bleaches for each of the three color layers of the transparency, plus an overall bleach that removes all colors equally, and a total bleach that strips an area of colors entirely. If you goof, some removed colors can be partially regenerated with yet another chemical.

Figure 1.2
A famous blimp, high
over the skies of Paris,
thanks to compositing

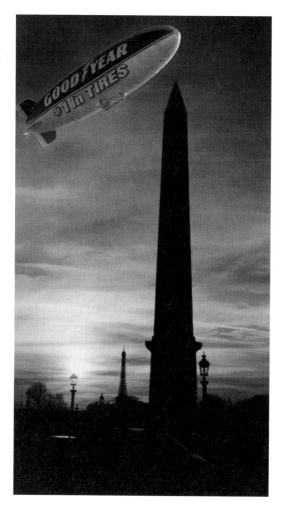

Then, it's necessary to apply special dyes that match the originals. These dyes must match the original colors precisely (so the retoucher can visually gauge his or her results while working), yet look identical under the laser eye of a commercial scanner (which doesn't necessarily see colors exactly as we do). Manual retouchers must be something of a scientist to know *how* to add or remove colors, and quite skilled artists to know *where* to add or remove them.

Retouching transparencies is simple, in some ways, when compared to retouching negatives. Negative retouching is often done using the original camera film, so there's very little latitude for goofs. The process is complicated by the fact that the image is *reversed*; the retouching artist has to visualize how the final image will look as a positive. For example, prominent veins appear in color negatives as yellow-orange lines that must be removed with cyan dye or a blue pencil. Sometimes, the negative must be viewed

through color filters to help isolate features to be fixed. If you've ever looked at a color negative, you know negatives have an overall orange cast, so there is also the backdrop of the familiar color negative red-orange mask to contend with.

Color or black-and-white prints are probably the easiest photographic media to retouch, and this method is often chosen if the original camera film is a tiny 24mm × 36mm negative or slide produced by a 35mm camera. A variety of tools are available, ranging from pencils to dyes to judicious application of an airbrush. The chief drawback to retouching a print, however, is that it's a one-off finished product. Whereas you can make as many prints or duplicates as you want from a retouched negative or transparency, a retouched print stands alone unless you make a duplicate negative and are willing to lose some quality in the duplication process.

Compositing is even more of a hair-raising activity, and in times past often involved physically cutting apart negatives or transparencies, butting portions together, and then attempting to disguise the boundaries between the melded sections. Although compositing may demand a little less science, it calls for much more of the artisan and artist's skills to achieve manually. One of the most important applications of the earliest digital color separation drum scanners (which could cost a million dollars for the scanner and computer equipment that controlled it) was in using the digital data to create composites. Combining images was so difficult and tedious that it was easy to justify an expensive piece of equipment for commercial applications.

You may or may not have an interest in ancient history, but this background should help you appreciate just how much power Photoshop has placed in your hands. Prior to Gutenberg's application of movable type, the majority of people had probably never even held a book in their hands. Prior to the invention of photography, most people had no idea what their great-grandparents looked like, unless they had physically met them or their ancestors were wealthy enough to afford a painted portrait. And prior to the digital imaging era, there was no easy way for an amateur photographer to make substantial modifications to a photograph: What you saw *was* what you got.

That's all in the past.

Overview of Your Image Manipulation Toolbox

Photoshop offers a bulging toolbox of implements that can handle every imaginable retouching and compositing chore. In the non-digital world, such a toolbox would contain brushes, etching knives, dyes, pigments, a set of the venerable Marshall's Photo Oils, and maybe an airbrush. Photoshop contains the equivalent of all these tools, plus many more. This section is an overview of the most important capabilities of Photoshop for making the kinds of modifications we explore in this book. All of them are covered in more detail in later chapters.

Selection Tools

The selection tools are probably the single most important set of Photoshop features you need to master. Only by selecting exactly the right area of an image can you apply changes only to the portion that will benefit from the modification. For example, you may want the main subject of a photograph to stand out a little more dramatically. Sharpening the subject and/or blurring the background a little can produce the effect you're looking for. However, to apply Photoshop's sharpening or blurring effects, you must first select the area to which the effects will be applied. That may be simple (if, for example, the portion of the image is rectangular or circular and can be easily selected using the Rectangular or Elliptical Marquee tools) or more difficult (if the image area has fuzzy, furry, or irregular edges).

Photoshop includes tools that make selecting much simpler, including a Magnetic Lasso that "sticks" to the edges of objects, a Color Range command that grabs only pixels of a certain range of hues, and the invaluable Extract feature, shown in Figure 1.3, which lets you extricate the most complex shapes mired in a sea of pixels. You'll learn to marshal all of Photoshop's selection weapons in Chapter 2, "Selecting Objects and Backgrounds."

Figure 1.3
New tools such as the Extract command let you extricate complex shapes easily and quickly

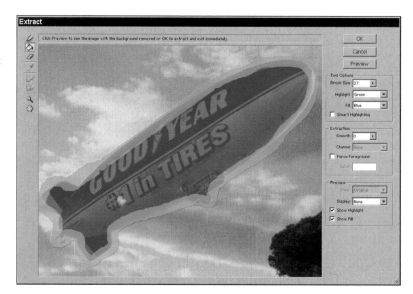

Layers

Photoshop's layers capabilities are arguably the second most important tool in your arsenal. Layers allow you to separate portions of an image into individual overlay-like stacks that you can manipulate individually and then combine in a variety of ways. If you're working on a shot of a soccer game, for example, you can extract the soccer ball, put it into its own layer, then move it anywhere on the field. Blur the ball to simulate motion, make it semitransparent as if it were beaming up to a starship, or change its colors in dramatic ways.

Layers are indispensable when you're compositing multiple images, but they can also help when retouching a photo. You can, for instance, paint various hues on separate layers to convert a black-and-white image to full color, or create a layer of texture that masks defects in an image. Master Photoshop's layer tools and you'll find a vast new array of capabilities at your fingertips.

Using layers effectively involves working in tandem with other tools, so there is no separate chapter on layers in this first section of the book. Although learning selection tools is something you can do independently, the use of layers changes, depending on the task at hand. You'll find lots of tips for working with layers in Parts II and (especially) III of this book.

Sizing, Cropping, and Orientation Controls

These tools help you adjust the size of an image or selection, modify the area contained within the image's borders, and rotate or flip it to create a new perspective.

Photoshop includes several tools that let you resize an entire digital image, or rescale portions of the image while leaving the rest of the picture untouched. Go ahead, make that soccer ball huge. Enlarge that tree in your front yard to see what it will look like in 15 years. Make your company's products larger in comparison to your competitors'. Image scaling tools can be used to resize a picture or object proportionately (that is, the same amount in all directions) or in only one direction. I've used sizing to make myself look taller and thinner, to stretch out a wall, or make a patch of sky I was pasting into an image wider to fill a larger area.

Cropping tools let you trim excess image area from your photos, providing a better composed image or one that better fits the "hole" you have for it in a desktop publication, picture frame, or a collage that you're compositing together.

Use orientation tools to flip an image left to right or vertically, to suit a composition, or just to provide a new view. Photoshop also allows you to rotate images around an axis of your choice so you can, for example, appear to be climbing a steep slope when, in the original picture, you were walking on flat ground and merely leaning forward.

Painting/Cloning Tools

You needn't be an artist to use Photoshop's broad array of painting tools. You may need to convert a fairly dark background to an inky black one, and find that a fuzzy brush used with a black tone is your best friend. Or, you might need to copy some background texture over a portion of an image to hide, for instance, an unfortunately located fire hydrant. Photoshop boasts a variety of brush tips and shapes and many different tools that use those brushes in different ways.

The Clone Stamp tool, represented by a rubber stamp icon, is one of them. It duplicates part of an image, pixel by pixel, in a location of your choice. The stamp analogy isn't perfect, however, because you're actually drawing with a brush that you can size and control in other ways allowed by Photoshop, such as transparency of the image laid down.

Cloning can be used to copy portions of an image to another location in the same or a different image. If your desert scene is too sparse for you, a single cactus can be multiplied several times or even copied from a different desert altogether. You may add a window to the side of a building by "painting" one from another building using the Clone tool.

Photoshop 7 added some sophisticated new Clone tools in the Healing Brush and Patch tool. Both copy pixels from one place to another, but take into account the lighting and texture of the area being repaired.

If you're simply retouching a photo with no intent to add or subtract anything other than the defects, the Clone tools are useful for copying portions of an image over the parts you want to replace. Or, you can combine several images to create visions you might not encounter in nature, such as the one shown in Figure 1.4. You'll find lots of information about using the Clone tools in Chapter 3, "Cloning, Patching, and Healing."

Figure 1.4
Can you spot Dolly and her four clones in this picture?

Tonal Controls

Photoshop's Toning tools (Dodge, Burn, and Sponge) can be used to apply lightening and darkening effects with a brush, or to soak up or add color to specific areas. The dodging and burning features have their origins in traditional photography: When color or black-and-white prints are made by exposing photosensitive paper under an enlarger, the darkroom worker can modify how the image appears. That's done by giving extra exposure to some areas of the print (burning), and holding back other areas so they don't receive as long of an exposure (dodging).

You can use dodging and burning to lighten some shadows under and above the eyes of a subject, or burning to darken a highlight that is too light. These tools are a good choice for selectively brightening and darkening only parts of an image, rather than the entire photo. Photoshop has dialog-based tonal controls that operate on selections, too. You'll learn about all these in Chapter 4, "Tools for Adjusting Tones."

The third Toning tool, the Sponge, lets you reduce the saturation of portions of an image, or increase the richness of the color, depending on how the Sponge brush is deployed. You'll find more information about the Sponge in Chapter 5, "Adjusting Color."

Blurring and Sharpening

The ability to selectively blur and sharpen portions of an image is an important retouching and compositing tool. Sharpening can bring out details that are hard to see. Blurring can eliminate defects such as dust spots, or make portions of an image less prominent. Photoshop has a variety of tools for blurring and sharpening, ranging from the brush-like Blur, Sharpen, and Smudge tools, to plug-ins called filters that apply blur or sharpening to all of an image, or just a selection. If you're interested in going really overboard, Photoshop also includes a versatile Liquify filter that can twist your pixels in interesting and surprising ways.

The use of sharpening isn't difficult to understand. Blur is bad, so sharp must be good, right? Not necessarily. When retouching photos and creating composites, you should use sharpen tools carefully to avoid making your image look too sharp. When an image or portion has been sharpened too much, the defects in the picture become more readily apparent whether those defects are dust spots, scratches on a scanned print, or the pixels themselves in a digital photograph.

In addition, you always need to keep in mind the sharpness of the image area surrounding the section you're working on. Nothing screams COMPOSITE! so clearly as when an object that's dropped into a particular area is noticeably sharper than an object that supposedly resides in the same plane under the same lighting.

And blurring isn't always bad, either. In fact, selective blurring of unimportant areas of your image can make the rest of the picture look sharper in comparison. Blurring is also valuable for minimizing defects (including those dust spots or scratches). If you're creating a composite, you may need to blur an object to help it blend in with adjacent objects, or blur a boundary to make the transition more subtle.

You'll find more on using blurring and sharpening in Chapter 6, "Simple Retouching Techniques."

Texture Controls

Matching textures is a key to creating satisfactory retouching and believable composites. When repairing skin defects in a portrait, for example, it's important that the modified area have a texture that's similar to the surrounding areas of the face. Moving an object within an image or between images also calls for eliminating jarring differences in texture. You can use the blurring and sharpening tools described previously, work with the Clone tools to duplicate textures, add random pixels using the Noise filters, or create other textures using Photoshop's variety of filter effects. Working with textures is covered throughout this book, but you'll find a special section on Photoshop's more outrageous filters in Chapter 14, "Fantasy Compositing."

Color Correction

Color correction is an essential part of both retouching and compositing. If you're retouching a color image, correcting any color casts is part of the image repair process. When compositing several images or parts of images, you'll not only need to correct color, but also match the colors of the different components. Matching colors can be quite tricky, but Photoshop includes a broad range of tools for adjusting color. These range from color balancing sliders to Photoshop's clever Variations mode, shown in Figure 1.5, which lets you compare several different versions of an image and choose the color rendition that looks best to you.

You'll find a solid introduction to color correction in Chapter 5, "Adjusting Color."

Figure 1.5
Photoshop's Variations mode lets you choose the right color balance from a selection of different versions

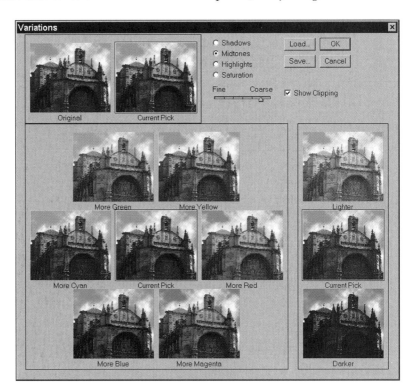

Your Hardware and Environment

The final piece of the retouching and compositing puzzle is the hardware you work with, and the environment you choose to work in. If you're a Photoshop veteran, you probably have the three most important requirements taken care of already (a lot of RAM; more RAM than that; and some additional RAM that you never expected would be so useful). But here's a run-down of the physical goodies you'll want to have in place when you begin your image manipulations in earnest.

Equipment

You don't need to break the bank to equip yourself with an ideal system for retouching and compositing. Computer processing power has continued to run far enough ahead of the requirements of most applications that a medium-priced computer will do what you need. Just follow these guidelines:

▶ **Computer System**. Any Windows-based or Macintosh computer in the 800 MHz range or faster should do fine. One of those 3 GHz Intel juggernauts or the latest dual-processor G4 Macintosh will certainly run faster and reduce the amount of time you spend waiting for Photoshop to finish a task, but the difference in performance has become less important in recent years. I have actually used an early version of Photoshop on a 16 MHz Macintosh II in the early 1990s and can recall waiting several minutes for a sharpen filter to be applied to a relatively large image. Once processors reached the 800 MHz mark, Photoshop began operating in a fairly speedy manner. Even complex effects can be applied in a second or two. I know most books about Photoshop recommend that you always buy the fastest computer available, but experience tells me you can work quite comfortably with a less gnarly machine. The last time I had some big bucks to spend, I sprang for a better digital camera, kept my old computer for another year, and never regretted it. If you're retouching or compositing images professionally, or manipulating a large number of multi-megabyte photographs, you'll certainly want to spring for the fastest processor you can afford. Even a few seconds saved can add up when you're working with Photoshop all day, every day. But the rest of us can avoid mortgaging the house to make an upgrade if our computers fall into the comfort range.

▶ **Memory**. One thing that hasn't changed, however, is the need for a lot of RAM. If you have 256 MB of memory (or less, if that's humanly possible), you can boost Photoshop's speed more effectively by tripling the amount of memory than by tripling the processor speed. As you work with an image, Photoshop keeps copies of the image in memory every time you make a change, add a layer, or perform most other common functions. When memory runs out, Photoshop must use your hard disk drive as a substitute for RAM. How much faster is RAM? Memory functions are measured in nanoseconds, whereas disk functions are measured in milliseconds. The difference between a nanosecond and a millisecond is on the order of saying, "Wait a second…" and "Wait 32 years…" Most computers today have at least three memory slots, and 256 MB RAM components cost a pittance, with even 512 MB modules not particularly outrageously priced. You shouldn't even consider running Photoshop with less than 768 MB of RAM, and 1.5 G of memory would be even better. I'm not kidding.

▶ **Hard disk**. You'll want to save intermediate files with all their layers intact as you retouch or composite images. Photoshop also has a "snapshot" feature that lets you store an image and all the steps used in an editing session. Keeping five or ten different copies of a single image may be a good idea from a working and backup standpoint, but an active Photoshop worker's hard drive can fill up faster than Yankee Stadium on Bat Day. Hard disk drives in the 120 GB to 160 GB range and larger are cheap. You need one. Or two. Or three. The more hard disk space you have, the more active projects you can keep "online" at once. ("Online" had a different meaning in the olden days, before the Internet.)

▶ **Removable/archival storage**. Even the largest hard disk won't store everything. If you have an older computer without a CD-R/RW writer, now is the time to upgrade. Some generic models cost little more than ordinary CD-ROM drives *without* a burner built in. (I recently paid $39, after rebates, for a very nice 24×10×40× CD-RW drive that writes CD-Rs at 24× speed, CD-RWs at 10×, and reads CDs at 40×.) Any CD-R writing speed of 24× or faster is fine; any CD-RW speed around 10× is great. You won't really notice much improvement with drives offering faster write speeds. A full CD-R recorded at 24× may take three minutes to write. Pop for a 48× writer instead, and you'll save only 90 seconds, and probably have to use more expensive media to boot. Equipment vendors may actually get the DVD-burner standards sorted out during the life of this book. If so, the much greater capacity of the DVD drives can be quite valuable for those who are retouching or compositing images.

▶ **Video display**. The 19-inch monitor has become almost standard for new computers these days, and video cards with 16 MB to 64 MB of memory are very common (particularly when the computer is sold for insanely video-intensive gaming purposes). I run my main monitor at 1920 × 1440-pixel resolution, which shrinks down the non-document image components of Photoshop, such as menus and tool palettes, to a small enough size that I have lots of real estate to work with. However, even high resolution can provide a cramped Photoshop workspace. So, I added a second video card and second monitor and extended my desktop over both. I can work with images on one monitor and keep the tools or even a second application open on the additional monitor. Both Mac OS and Windows make working with two monitors relatively painless, as you can see in Figure 1.6. You can pick up a basic 17-inch monitor (the smallest I recommend as a second monitor) and a low-end 16 MB video card for less than $200 (which is what I did). You'll never want to work any other way.

Figure 1.6
Both Windows and
Mac OS support
extending your desktop
to multiple monitors

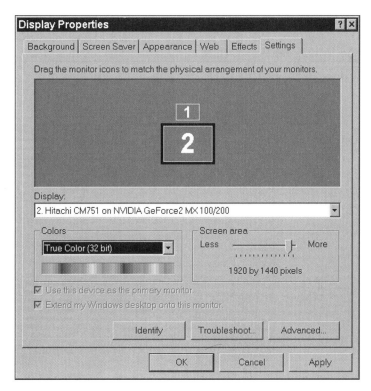

▶ **Digitizing tablet**. Which would you rather use to sign your name: a bar of soap or a pen? Retouching, in particular, calls for a great deal of brush-stroke activities, and a digitizing tablet can make painting, defining selections, and other functions much easier. As a bonus, such tablets respond to the amount of pressure you apply to a pen, giving you the ability to narrow or broaden your brush strokes simply by pressing harder or more lightly with the pen. Compared to, for example, having enough RAM, or increasing your screen real estate, a digitizing tablet is not as important. However, if you have an artistic bent and are already comfortable drawing with a pencil or pen, you'll find this accessory, shown in Figure 1.7, well worth your investment.

▶ **Scanner**. A scanner is a valuable tool for grabbing the digital images that you'll be retouching or combining. Many models are available for less than $100, but if you're serious about photo manipulation, I recommend tripling your expenditure and getting a decent scanner. The Epson scanner I am currently in love with has true 2400 × 2400 optical resolution (not particularly useful for scanning photos, but a godsend when grabbing images of slides) and includes the best and most convenient system for slide scanning that

I've seen in a flatbed. If you capture many transparencies, you should consider a dedicated slide scanner, but flatbed models like my Epson can do a great job with transparencies from 35mm up to 4 × 5 inches.

Figure 1.7
A digitizing tablet is a great investment that will help you make selections and paint strokes more accurately

▶ **Printer**. Sometimes, the only way to tell if you've done a good job retouching or making a composite is to print out a hard copy. It's hard to go wrong with one of today's slick ink-jet printers. I make lots and lots of prints and prefer printers like my Canon model that uses separate ink tanks for each color. Nothing is more annoying than paying $32 for a combined color ink cartridge, and then having it run out of, for example, yellow ink while the cyan and magenta tanks are still half full.

Your Environment

You'll want a comfortable desk and chair with enough space for your keyboard, mouse and/or digitizing tablet, both monitors, and your scanner. That's a lot of hardware, so you might need more than the average amount of desk space. My own workspace is shaped like a U, so I can swivel around to each component as I need it.

If you're working with hard copies and slides, you may also need a small viewing booth and light box to evaluate your originals. Graphics supply houses can provide both with 5000 K (color temperature) lighting for the most accurate look at the colors in your images. The rest of the lighting in your environment should be subdued and should not reflect on your monitor. Some workers like to have visors around their monitors to keep extraneous light from falling on the screen.

It's also a good idea to control the temperature and humidity of your workspace. I use air conditioning even on balmy days to maintain a constant environment in my work area, and to reduce the amount of dust that can settle on scanner, transparencies, or hard copy originals.

Next Up

By now, you should have a good overview of what tools, equipment, and Photoshop skills you'll need to begin retouching and compositing photos. The rest of the chapters in this part of the book concentrate on getting the most from Photoshop's most important functions and features. Next up is a primer on making selections.

2

Selecting Objects and Backgrounds

Virtually every step in the retouching or compositing process requires making a selection to isolate one portion of the image from the rest of the photo. You may make a selection because you want to apply a filter or color adjustment only to one section of the image. Or, you simply may want to protect most of an image from errant brush strokes. A selection can also be copied and pasted down into its own layer for further manipulation.

Making the right selections is one of the foundations of working with Photoshop, so I'm going to devote an entire chapter to the broad array of tools and techniques at your disposal. You'll learn how to use the basic selection tools, such as the marquees and lassos, and work with more advanced tools, such as the Quick Mask mode.

You'll want to master selecting skills now, because we'll be using them extensively as we begin specific kinds of retouching and compositing projects in Parts II and III of this book.

Masking and You

What we think of as making selections has its origins (like many of Photoshop's features) in conventional photography. Graphics professionals have long worked with masks to isolate image areas, to make it easy to expose one portion of an image to manipulation while protecting other areas. The term *mask* comes from the protective function: Just as you mask off the doorknobs and hinges (maybe with *masking tape*) when you paint a door, a Photoshop mask can protect parts of an image you are editing.

There are many different ways to create masks in the non-digital world. Sometimes, images are covered with a protective translucent film like Rubylith, and areas of the mask are cut away with a sharp knife-like tool. The overlay may be red so the underlying image can still be seen, especially when the original is backlit. Certain kinds of film don't register red light at all, so such a mask can be photographically opaque even if our eyes are able to see through it.

Before digital photography tools became common, photographers would often use a technique called in-camera masking. That's a tricky but fun technique involving two exposures of a single subject and a camera mounted on a tripod to hold it absolutely steady. For one exposure, an object is posed against a white background and lit so that it forms a black-on-white silhouette. Then, a second picture is taken using a black background and normal lighting, sandwiched with a desired background image. When the "mask" film is combined with the second exposure, the result is a composite in which the subject appears to float against the background image. As you might guess, this effect is a *lot* easier to achieve using Photoshop.

Another type of masking is called *unsharp masking*, which is a way to sharpen images. In this darkroom technique, a film positive is made from the original film negative. The positive is a "reversed" negative. This positive is slightly blurred, which causes the image to spread, just like any other out-of-focus image. When the positive and negative are sandwiched together and used to expose yet another image, the light areas of the positive correspond very closely to the dark areas of the negative, and vice versa, canceling each other. However, at the edges of the image, the blurring in the positive produces areas that *don't* cancel out, resulting in lighter and darker lines on either side of the edges, emphasizing the edges and producing a sharper-looking image, as shown in Figure 2.1. This is another effect that is waaaay easier to achieve in Photoshop.

Figure 2.1
Combine a blurry positive with a negative to end up with an edge-enhanced image

Photoshop includes several different kinds of masks, including clipping groups, selection masks, vector masks, and layer masks. All share a common function: They mask off a portion of an image. The following sections detail the differences between them.

Clipping Groups

A clipping group is a set of layers in your image, with the information in the bottom layer serving as a mask for the entire group. Anything not obscured by the mask in the bottom layer is visible; everything else is invisible, as if it had been clipped from the image entirely. Of course, the "missing" part of the image hasn't been clipped at all, but remains available if you decide to modify the clipping group. For example, you might want to show only part of a photo, as in Figure 2.1, and create a clipping group to control the

amount of the image shown. Masks created by clipping groups are more of an artistic feature than one used extensively for retouching or compositing.

Selection Masks

Selection masks are often simply known as selections. Selections are created with any of Photoshop's multiple selection tools (described later), "painted" using Quick Mask mode (also set for full coverage later in this chapter), or derived from other components in an image. (A path, for example, can be converted into a selection.)

The function of a selection mask is to protect part of your image from modification. Any portion of a photo inside a selection is fair game: You can apply a filter to it, paint over it, cut it, change its size, or perform just about any function on the selection. Portions outside the selection are protected from these changes. Portions of a selection mask, most often the edges or outside border can be semitransparent, though, exposing the outer part of a selection to *partial* modification. For example, if you're painting within a selection and stroke a fuzzy edge, the paint stroke will seem to fade out.

Selection masks can be stored permanently as alpha channels, which are additional grayscale channels that appear in the Channels palette along with the red, green, and blue channels (or cyan, magenta, yellow, and black channels if you're working with a CMYK image). A selection saved as an alpha channel can be recalled later for reuse. You can even edit such a mask using any of Photoshop's editing tools by selecting the alpha channel in the Channels palette. I'll show you some uses for this ability later on. Selections are a primary tool of both retouching and compositing.

Vector Masks

A vector mask is a sharp-edged shape assigned to a layer of its own, and which can show or hide portions of an image inside or outside the mask. Vector masks are not pixel-oriented like selection masks, which means you can resize or reshape a vector mask without being subjected to the jaggies that plague rasterized (pixel) objects. Like clipping groups, vector masks are more of an artistic tool, but can be used for retouching or compositing if you have a sharp-edged object in your image.

Layer Masks

Layer masks are masks associated with a specific layer—which doesn't tell you a lot, does it? Think of a layer mask as a kind of selection, stored as an alpha channel, which applies *only* to one particular layer. You can show or hide portions of that layer, depending on what's contained in the layer mask. The cool part about layer masks is that you can turn them on or off, add to them, subtract from them, and otherwise change how a particular layer is masked *without* making any changes to the layer itself. Layer masks are quite useful for retouching and compositing applications.

Using Photoshop's Selection Tools

Mastering selections should be an early and important part of your image manipulation training. It's like the ability to fall without getting hurt when learning judo, or the techniques involved in slamming on the brakes and yelling at the driver who cut you off when learning to operate a car. Selections are as fundamental as time itself: Without time, everything would happen at once; without selections, filters, cut-and-paste operations, and errant paint strokes would be applied everywhere in your image at once.

Photoshop offers a ton of different tools for making selections, each with its own subtle differences. Think of your selection tools as an axe, saw, chisel, or router for images. All of them will grab a hunk of your image, but some of them are precision tools, whereas others are better suited for slightly rougher work.

One thing that the selection tools all have in common is that once you've made a selection, it is surrounded by that glittering parade of clockwise-rotating pixels known, variously, as "marching ants," a "marquee," or, if you're particularly stodgy, a "selection border" like the one shown in Figure 2.2. The border can be made jagged edged, smoothed, or feathered (faded out). The selection border is useful for helping you see the margins of the selection, although, in the case of fuzzy or feathered selection edges, the margin will only be approximate. Sometimes, you'll want to turn off the display of the selection border so you can see the entire image. Do that by pressing Ctrl/Command+H. When you want to make the selection border visible again, press the same keys. Your selection doesn't actually go anywhere; it just becomes invisible while the display is switched off.

Figure 2.2
Selection borders define the area that can be modified by Photoshop's filters and other tools

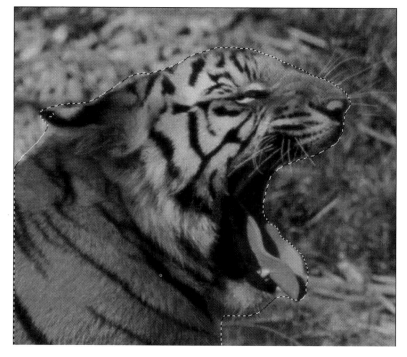

CHECK THE SELECTION EDGES BOX
If you find that pressing Ctrl/Command+H has no effect, you have accidentally (or intentionally) turned off this control feature. Choose View > Show > Show Extras Options. In the dialog box that appears, make sure that the Selection Edges box is checked. If it's not, you won't be able to use Ctrl/Command+H to hide or show the selection edges.

After you've made a selection, you can do any or all of these things with it:

▶ Add to, subtract from, enlarge, contract, or transform the shape of the selection itself. You can also move the location of the selection (only) without moving the underlying image area.

▶ Change the selection itself into a vector path you can edit with Photoshop's Pen tools.

▶ Copy the contents of the selected area (press Ctrl/Command+C) and paste it down (press Ctrl/Command+V) in a new layer of its own in the same image, or in another image entirely. The pasted area will be surrounded by transparency, so the layers underneath it will show through.

▶ Use any of the brush-oriented tools, such as the Brush (to paint), the Blur/Sharpen tools (to make parts of the selection fuzzy or sharp), or the Toning tools (to dodge or burn within the selection, or to soak up or add color richness with the Sponge).

▶ Fill the selection with a solid color or pattern.

▶ Combine images by pasting another copied image or selection into the boundaries of the selection.

▶ Apply a filter only to the area within the selection boundaries.

▶ Save selections in channels or layers for later use, and use those saved selections to add to or subtract from new selections that you create.

Making Selections in Regular Geometric Shapes

Photoshop's Marquee tools can be used to create selections in regular geometric shapes, such as rectangles, squares, ovals, and circles. Although there is no special tool for creating other kinds of pixel-oriented regular curved shapes or polygons (such as heart shapes, triangles, or pentagons), you can use other Photoshop tools to draw them. The Shape tool, for example, can create these shapes as outlines, which you can then convert into a pixel-based object, or into a selection. The Marquee tools include the Rectangular and Elliptical Marquees, the Single Row Marquee, and the Single Column Marquee. All can be accessed from a single icon in the Photoshop Tool palette. You can use these selection tools when the area you want to select is regular in shape, such as a window or the hubcap of an automobile tire.

The quickest way to access any of these tools is to press the M key on your keyboard. This makes the current Marquee tool active. If the one you want is hidden, hold down the Shift key and press the M key to cycle through the four different marquees until the icon for the one you want is shown. Creating a selection that encompasses only a single row or column of pixels is simple: Just click at a point where you want the row or column to be selected. Don't worry about being exact. After the selection is made, you can press the cursor arrow keys to move the row or column selection left or right, up or down.

Creating a rectangular or oval selection requires a little more effort. If you're new to Photoshop, you'll want to practice using the Rectangular or Elliptical Marquees by following these steps:

1. Select the marquee by pressing M or Shift+M until the tool you want is active.

2. To start a selection by defining one corner or edge, click at the point where you want to start creating the rectangular or elliptical selection and drag diagonally down or up from that point. Alternatively, you can define the center of the selection first by holding down the Alt/Option key before you start to drag. In that case, the selection radiates outward from the point you clicked, which becomes the center of the selection. Hold down the Shift key as you drag to create a perfect square or circle.

3. Release the mouse button when you've created the selection in the correct size.

4. If the selection isn't exactly where you want it (for example, you didn't click exactly in the center of the hubcap when creating a circle, so your selection doesn't quite cover the desired area), press the cursor arrow keys to nudge the selection a pixel at a time in any direction. For more radical moves, hold down the Shift key as you press the arrows to nudge five pixels per move.

If you want to scrap the selection and start over, click anywhere on the screen outside the selection, or press Ctrl/Command+D. You'll probably immediately have regrets about doing this, but don't panic. You can *reselect* the area you just deselected by pressing Shift+Ctrl/Command+D. Learn these keyboard shortcuts; you'll be using them a lot.

An important thing to remember is that there will be many times that you'll wish you had a painstakingly-created selection available. After you've moved on to another step, the selection is lost forever unless you remembered to store your selection (as described later) or are willing to retreat through previous steps (using the Image > Step Backward command), which is not ideal, because moving back also undoes any of the other steps you've performed in between.

You can also create oval and rectangular selections that are of fixed proportions that you choose or of a fixed size. Suppose you want to create several selections of varying sizes, but all with a 2:3 aspect ratio. Or, perhaps, you might want to create a series of 50 × 50 pixel selections. You can set these parameters in the Options bar that becomes active when you choose one of the Marquee tools.

To define the proportions of the selections, choose Fixed Aspect Ratio from the Style drop-down list in the Options bar. Enter the proportions you want to use in the Width and Height text boxes. For example, if you enter 1 for the width and 5 for the height, any rectangular selections you draw will be vertical rectangles or ovals that are five times as tall as they are wide. If you enter the same value in both the Width and Height boxes, the selections will always be perfect squares.

Or, choose Fixed Size from the Style drop-down list in the Options bar and type in the dimensions, in pixels, for your selections, as shown in Figure 2.3. Suppose you want to capture a 640 × 480 pixel selection, and want it to measure *exactly* 640 × 480 pixels. By specifying a fixed size, all you need to do is click anywhere in the image to create that exact size selection. Then, with any selection tool active, drag the selection around the screen, or use the cursor arrows to nudge it to the exact location you want.

Figure 2.3
You can make selections of a fixed size by entering the dimensions you want in the Options bar

PRECISION SELECTIONS
The Info palette can also help you make precise selections. With the Info palette visible, click the palette options button (the right-pointing triangle) and choose Palette Options. At the bottom of the Info Options dialog box, in the Mouse Coordinates area, make sure Pixels is selected as the Ruler Units for the palette. Thereafter, the two bottom displays in the Info palette show the information you need to create selections of a particular size or at a particular location. The X/Y information area in the Info palette displays the X and Y coordinates of the cursor so you can begin dragging at a specific point, and end dragging at another point so you can, for example, create a selection that begins 100 pixels from the top and left edges of an image, and extends down and to the right 300 pixels more.

The W/H (width/height) area of the Info palette displays the current dimensions of the selection. You can use this feedback to create a selection of a precise size.

Drawing Selections Freehand

Most of the time, the selection you want to make won't be a simple oval or rectangle. Instead, you'll often need to select an irregularly shaped object, such as a face or entire figure. Photoshop has three freehand selection tools that can be used to draw the area you want to select.

▶ **The Lasso tool**. This tool works like Photoshop's Pencil tool, creating a single-pixel selection border as you drag around an object with the mouse. To use it, click at the starting point, drag to draw the selection, and release

the mouse button when you're finished. You can either enclose the selection by finishing at your start point or let Photoshop connect the start and end points with a straight line that's created automatically when you release the button.

▶ **The Polygonal Lasso tool**. This tool creates selections using straight lines, and is a good choice for making rough selections in odd shapes. To use it, click at the start point and release the mouse button. As you drag away from the start point, a straight line trails behind the cursor like a stretched rubber band. Click again, and a selection border line is drawn between the two points. Repeat until you've closed the selection by clicking on the start point again, as shown in Figure 2.4. Or, you can double-click an end point and Photoshop connects the start and end points with a straight line selection border.

Figure 2.4
The Polygonal Lasso tool lets you create a selection using line segments

▶ **The Magnetic Lasso tool**. This tool creates selections between points as you drag and click, something like the Polygonal Lasso tool. The main difference is that the tool acts as if the edges of objects are magnetic, so that they "attract" the selection lines. The Magnetic Lasso uses the contrast between portions of your image to determine how magnetic the edges are, so if you have an object with well-defined edges, like the one shown in Figure 2.5, the tool can do a good job of selecting it.

Figure 2.5
Well-defined edges
let the Magnetic Lasso
tool do its job better

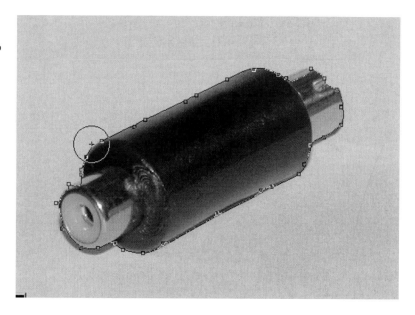

SWITCHING THE LASSO TOOL

You can convince the Lasso tool and Polygonal Lasso tool to switch behaviors temporarily. When using the Lasso, hold down the Alt/Option key and click to create straight-line segments like those produced by the Polygonal Lasso. When you release the Alt/Option key, the Lasso returns to its freehand behavior. Similarly, when you're using the Polygonal Lasso, you can hold down the Alt/Option key to create freehand lines.

Each of the Lasso tools has parameters you can set in the Options bar that becomes active when the tool is active. All three let you determine how hard or soft the edges of the selection are by setting anti-aliasing and feathering. Anti-aliasing is a feature that, when enabled, tells Photoshop to smooth the edges of the selection by fading the selection into the background. This option is useful when copying portions of an image for pasting into a composite, because the edges merge more smoothly with the area being pasted into. Remember to mark the check box before making the selection; after you've created a selection, you can't add anti-aliasing.

Feathering is a more elaborate method of softening a selection. It creates a fade-out "zone" around the edge of the selection. You determine the width of the zone, which measures from 1 to 250 pixels. This zone blurs the edges of the selection, producing a smoother transition, such as the castle that's fading into the floating rock in Figure 2.6. When used with caution, feathering is another way to blend a copied selection into a new background. Unlike anti-aliasing, feathering can be applied after the fact. With an active selection, just choose Select > Feather, choose the feather radius, and then click OK.

Figure 2.6
Thanks to the
feathering of the
selection, the castle
seems to fade into the
floating rock

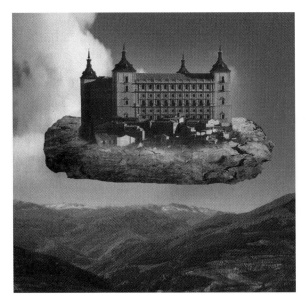

The Magnetic Lasso tool has even more options to choose from.

▶ **Width**. This sets a detection width on either side of the mouse pointer that Photoshop uses to look for high contrast areas to "hug" to. It looks for edges only within the width you enter. You can change the edge width dynamically as you're creating a selection by pressing the] (right bracket) key to increase the width by one pixel, or the [(left bracket) key to decrease it by one pixel.

▶ **Edge Contrast**. This is the degree of difference in contrast between pixels that must be present to qualify as a clingable "edge." The default is 10 percent, but you can enter values from 0 to 100 percent. The higher the percentage, the more distinct the edge must be before the Magnetic Lasso will see it.

▶ **Frequency**. This is the spacing between automatically laid-down magnetic points. Use a high number and Photoshop adds points more frequently, creating a rough, but detailed magnetic selection that closely corresponds to the edges of the object. A lower number creates a smoother-looking selection that is less accurate, but also much less rough-looking. You can choose values between 0 and 100.

▶ **Pen Pressure**. If you're using a pressure-sensitive tablet, mark this check box to increase the size of the edge width as you press harder, and decrease the edge width as you let up on the stylus. You can see the Options bar for the Magnetic Lasso tool in Figure 2.7.

Figure 2.7
The Options bar for
the Magnetic Lasso
tool lets you control
how the lasso behaves

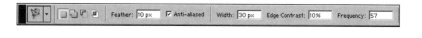

Creating Selections by Magic

The first time I saw the Magic Wand tool in operation (in MacPaint, on my first Macintosh, in March, 1984), I was really impressed. The ability to manipulate every single pixel of the entire display screen, in those days of blocky character-oriented graphics, was amazing enough. The Marquee tools and Lasso were more surprising yet, but the Magic Wand was *impressive*. All you had to do was click in your image, and the tool would search out and select every single pixel within the boundaries of your object, as if by magic.

Today, the Magic Wand is no less important in its souped-up version for anyone making selections of pixels for retouching or compositing tasks. Used properly, the Magic Wand can save you hours of time tediously selecting objects manually, grabbing *all* of, for example, a sky area or the background surrounding an object you want to isolate.

Of course, with the original Mac, all pixels were either black or white, with no grays (or colors) at all, so grabbing pixels was fairly easy. Today's Magic Wand has full color to contend with. It performs its magic by selecting all pixels that are similar in hue and value to the pixel first clicked on, based on parameters that you specify. So, if your background is a fairly uniform shade of blue and you click on an average blue pixel, the Magic Wand selects a whole bunch of other blue pixels, as shown in Figure 2.8. Exactly *which* other blue pixels is part of the art and science of using the wand. Here are some basic ground rules:

> ▶ The pixels selected are based on the pixel you click on, in the exact center of the cross-hair cursor that appears when the Magic Wand tool is selected. (This assumes you haven't chosen Standard Cursors instead of Precise Cursors in Edit > Preferences > Display & Cursors.) You might want to zoom in on your image if the exact pixel selected is important (for example, you want to choose a particular blue from among a broad range in the image area).

Figure 2.8
The Magic Wand
didn't select all the
pixels in the
background, but it
made a good start

THE MAGIC OF THE MAGIC WAND

Photoshop uses *both* hue and luminance to characterize pixels selected by the
Magic Wand, using a super-secret algorithm that you don't want or need to know
about. Suffice it to say that pixels selected by the Magic Wand are very similar to
the one you click first.

▶ The pixel you click on resides in the currently active layer, unless you
click the Use All Layers check box in the Options bar. In that case, Photo-
shop uses the information from *all* the visible layers to determine the basic
value used for selecting pixels.

▶ To select additional pixels beyond those with the exact hue and darkness
settings of the one you click, adjust the Tolerance setting in the Options
bar. If Tolerance is set to 0, Photoshop selects only pixels exactly like the
one you first clicked. The larger the number, the less fussy Photoshop
becomes. If you've set Tolerance to 32 and you click a pixel that Photo-
shop calculates (using its super-secret algorithm) as 120, then the pixels to
be selected have values within that range of 32, that is, 104 to 136.

▶ Choose your Tolerance level carefully: A value of 32 is a fairly large value,
even though it's the default, encompassing 1/8 of all the pixels in an
image. You may want to move the value up or down until the range of pix-
els you want to select is within your sights.

▶ Mark the Anti-Aliased check box if you want to smooth the edges of the
selection.

► Mark the Contiguous check box to select only pixels within the specified range that are touching each other. Remove the check mark, and the Magic Wand selects *all* pixels in an image that are similar in hue and value within the Tolerance range you specify. You might want to use the Contiguous option to select, for instance, a background area that contains colors that are similar to those in other parts of the image. By limiting the selection only to pixels that touch, you'll grab just the background pixels, or those along the edge that are similar in color. The noncontiguous option is a good choice for selecting things such as a sky area within the wires of a chain-link fence. The pixels don't touch (they're separated from each other by the chain links), but they're similar enough that you can select them quickly using the Magic Wand.

Modifying Selections

As you learn to use the selection tools, you'll rarely make the exact selection you need on your first try. Much of the time, you'll want to add a little to a selection, subtract a smidge here or there, or create a new selection by combining several selections. The following sections describe the ways you can modify your selections in Photoshop.

Adding to a Selection

You can add to a selection using any of the selection tools, even those that weren't used to create the original selection in the first place. For example, if you create a rectangular selection, you can add to it with the Elliptical selection tool or Lasso, if you want. Just select the tool you want to use, hold down the Shift key, and drag or click with the mouse. The new selected area becomes part of the original selection.

Notice that the additionally selected area does not have to be contiguous with the original selection. You can select a rectangle, then add to that selection an elliptical shape located on the other side of the image. The added selection *may* touch the original selection, but does not have to. Figures 2.9 and 2.10 show a rectangular selection in its original form, and after a circular selection has been added to it.

CHAPTER 2

Figure 2.9
The original
rectangular selection

Figure 2.10
A circular selection
has been added to the
original selection

Another way to add to a selection is to click the Add to Selection icon in the Options bar. When you do so, any selections you make are added together until you turn the option off.

You'll want to add to selections to make them fit the area you want to work with more precisely. For example, if you want to select a background that consists of both dark and light tones (for example, a bold striped pattern), you can first select the light stripes in the pattern, then add to your selection by choosing the dark stripes.

There are four ways to add to a selection from the Select menu.

▶ Choose Select > Similar to add pixels that are similar in hue and brightness to the pixels already selected. This has an effect like deselecting the Contiguous check box when using the Magic Wand. Pixels anywhere in the image that fall within the Magic Wand's current Tolerance setting are added to the selection.

▶ Choose Select > Grow to add pixels that are adjacent to the selection that falls within the Magic Wand's current Tolerance setting. This is similar to using the Magic Wand with the Contiguous check box marked.

▶ Choose Select > Expand to enlarge the selection by the number of pixels you specify.

▶ Choose Select > Smooth to add (or remove) pixels to even out the borders of a selection.

Subtracting from a Selection

Subtracting from a selection can also be done with any selection tool. Just hold down the Alt/Option key as you use the selection tool. Anything you select in this mode is *subtracted* from the original selection. You can also click the Subtract from Selection icon in the Options bar to make subtraction temporarily the default mode. Using these icons to add or subtract frees your hand from having to hold down the Shift key (to add) or the Alt/Option key (to subtract).

Use the subtraction option to rid your selection of unwanted pixels. Suppose you want to select an irregular area that's inside a plain background. First, you could draw a large selection around the entire object using the Lasso tool, including the plain background. Then, you could use the Magic Wand tool to subtract the background area from your selection, leaving only the object selected. This is an easy way to select objects that themselves have too broad a range of tones for easy selection with the Magic Wand, but which are located on a background that is somewhat simpler to select. Figure 2.11 shows the original rectangular selection with a circular selection subtracted from it.

You can also subtract from a selection by choosing Select > Contract to move the selection border inward by the number of pixels you specify, or feather the selection by choosing Select > Feather (or Alt/Option+Ctrl/Command+D) and specifying the number of pixels to fade out the selection.

Intersecting Selections

Intersecting is a way to create a selection that includes only the areas of two selections that overlap each other. That is, if you create two rectangular selections that overlap at one corner, *only* the corner would remain selected. You can choose to intersect selections by clicking the Intersect icon in the Options bar when a selection tool is active. Figure 2.12 shows the selection that results when you intersect the rectangular and circular selections.

Figure 2.11
Subtract a circular
selection from the
rectangular selection
to produce a selection
with a "hole" in it

Figure 2.12
Overlapping
selections create a new
selection from the
intersecting parts

CHAPTER 2

Selecting Everything/Nothing/Reverse

Select everything in an image by choosing Select > Select All (or Ctrl/Command+A); des-
elect everything by choosing Select > Deselect (or Ctrl/Command+D). You can reverse a

selection, which selects everything that was not previously selected, by deselecting every-thing that was or by choosing Select > Inverse (or Shift+Ctrl/Command+I). If you cancel a selection and change your mind, restore the most recent selection by choosing Select > Reselect (or Shift+Ctrl/Command+D).

Learn the keyboard shortcuts! I find myself constantly pressing Ctrl+D and Shift+Ctrl+I throughout a work session as I make selections, clear old selections, and invert selections I've already made.

Transforming Selections

You can change the shape of a selection with Photoshop's transformation tools. Choose Select > Transform Selection to create a bounding box around your selection (regardless of its shape) with a set of handles at the corners and each side of the box. You can drag the corner handles to make a selection proportionally larger or smaller, or drag one of the handles on the sides, top, or bottom to stretch the selection in only one direction.

Right/Control-click on the selection to produce a context menu that has the other Photoshop transformation options, such as Scale, Rotate, Skew, Distort, and Perspective.

Saving Selections

Selections are a precious commodity. After you've expended the painstaking effort to make the exact selection you need, you'll want to store the selection for reuse later on. To save a selection, choose Select > Save Selection. Apply a name in the dialog box that appears. The New button, which indicates you're saving the selection for the first time, is checked by default.

If you save a selection again, using the same name, you'll be able to specify whether you want to replace the previous selection by that name completely, or whether you'd prefer to add, subtract, or intersect the new selection with the old one.

Painting Selections

If none of the previous selection tools suits you, Photoshop lets you paint a selection using Quick Mask mode. When you shift into Quick Mask mode, selected or nonselected areas (your choice) are represented by a tone, usually red. You can add or subtract from a selec-tion by using painting and erasing tools, or even other selection tools. When you leave Quick Mask mode, the areas you've painted and erased are transformed into a selection.

Quick Mask mode can be used to create a mask from scratch, or to modify any existing selection. Here's a quick run-down of how to use Quick Mask mode:

1. Enter Quick Mask mode by pressing Q, or by clicking the Quick Mask icon in the Tool palette. When you double-click the icon, a dialog box appears that lets you specify how you want Quick Mask mode to work.

▶ In the Color Indicates area, you can choose whether the tint color of the mask represents the selection itself, or the protected, masked areas. Often, it's easier to have the color represent the selection so you can see exactly what your selection looks like.

▶ In the Color area, you can click the color patch and choose another hue instead of the default red color. You might want to do that if the object being selected or its background contains a lot of red and it would be difficult to differentiate between the two. You can also choose the opacity of the tint color. The default value of 50 percent allows the underlying image to show through while still clearly differentiating the area you're painting. You might want the tint to be more or less opaque, depending on your subject matter.

2. Create your selection by painting, drawing, or filling, choosing any or all of these options:

▶ You can paint or draw with any of the Brush tools, as shown in Figure 2.13.

▶ Make a selection using the Marquee, Magic Wand, Lasso, or other tools and fill those selections with the Paint Bucket tool, or remove them by pressing Delete.

▶ Erase part of the selection using the Eraser tool.

Figure 2.13
Use the painting tools to paint your mask or selection

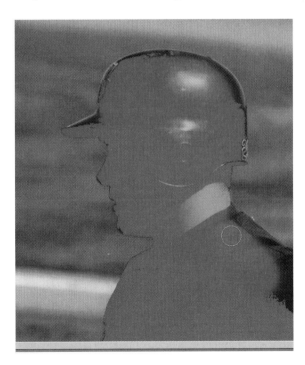

CHAPTER 2

3. When you've finished creating or modifying the selection, exit Quick Mask mode by pressing Q.

Transforming Paths to Selections and Vice Versa

All the selection tools mentioned so far create pixel-oriented selections. Although Photoshop may not be your best choice for working with vector graphics (scalable line and curve-oriented objects), Adobe's flagship image editor has some features that can perform fairly well as a stand-in for stablemate Adobe Illustrator. Indeed, Photoshop includes a Pen tool that can create lines and shapes that can be fine-tuned, saved as paths, filled with color or outlined (stroked), and used as the basis for selections. Conversely, you can change selections into paths and edit them with the tools on the Paths palette.

If you're comfortable using the Pen and the Paths palette, Photoshop's vector tools may serve you well, as they are well-suited for outlining objects that consist of precise curves and lines. Depending on the kinds of images you retouch or composite, you may not need these capabilities often—or you may live and die by them.

Unlike pixel-oriented graphics, paths consist of line segments that can be edited, combined, rescaled, and otherwise manipulated without picking up the dreaded "jaggies" that result when pixels are enlarged. Paths can consist of lines or a closed shape or a series of lines, a series of shapes or a combination of lines and shapes. You can stroke and fill sub-paths as well as paths. Paths can be converted to selections, which is useful when you want to select an area of an image that can be closely approximated by a path.

After you've created a path, you can easily convert it into a selection:

1. Select the path you want to transform by making its layer active.
2. Right/Control-click the path and choose Make Selection from the context menu.
3. In the Make Selection dialog box, you can set the feather radius for the selection border and you can choose the Anti-aliased option if you want.
4. Choose whether you want a new selection, or add, subtract, or intersect a current selection.
5. Click OK to change the path to a selection.

If you later decide you want to convert a selection into a path (so you can edit the path using the Pen tools), choose the Paths palette, and from the fly-out palette menu, select Make Work Path. The selection will be transformed into an editable path.

Next Up

Although the ability to select parts of your image deftly is important, you'll also need to master Photoshop's powerful cloning, patching, and healing features. These features let you copy pixels from one place to another to obscure unwanted detail, fix defects such as dust spots, scratches, or missing areas of an image, or even move objects from one place to another. We look at this important capability, with a special focus on the Healing Brush and Patch tool introduced with Photoshop 7, in the next chapter.

3

Cloning, Patching, and Healing

The science of cloning has been in the news lately as scientists discover ways to make reasonably exact copies of living creatures. If you think the process of inducing cells from donor organisms to develop as an embryo is complex, try cloning—copying image pixels from one place to another—in Photoshop sometime. Pixels can be more frustrating to work with than cells, and your end results will be evaluated considerably more rigorously. After all, the creators of Dolly were happy just to get a healthy sheep; photos you retouch must pass the critical review of everyone who looks at them.

Of all the techniques found in electronic retouching and compositing, cloning parts of an image is the least like any of the possible conventional image manipulation techniques. Graphics professionals working with film or prints have been able to adjust the brightness or darkness of tones, correct colors, make areas sharper or more blurry, or perform other image magic using manual techniques. Cloning, however, is not something that's easily done outside the digital realm.

Cloning can be used to cover up areas you want to hide, remove objects or replace them with other objects, fix defects in an image by copying texture from one place to another, or create duplicates of objects. Photoshop includes several clone and clone-like tools, including two variations of the Clone Stamp, the Healing Brush and the Patch tool. The History Brush, which allows you to copy pixels onto an image from an earlier version of the image, is almost a clone implement, as well.

We'll be using cloning extensively in the practical chapters of this book. This chapter serves as an introduction to the tools you need to learn to work successfully with pixel-duping.

Cloning: Pre-Photoshop

There really weren't many options for copying parts of an image from one place to another prior to the introduction of image editors like Photoshop. The methods at the photographer's disposal included manual retouching by a retouching artist, or physically

duplicating and compositing portions of an image using a combination of knives and photographic tricks. None of these were techniques for the unskilled or faint-hearted.

Take something as simple as obliterating dust spots on an image. Most images taken with a non-digital camera have dust spots on them, no matter how carefully we try to keep our equipment and working environments clean. Even digital images can have "dust" in the form of artifacts caused by the quirks of the imaging sensor. Some things that look like dust can actually be tiny bright spots or reflections in the image. In all cases, the goal is to remove them.

With conventional photos, such dust spots are usually removed from the final print, using spotting brushes or pencils. The retoucher carefully matches the shades and hues of the surrounding area to blot out the offending spot. The spotting color may not have to match perfectly (there are always variations in color and tone in any area of a photo, after all), but the cover-up must be close enough that it's not visible when the print is inspected up close. Moreover, the texture and surface of the added color must be consistent with the surrounding print (a matte dot on a glossy photo may be readily apparent under some circumstances, for example).

Cloning in Photoshop doesn't require an artist's skills. If you make a mistake, you can undo it. Selecting the correct color or texture is easy: You choose a matching area from elsewhere in the image. Although spotting is the easiest of all retouching skills to master, Photoshop makes it easier.

Now, consider an even more complex task: repairing a damaged area in which the image information is distorted or missing entirely. You might encounter an old photograph with a torn corner, and need to replace the background in the missing area. Using conventional photographic tools, you might be able to create a duplicate of a portion of the image and combine areas to create a reasonably realistic whole. Or, you might call on an artist's skills to paint in the area. With Photoshop, you can simply copy pixels to fill in the missing corner.

Using the Clone Stamp

Photoshop's Clone Stamp tool is a thousand times better than a spotting brush, because it can use as its "color" actual pixels from elsewhere in your image or in another image. It's also more useful than manual compositing techniques, because it's easy to blend cloned pixels in with their surroundings, either realistically, or in an abstract way for an artistic effect, like the one shown in Figure 3.1. We use this tool extensively in the retouching and compositing chapters, but here's an overview that will introduce you to this remarkable aide.

The Clone tool operates similarly to all other Photoshop brush-like tools, with a few exceptions. You can choose brush size and shape, blending modes, and other options. These can all be chosen from the Options bar, shown in Figure 3.2. I'll show you how each of these work, one at a time, working from left to right on the Options bar.

Figure 3.1
The flower on the right is the original bloom; the one on the left has been cloned, not biologically, but by using Photoshop

Figure 3.2
The Clone Stamp Options bar contains all the controls you need to use the tool

Clone Tool Presets

New Photoshop users often can't figure out what to do with the drop-down menu at the far left of the Options bar. Some think the only thing it's good for is to hold an icon representing the currently active tool. Others click on its down-pointing arrow and see that it has a palette menu (yet another arrow, this one pointing to the right) that lets them reset the tool's default values. If you look a little deeper, you'll see that this little object, called the Tool Presets menu, lets you create settings that you can recall at any time to use any combination of the other choices in the Options bar.

For example, if you frequently clone using a 64-pixel soft brush with the opacity set to 40 percent in Airbrush mode (more details on all of these in the following section), you can define those settings as a preset. Here's how to do it:

1. Choose your settings using any of the choices on the Options bar.
2. Click the down-pointing arrow on the Tool Presets menu to access the menu.
3. Click the flyout palette menu and choose New Tool Preset, as shown in Figure 3.3.
4. Enter a descriptive name for the settings that you'll find easy to associate with the image editing situation you use it for.
5. Click OK in the New Tool Preset dialog box.

Thereafter, to use that tool setting, simply click the Tool Presets menu and choose the setting from the scrolling list.

CREATING TOOL PRESETS

Tool Presets are available for all tools in Photoshop, in addition to the Clone tool, of course. You can highlight a preset and rename or delete it, or save libraries of presets to your hard disk. For example, you may have particular settings you use for certain retouching tasks. Choose Save Tool Presets from the palette menu, apply a name, and you can reload those settings at any time for reuse.

Figure 3.3
Choose New Tool
Preset to create a
setting for the tool
that you can reuse at
any time

Choosing Brush Sizes and Tips

There's nothing really different about choosing brush sizes and tips with the Clone tool than there is with making these selections with other brushes. So, everything you learn here can also be applied to the Healing Brush; the Toning tools, such as Dodge and Burn; the Blur, Smudge, and Sharpen tools; or even the ordinary Brush tool.

Click the down-pointing arrow next to the Brush Preset picker to display an array of the available predesigned brushes. You'll probably get the most use from the six round hard-edged brushes and the 12 round soft-edged brushes. Other brushes are furnished in non-round shapes, ranging from square or elliptical forms to starbursts, leaves, and cross shapes. In default mode, the diameter of a particular brush, in pixels, is shown beneath the thumbnail of its shape. If you want, you can change this to display the brush tips in large or small thumbnail modes, as text only, text lists with thumbnails, or as a list with sample brush strokes, as you can see in Figure 3.4. The flyout menu at the top-right corner of the Brush Preset picker contains these display options.

The flyout palette menu also has a list of other brush tip libraries furnished with Photoshop, with names like Assorted, Faux Finish Brushes, and Wet Media Brushes. You can load one of these, or a library you create yourself, from the menu. In general, however, most of these fancy brush tips are useful primarily for painting artistic images. When cloning, you'll usually end up sticking with the plain round brushes, unless you're trying to create a special texture.

Figure 3.4
Choose various sized brush tips from the Brush palette and its palette menu

Activate one of the preset brush tips by clicking it in the palette. You can also select a brush tip and then make it larger or smaller by moving the Master Diameter Slider at the top of the palette. I use this control when I need a hard-edged brush larger than the maximum 19 pixels in diameter supplied by Photoshop. Or, you might want a very large soft-edged brush to clone pixels in a large, high-resolution image. Photoshop allows you to boost the brush size all the way up to 2500 pixels, which should be much bigger than you'll realistically need. You can also alter the brush size from the keyboard as you work: Press the left bracket key to make the brush smaller and the right bracket key to make the brush larger. The increment that each brush changes varies, depending on the original size of the brush.

Choosing a Brush Mode

Photoshop includes a variety of blending modes that govern how pixels merge together when new pixels are applied (as with brush strokes) or when two layers are combined. We'll work in both modes (so to speak) throughout this book, so I'll take some time here to explain what the individual modes do. The differences between modes may not make a lot of sense at this point, but you can refer back to this chapter as you work through this

book and need a refresher. Blending modes are one of the most confusing aspects of Photoshop, so I recommend you try them on with different photos, layers, and tools to see what they do. I'll use several of these in later chapters to show you which modes are of most use when retouching and compositing.

When pixels are merged using one of Photoshop's blending modes, you need to keep three different pixels in mind.

▶ **The base pixel**. This is the pixel that you're painting onto, the underlying layer that you're cloning onto.

▶ **The blend pixel**. This is the pixel that's being applied to the base pixel, or the pixels you're cloning onto the new location. This painted pixel can be 100 percent opaque, or partially transparent.

▶ **The result pixel**. This is the pixel you end up with after combining the blend pixel with the base pixel using the Clone tool.

Photoshop has more than 20 different blending modes. The most daunting thing about these modes is that it takes a great deal of experience to understand what particular modes can do for you. For example, Overlay mode can be useful when you want to change the color of pixels while preserving the detail in the highlights and shadows. Some blending modes are available only with certain tools, such as the Clear mode, which can be used with an ordinary brush, but not with the Clone tool. Here are Photoshop's blending modes that can be used with the Clone tool:

▶ **Normal mode**. Covers underlying base pixels completely when opacity is set to 100 percent. This is the most common painting mode. Figure 3.5 shows a widget that has been cloned on top of itself, at left, using Normal mode. The same widget was cloned using Exclusion mode at right.

Figure 3.5
Cloning in Normal mode (left) and in Exclusion mode (right)

▶ **Dissolve mode**. Produces a spattered effect by the blend pixels replacing the underlying base pixel color at random, based on the density of the applied paint at any specific pixel location.

▶ **Behind mode**. Allows you to apply pixels only to transparent areas. This mode is used when you are cloning onto layers that have transparency.

▶ **Darken mode**. Changes only base pixels *lighter* than the blend color.

▶ **Multiply mode**. Darkens the image (when drawing over the image) by multiplying the color values according to a mathematical formula. The best way to see the effect of this is to paint with a clear yellow on a pure white background. Paint over the same area, releasing and re-pressing the mouse button between strokes. (The yellow gradually gets darker and darker, like you're painting with felt-tip markers.) You do not get the darkening effect in Normal mode, even if you're painting brush strokes with partial opacity. The most you get is 100% opacity of your color.

▶ **Color Burn mode**. Compares the color information of each pixel, and darkens the base pixel to increase the contrast.

▶ **Linear Burn mode**. Compares the color information of each pixel, and darkens the base pixel to decrease contrast.

▶ **Lighten mode**. Changes only pixels *darker* than the blend pixels with which you are painting.

▶ **Screen mode**. Lightens the pixels you're painting over while giving them the tint of the blend color. Consequently, the white is not affected, but black, gray, and the other colors are affected. The Screen mode is the opposite (inverse) of the Multiply mode.

▶ **Color Dodge mode**. Compares the color information of the pixels and brightens the base pixel to reflect the blend pixel by decreasing contrast.

▶ **Linear Dodge mode**. Compares the color information of the pixels and brightens the base color to reflect the blend pixel by increasing contrast.

▶ **Overlay mode**. Mixes the base color with the blend color, preserving the highlights and shadows of the original image while overlaying the new color on top.

▶ **Soft Light mode**. Provides the effect of shining a diffused spotlight on the image. If the blend pixel is lighter than a base pixel, the pixel is lightened. If the blend pixel is darker than the base pixel, the pixel is darkened.

▶ **Hard Light mode**. Provides the effect of shining a harsh spotlight on the image. The same type of calculations are performed as in Soft Light mode, but pixels are made much lighter or much darker, as required, to produce a stronger effect.

▶ **Linear Light mode**. Darkens or lightens colors by decreasing or increasing the brightness, depending on the blend pixel's colors. If the blend pixel is lighter than 50 percent gray, the image is lightened by increasing the brightness. If the blend pixel is darker than 50 percent gray, the image is darkened by decreasing the brightness.

CHAPTER 3

▶ **Pin Light mode**. Replaces colors, depending on the blend pixel. If it's lighter than 50 percent gray, all pixels that are darker than that are replaced by the blend pixel. If the blend pixel is darker than 50 percent gray, all pixels that are lighter are replaced.

▶ **Difference mode**. Calculates the difference between the blend and base pixels, and the result color becomes the value that is determined.

▶ **Exclusion mode**. Similar to Difference mode, but creates a final pixel that is lower in contrast. You can see in Figure 3.5 that the pixels of the cloned widget represent the difference in color and tone between the clone copy and the original where they overlap.

▶ **Hue mode**. Changes the hue of pixels to that of the blend color, but they maintain their saturation (intensity) and luminosity (a measure of brightness).

▶ **Saturation mode**. Changes the saturation of the underlying base pixels, but leaves their hue and luminosity alone.

▶ **Color mode**. Changes underlying base pixels to the blend pixel's color. The hue and saturation of the pixels is changed, but not the luminosity.

▶ **Luminosity mode**. Changes only the lightness of the pixels; the color values are not affected. The Luminosity mode is the exact opposite (inverse) of the Color mode. Use this mode when you want to change pixel lightness while leaving the hue alone.

Setting Opacity, Flow, and Airbrush Modes

Sometimes, you'll want the Clone tool, or another Brush tool, to only partially obscure the pixels underneath. The Opacity control on the Options bar allows you to specify how opaque your cloned pixels are. You can type a value from 0 to 100 percent into the Opacity box, or choose an opacity with the slider.

The Flow control lets you specify how quickly the cloned pixels are applied. Higher flow rates mean the pixels are applied right away as you paint, whereas lower flow rates generate the cloned pixels more slowly.

If you want to feather your cloned pixels to produce a fuzzy edge, click the Airbrush option in the Options bar.

Using Clone Aligned and Clone Non-Aligned

One of the first things you need to learn before using the Clone tool is how the tool relates to its point of origin. As you probably know, you can select the point used as a reference for cloning by Alt/Option-clicking in the source image area. The source does not have to be in the same layer, or even in the same image as your destination. If you want to clone in some texture from one image to the background of another, simply Alt/Option-click in the appropriate area of the source image, then start cloning in the destination.

The Aligned check box determines what happens next. When the box is checked, Photoshop copies pixels from the point that you first marked as the source to the point in the image where you begin cloning. Then, as you move away from that point, Photoshop uses the distance and direction the cursor moves from the cloning point to determine which pixels to copy. For example, if you move 1/4 inch up and to the left of the first point where you start painting, the Clone tool copies pixels that are 1/4 inch up and to the left of the origin point. It doesn't matter if you stop painting and start again, unless you Alt/Option-click again somewhere else, the origin point is always used as the reference point.

When the Aligned check box is not checked, each time you begin painting again, the origin point is used in the new location. Figure 3.6 shows what happens. In both cases, I clicked on the gondola of the dirigible to set the origin point. Then, I began painting at a point near the bottom of the image.

At bottom center, the Clone Aligned check box was marked. I stopped painting and restarted several times, but each time the Clone tool took up painting again at a position relative to the cursor's distance from the origin point. At bottom right, I also began cloning near the bottom of the image, but with the Clone Aligned check box unchecked. When I released the mouse button, and then began painting at a different point, the Clone tool started over again, painting based on the origin point.

Figure 3.6
Clone Aligned (bottom center) and the Clone tool will always resume where you left off if you pause. Clone Non-aligned (bottom right) and the Clone tool will begin painting anew from the origin point

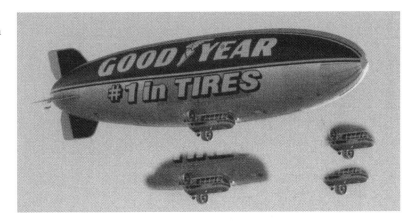

Use All Layers

By default, Photoshop copies pixels only from the layer you first Alt/Option-clicked in. Sometimes, you'll want to clone from all the visible layers, as when you're creating an image that you plan to flatten into a single image but haven't flattened yet. Mark the Use All Layers check box, and Photoshop pretends that the image has been flattened as it samples pixels and copies them to your destination image or layer.

Toggle Brushes Palette

At the far right of the Options bar is an icon that shows or hides the Brushes palette when you click it. It provides fast access to this tool. You'll find it extremely useful for changing the characteristics of preset brush tips, and for creating your own. The Brushes palette is shown in Figure 3.7.

Figure 3.7
Use the Brushes palette to create your own brushes for cloning or use with other Brush tools

Repairing Images with the Healing Brush

The Healing Brush is the next logical evolutionary step after the Clone tool. As useful as the Clone tool is, there are two problems with it. The first problem is that the tool is rather stupid. You have to tell it how to do *everything*, from pointing out what spot to use as its origin to how to merge the pixels at the destination location.

The second problem is that the people using the Clone tool aren't much smarter than the tool itself. We can make some guesses about what blending mode might merge the pixels most effectively. We can probably fiddle with Opacity settings to avoid completely obscuring all detail in the destination, if that's what we want. But, all in all, the Clone tool is useful but inelegant.

If you aren't clever (or lucky) at choosing the origin point, the cloned pixels won't blend very well. The textures won't match and the copied pixels will scream out "I'M CLONED!!" to everyone who views the image. There are workarounds, of course. You can always clone *onto* a new, transparent layer, and then play with the Opacity of the layer when blending it over the destination spot. Or, you can mess with the blending modes of the tool itself. For beginners, the process involves a lot of trial and error, and even veteran cloners may find that the errors are scarcely worth the trials.

The Healing Brush, in contrast, is a smart tool with a mysterious nanocomputer built into it that performs all sorts of arcane calculations as you copy pixels. It works, in many ways, like the Clone tool. You choose an origin point, a brush size, and (if you like) a blending mode. Then, begin painting in the destination of your choice. The Healing Brush's algorithms examine the destination area, calculate the texture, lighting, and shading, and then modify the cloned pixels to provide a good match. The copied pixels merge smoothly with those they are covering, so instead of replacing the detail completely, the Healing Brush blends the old and new pixels.

The process can be slow if you're using a high-resolution image and/or a slow computer. Many users report that it almost looks as if the new pixels are melting into place over the old ones. The lag shouldn't amount to more than a second, and it's interesting to watch, but it can slow you down. On the plus side, you'll find yourself healing more slowly and deliberately, which can be a very good thing.

Both are best applied to subjects that truly need "healing" of small areas that need to be blended in with the areas around them. I used the Healing Brush for a quickie fix of a reflection problem in a young man's eyeglasses and the glass he was holding. There wasn't time to laboriously remove all traces of the glare, and unless it is done very carefully (I'll show you how in Chapter 7, "Retouching Portraits"), the result looks unnatural. Instead, I wanted to tone down the reflections. The Healing Brush copied pixels from other parts of the glass over the pixels in the glare area, but allowed the underlying texture (such as the man's eyes) to show through. There's still a trace of the reddish glare, and the photo looks fairly natural, as you can see in Figure 3.8. Not bad for a fix that took less than two minutes!

There are some important differences between the Healing Brush and the Clone tool, however.

▶ The Brush presets are not available. Instead, you set the size of the Healing Brush from the controls that reside where the presets are normally found, as shown in Figure 3.9. You can adjust the diameter of the Healing Brush, the fuzziness of its edges (the hardness), the spacing of the strokes, and the angle/roundness of the brush tip if you don't want a perfectly round brush.

▶ The blending modes you can use with the Healing Brush are limited to the Normal, Replace, Multiply, Screen, Lighten, Darken, Color, and Luminosity modes. I strongly recommend leaving the mode set at Normal and letting the Healing Brush do its job.

CHAPTER 3

Figure 3.8
This quickie fix used the Healing Brush to tone down the reflections in the young groom's eyeglasses and drinking glass

▶ The Use All Layers option is not available. The Healing Brush always works from the layer you use as the origin point when you Alt/Option-click on a source pixel.

▶ In addition to healing from a source location you sample, you can also specify a pattern in the Options bar. You might want to use a pattern when the texture you want to use to heal a portion of the image isn't available within the image. Use a pattern that's close to the texture you'd like, and let the Healing Brush do the rest.

Figure 3.9
Set the parameters of your Healing Brush using this dialog box

Working with the Patch Tool

The Patch tool works something like the Healing Brush. However, you grab a selected area you want to use as a patch (much like cutting out a piece of rubber you're going to glue over a hole in an inner tube), and paste the patch over the area to be fixed. As with the Healing Brush, the patch takes into account the texture and other attributes of the area being fixed and merges smoothly.

Interestingly, the Patch tool can be used in two different ways. You can define the area you want to use as the patch first, and drag it over to the destination. Or, you can define the area to be fixed, and then drag it to a portion of your image containing the texture you want to apply to it. It's easy to decide which mode to use. If the size and shape of the patch isn't critical (say, the defective area is surrounded by tones that are similar), go ahead and define the patch first (mark the Source button in the Options bar), and then drag the patch over to the area to be mended. Figure 3.10 shows an image before and after patching. Unless you look closely and compare the two images, you'd never know that the shelf of books above the kids' heads in the top version has been smoothly replaced with a whole new shelf of books in the bottom version. The "patch" is seamless.

On the other hand, you may find that the area to be patched is surrounded by other image material that you don't want affected by the patch. In that case, mark the Destination button in the Options bar, and select only the area you want to fix. Then drag it over to the portion of the image containing the texture that will mend it.

The Patch tool also lets you patch using a pattern. You can select the pattern from the drop-down palette. Then, click the Use Pattern button to apply the pattern you've chosen to the selection you've made.

CHAPTER 3

Figure 3.10
Before and after patching. In the lower version, the shelf of books above the kids' heads has been replaced

Next Up

Making selections and cloning/healing are only two of the four key skills you need to sharpen before we begin retouching and compositing images in earnest. There are two more you need to work on: adjusting the tonal values and colors of your images. We look at Photoshop's varied tools for fixing exposure in the next chapter, before moving onto its color correcting features in Chapter 5, "Adjusting Color."

4

Tools for Adjusting Tones

One key step in retouching any image, whether the photo is black-and-white or color, is adjusting the relationship between the dark, light, and middle tones of an image, which we call the *tonal range*. The whole process can easily be confusing for tyro image retouchers (and veterans alike, at times), because the factors involved can be complex if you don't keep the basics in mind as you work.

For example, a given image may appear to be too dark, so all you have to do is lighten all the tones, right? Wrong! If you lighten all the pixels equally, you'll probably make the very lightest pixels in your dark image *too* light, so the detail in them is lost. The same is true for an image that appears to be too light. Darken all the pixels equally and you end up with dirty gray highlights. Fuss with the tones enough, and you'll start to mess up the color values of your image as well.

Properly retouching many images frequently involves making changes to a group of image components that are interrelated in interesting ways. Tones, colors, contrast, saturation, and other factors all must be considered. This chapter looks at the most fundamental part of an image, its tonal range. After you've got tones straight in your head, understanding color correction (addressed in Chapter 5, "Adjusting Color") will make more sense, too. This chapter serves as your introduction to two of the basic tools used, the Levels and Curves commands. It also provides you with the basic concepts we'll put to work in Parts II and III of this book.

What Are Tones?

The tonal range of an image is the range of dark to light tones, from a complete absence of brightness (black) to the brightest possible tone (white), and all the middle tones in between. Because all values for tones fall into a continuous spectrum between black and white, it's easiest to think of a photo's tonality in terms of a black-and-white or grayscale image.

In conventional photography, grayscale images (which we call black-and-white photos) are easy to understand. Or, at least, that's what we think. When we look at a black-and-white

photo, we think we're seeing a continuous range of tones from black to white, and all the grays in between. But, that's not exactly true. The blackest black in any photo isn't a true black, because *some* light is always reflected from the surface of the print. The whitest white isn't a true white, either, because even the lightest areas of a print absorb some light (only a mirror reflects close to all the light that strikes it).

Indeed, photographic manufacturers have been engaged in a never-ending quest to find "whiter" photographic papers. You can compare two prints made on different papers and easily see that one may have darker blacks and brighter, whiter whites than the other. That continuous set of tones doesn't cover the full grayscale spectrum.

Of course, in the digital realm, no scale is ever truly continuous. An analog watch divides a minute into the smooth 360-degree movement of a second hand, whereas a digital clock insists on slicing up that same minute into designated increments (whether they're seconds, tenth-seconds, or some other measurement). Your computer does the same thing, slicing up the grayscale spectrum, by convention, into 256 distinct tones. Black is assigned a value of 0 (no brightness), whereas white is assigned a value of 255 (maximum brightness). Every tone in between, from an almost-black dark gray to an almost-white, super-light gray, must be represented by one of the other 254 numbers between 0 and 255.

If you're new to Photoshop or want to better visualize the concept, you can check this yourself easily. Just follow these steps:

1. Open a new, empty image document in Photoshop. It doesn't matter whether you choose Grayscale or RGB mode in the New dialog box.

2. Press Shift+G until the Gradient tool is visible in the Tool palette.

3. Press D to make sure Photoshop's default foreground/background colors are black and white, respectively.

4. From the Gradient palette, choose a Foreground to Background gradient. This lets you create a smooth gradient from black to white, with all the tones in between.

5. Hold down the Shift key and click at the top of your image, and then drag downward to the bottom. When you release the mouse button, a smooth black-to-white gradient is created, as shown in Figure 4.1.

6. If the Info palette isn't visible, click its tab. You may have to choose Window > Info to make it visible.

7. Place the cursor in the black area of your document. You'll see that the RGB readout in the Info palette shows a very low value (around 0 to 3, depending on where you place the cursor) for all three colors: red, green, and blue. That's because a neutral black has equal amounts of all three primary colors.

8. Drag the cursor toward the white area of the gradient. Notice that as you move the cursor, the numbers in the RGB readout become larger as the gradient becomes brighter, until you reach the maximum of 255 in the very whitest area.

Figure 4.1
A grayscale gradient
shows every tone
from pure black to
pure white

Why 256-Grays?

Of course, your computer, digital camera, scanner, or other component that works with digitized images doesn't *have* to divide up the entire grayscale into 256 different tones. Other values are, in fact, used to express grayscales. A scanner may indeed capture 1024 different gray tones when grabbing an image of a black-and-white photo, and then select the best 256 tones out of that range to represent the photo. Before you became involved with computers, those numbers might have seemed arbitrary to you, but by now you recognize them as values that are convenient for programmers. For example, 256 different tones are the most that can be represented by a single eight-bit byte (from 00000000 to 11111111 in binary equals 0 to 255 in our decimal notation). So, the real reason why we work with 256-tone grayscales is that this range makes things a heck of a lot simpler for programmers, like those who created Photoshop.

Are 256 tones enough? In truth, studies have shown that the human eye can differentiate only about 30 to 60 different gray levels. A highly detailed subject with no large gradated areas can sometimes be represented by as few as 16 gray levels, as you can see in Figure 4.2, which has precisely 16 different gray tones—no more, no less.

Figure 4.2
Sixteen gray tones are
enough to provide a
presentable rendition
of a grayscale image

The full 256 gray tones become useful when you have an image that has large expanses of
tone that change gradually from one shade to the next, like the gradient you created in
the previous exercise. In the real world, pictures with sky, water, or walls typically
require more gray tones to represent accurately. If not enough grays are available, the
image is divided into objectionable bands, like those shown in Figure 4.3.

Figure 4.3
However, six tones
are not enough to avoid
objectionable
banding and a
posterization effect

The need for more than 64 or so gray tones also comes into play in many other kinds of images. Those are photos in which the gray levels we can discern aren't spread evenly along the entire gray spectrum.

Think of a picture taken of a group of campers around a campfire. Because the light from the fire is striking them directly in the face, there aren't many shadows on the campers' faces. All the gray tones that make up the *features* of the people around the fire are compressed into one end of the gray spectrum, the lighter end. If we used only 64 gray tones and distributed them equally, we might have only 16 to represent all the nuances of the human face illuminated by the campfire.

Yet, there's more to this scene than faces. Behind the campers are trees, rocks, and perhaps a few animals who have emerged from the shadows to see what is going on. These are illuminated by the softer light that bounces off the surrounding surfaces. If your eyes become accustomed to the reduced illumination, you'll find that there is a wealth of detail in these shadow images. Certainly, there is a lot more information than can be represented by, for example, 16 gray tones assigned to the "dark" end of the scale.

This campfire scene would be a nightmare to reproduce faithfully under any circumstances. If you are a photographer, you are probably already wincing at what is called a *high contrast* lighting situation. Some photos may be high in contrast, like the one at the top of Figure 4.4, whereas others may be low in contrast, like the one at the bottom in the same figure. In the high-contrast image, there are fewer tones and they are all bunched up at limited points in the grayscale. In a low-contrast image, there are more tones, but they are spread out so widely that the image looks flat and gray.

Manipulating these tones can improve either type of image. For example, having 256 tones available gives you extra tones, which you can then distribute as you wish to adjust the reproduction of an image. With 256 different gray levels, even if uniformly distributed along the gray spectrum, you still have 64 different highlight tones and 64 different shadow tones from which to choose, and another 128 tones to distribute in the middle. And Photoshop doesn't force you to parcel out the tones equally. You can concentrate more in the areas that need them, using techniques that I'll show you later in this chapter.

Sophisticated image manipulation software such as Photoshop allows you to adjust the gray "map" used to portray an image. If you want, you can bunch the gray levels you want to use at one end of the scale or the other to provide added detail in the shadows or highlights. Or, you can neglect the middle tones in favor of the ends.

CHAPTER 4

Figure 4.4
Same tiger, in
high-contrast (top) and
low-contrast (bottom)
versions

Perhaps now, you see the true value of having 256 different gray tones. They give you the freedom to throw away those gray levels that have been captured but have no detail in them; you can keep only the 64 that you are most interested in. It's not usually possible to go through the entire gray spectrum and select only the tones that are found in a certain image. However, it is practical to see where groups of useful tones are clustered, for example, at the highlight, middle tone, or shadow ends of the scale, and concentrate your selections there.

Working with Gray Maps and Histograms

Photoshop offers several graphically based tools that let you visualize the current distribution of gray tones in your image and adjust that distribution to suit the photo. One of these is the histogram, which you might think of as a bar chart that displays the distribution of particular gray tones in another way. A typical histogram is shown in Figure 4.5. Along the bottom of the chart is a grayscale, which represents the gray spectrum from black to white. Arranged along this continuum are vertical bars, each of which depicts the number of pixels found in your image at a given gray level. A glance at the histogram can show you whether the gray values are bunched at one end of the spectrum, evenly distributed, or arranged in groups. Photoshop uses the Levels command to put this kind of histogram information to work.

Figure 4.5
The height of the bars on the histogram represents the number of pixels at that particular level

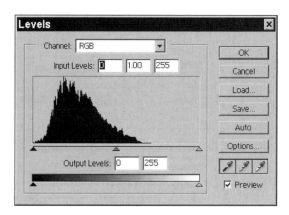

The other common tool is the gray map, which is a two-dimensional graph showing the relationship between the grays in your original image and the way they are represented by the transformations you've performed in the current editing session. A typical gray map is shown in Figure 4.6. Don't worry about the various controls and their operation just yet; we'll immerse ourselves hip deep (at least) in them shortly. Photoshop's Curves feature is used to adjust gray maps, both for an an image's overall tonal values (the grayscale component) as well as for individual color channels (such as the red, green, and blue information).

CHAPTER 4

Figure 4.6
The Curves
command produces a
two-dimensional graph
like this one

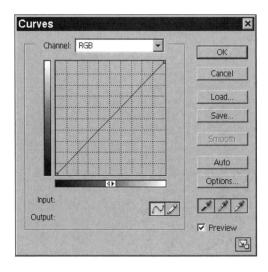

WHAT ABOUT BRIGHTNESS/CONTRAST CONTROLS?

The beginner's first impulse when faced with a photo that is too dark or too light is to reach for Photoshop's Image > Adjustments > Brightness/Contrast dialog box, shown in Figure 4.7. Unless the photo needs a very minor overall adjustment, that's usually the worst thing you can do. The Brightness slider operates on *all* the pixels in an image, making them uniformly brighter, even those that don't need any brightening. Similarly, the Contrast control compresses or decompresses the tonal range without regard for the content of the image itself. As you've seen from our examples, most photos that need fixing don't have all their tones evenly distributed in a way that can benefit from brute force brightening/darkening or contrast control. Even though a photo can look good with only 64 different gray tones, they have to be the *right* 64 grays. Photoshop's Curves and Levels controls, discussed next, give you much more control over the tones you select.

Figure 4.7
The Brightness/
Contrast dialog box
is not your best friend

The Levels Command

With an image of normal contrast and typical subject matter, the bars of the histogram will form a curve of some sort. When you use Photoshop to produce a slightly more or less contrasty image, you'll see something happen to the distribution of the bars in the histogram. Figure 4.8 shows an image with fairly normal contrast. See how the bars of the histogram create a curve across most of the width of the grayscale? However, there aren't really any true black areas in the photo, which you can tell from the histogram: There are no tones at all at the far left.

Figure 4.8
This image has fairly normal contrast, even though there are no true blacks showing in the histogram

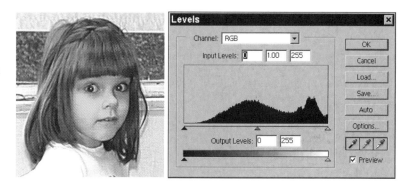

With a lower contrast image, like the one shown in Figure 4.9, the basic shape of the histogram remains recognizable, but is gradually compressed together to cover a smaller area of the gray spectrum. The squished shape of the histogram is caused by all the grays in the original image being represented by a limited number of gray tones in a smaller range of the scale.

Instead of the darkest tones reaching into the black end of the spectrum and the whitest tones extending to the lightest end, the blackest areas are now represented by a light gray, and the whites by a somewhat lighter gray. The overall contrast of the image is reduced. Because all the darker tones are actually a middle gray or lighter, this version of the photo appears lighter as well.

Figure 4.9
This low-contrast image has all the tones squished into one end of the grayscale

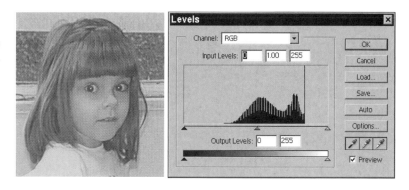

Going in the other direction, increasing the contrast of an image produces a histogram like the one shown in Figure 4.10. In this case, the tonal range is now spread over a much larger area, and there are many tones missing, causing gaps between bars in the histogram. When you stretch the grayscale in both directions like this, the darkest tones become darker (that may not be possible) and the lightest tones become lighter (ditto). In fact, shades that might have been gray before can change to black or white as they are moved toward either end of the scale.

The effect of increasing contrast may be to move some tones off either end of the scale altogether, while spreading the remaining grays over a smaller number of locations on the spectrum. That's exactly the case in the example shown in Figure 4.10. The number of possible grays is smaller and the image appears harsher.

Figure 4.10
A high-contrast image
produces a histogram
in which the tones are
spread out

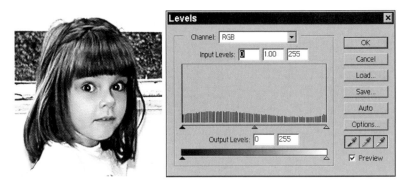

What does the brightness control do to our histogram? As you add or reduce brightness, the proportional distribution of grays shown in the histogram doesn't change; it is neither stretched nor compressed. However, the whole lot of them is moved toward one end of the scale.

So, as you darken the image, grays gradually move to the black end (and off the scale), while the reverse is true when you brighten the image. The contrast within the image is changed only to the extent that some of the grays can no longer be represented when they are moved off the scale.

Open the Levels dialog box by pressing Ctrl/Command+L or selecting Image > Adjustments > Levels. As you'll recall, the graph you see is called a histogram and is used to measure the numbers of pixels at each of 256 brightness levels. The horizontal axis displays the range of these pixel values, with 0 (black) on the left and 255 (white) on the right. The vertical axis measures the number of pixels at each level. There are several ways we can use the Levels feature to correct the brightness and contrast.

Setting Black and White Points Manually in the Levels Dialog Box

You can reset the white and black points by moving the position of the white and black triangles on the input sliders immediately below the histogram. As you move the white and black sliders, you'll see the values in the left and right Input Levels boxes above the histogram

change. You can also enter numbers in these boxes directly. The three boxes represent the black, gray, and white triangles, respectively. Use the numbers 0–255 in the white (left) and black (right) boxes. We'll come back to the center box, which represents the gray triangle later.

Moving the black triangle to the right reduces the contrast in the shadows and lightens the image. Moving the right triangle to the left reduces the contrast in the highlights and darkens the image.

The center (gray) triangle slider (and the center Input Levels box) in the Levels histogram is used to adjust the midtones. Dragging this triangle to the left lightens the midtones. Dragging it to the right darkens the midtones while leaving the highlights and shadows alone. You can also move the gray triangle by entering numbers from 9.99 to 0.1 in the center option box. The default value, 1.0, lies exactly in the middle of the range.

In Figure 4.11, I've adjusted the sliders for the picture of the little girl so that the black point is located solidly within the histogram bars that show detail in the black areas. I've left the white triangle alone, and moved the gray triangle a little to the right, producing a photo with overall better tonal rendition.

Figure 4.11
Adjusting the sliders produces a much better image

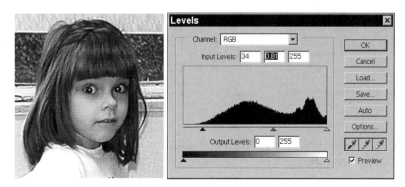

We'll get more practice working with the Levels command in Part II of this book.

Other Levels Options

If you like letting Photoshop do things for you, the easiest way to adjust the levels is to click the Auto button in the Levels dialog box and let Photoshop apply its own suggested changes. (You can also use Image > Adjustments > Auto Levels.) This resets the white point and the black point to the positions in the histogram that actually have tones, and redistributes the gray values of the pixels in between. Afterward, the histogram shows that the pixels fill the complete range from white to black.

If you want more even control, you don't have to refer to the histogram's readout. You can select the darkest portion of your image that you want to contain detail, as well as the lightest portion, by sampling those areas in the image itself. Use the Eyedroppers in the Levels dialog box to set the black and white points. (Make sure the Info palette is open and that the HSB and RGB color models are displayed. If they are not, select them from the Options submenu, revealed by pressing the arrow.)

First, select the White Eyedropper tool and drag it around the image while watching the Info palette. You are looking for the lightest white in the image. Select that point by clicking. Next use the Black Eyedropper tool to select the darkest black in the image (the deep shadows in the lower right). The combination of these two choices redistributes the pixels from pure white to pure black.

If you're working with a batch of photos taken under the same conditions, you may find it convenient to save the adjustments you make to one image and reuse them on another image. I find this capability helpful when I'm editing a batch of stills taken from a video. All the stills are likely to need roughly the same amount of correction. Save your settings by clicking the Save button in the Levels dialog box and saving them as a file. This file can be loaded later by clicking the Load button in the same dialog box.

The Curves Command

The gray maps offered by the Curves command show you some of the same information presented by the Levels command, but in a different way. However, whereas a histogram shows you the relative gray values as they are, the gray map shows you what they will be in the final image when that particular gray map is applied to the image. Gray maps are particularly useful, because they can be edited to alter the distribution of gray tones. You can even take a smooth, gradual grayscale and make it rise or fall sharply or even take on a posterized, discontinuous aspect.

An unedited gray map is shown in Figure 4.12. In this example, the origin of the graph, in the lower-left corner, represents black, whereas the upper-right corner represents pure white. One axis of the graph represents the progression from black to white of the pixels in your original image. The other axis provides a look at how they are displayed on the screen.

Figure 4.12
An unedited Curves map is a straight diagonal line

An unaltered gray map is shown by a straight line at a 45 degree angle connecting the two corners. Because the screen and image gray tones are the same, a line bisecting the two axes indicates that the gray map currently is taking a neutral, middle road. As the shortest

route between the pair, the 45 degree angle means that the gray tones of the image are reproduced exactly as they appear in the original, with no deviations.

How gray maps work will become more clear when you examine the effects of changing this default map, which is also called a ramp curve, because it looks like the ramp you might use to launch a boat into the water.

Changing the shape of the curve tells the image editing software that you want to alter the grays used to represent a given tone at that point. For example, the middle tones of an image are represented by the middle part of the ramp curve. Figure 4.13 shows a curve that has been bent in the center slightly toward the upper-left corner. The tones in the very middle are similarly skewed toward the white end of the scale, or made lighter, even while the shades at either end remain much the same. Making the curve bend down toward the lower-right corner (as shown in Figure 4.14) has the opposite effect. Drawing a line from the upper-left corner to the lower-right corner (the exact opposite of the default map) reverses the gray values in an image, producing a negative. (See Figure 4.15.)

CHAPTER 4

Figure 4.13
Bending the curve to the upper-left produces this effect

Figure 4.14
Bending the curve the other way reverses the effect

Figure 4.15
Reversing the direction
of the curve produces
a negative

Your gray map curve can be tailored to meet the needs of your particular image, or even twisted wildly for special effects (see Figure 4.16). For example, an oscillating up-and-down curve (which reverses only some of the values as the curve dips below the neutral 45 degree line) causes some strange, poster-like images, producing the half-negative/half-positive effect photographers call solarization. Manipulating the gray map in this manner takes experience. You'll need to play with a large number of images to see what happens with each change of the curve.

Figure 4.16
An arbitrary curve
gives you strange
colors, some of them
reversed

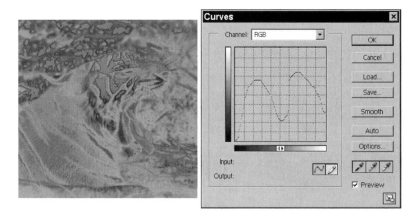

Curves is one of the most advanced Photoshop tools, offering the user subtle control over the brightness, contrast, and midtone levels in an image—control that is far beyond that offered by the Levels command and (especially) the Brightness/Contrast dialog box.

As you'll recall, the Brightness/Contrast dialog box lets you change an image globally, with no difference between the way the changes are applied to the highlights, midtones, and shadows. The Levels command adds more control, allowing you to change the shadows, highlights, and midtones separately. The Curves command goes all out and lets you change pixel values at any point along the brightness level continuum, giving you 256 locations at

which you can make corrections. For simplicity, we work with all three color layers at once in this chapter, but the same principles apply to changes applied to individual color layers.

Using Curves

Open the Curves dialog box by pressing Ctrl/Command+M or by selecting Image > Adjustments > Curves from the menu bar. The horizontal axis maps the brightness values as they are before image correction. The vertical axis maps the brightness values after correction. Each axis represents a continuum of 256 levels, divided into four or ten parts by finely dotted lines. (To switch from the coarse grid to finer grid, or back again, hold down the Alt/Option key and click in the map.)

In the default mode, the lower-left corner represents 0,0 (pure black) and the upper-right corner is 255,255 (pure white). If you want to reverse the way the scale is represented, you can click the central arrows in the scale underneath the map. This places white on the left and black on the right and measures levels in percentages instead of brightness values.

When you open the window, the graph begins as a straight line, because unless changes are made, the input is exactly the same as the output, a direct 1:1 correlation. You can change the relationship of the tones by adjusting the shape of the curve. There are several ways to do this. Like the Levels command, the Curves dialog box has an Auto button that you can click to let Photoshop take a first stab at adjusting the curves for you. As you click the Auto button, the darkest pixels in the image (the deep shadows) are reset to black and the lightest areas (the highlights) are remapped to white. As it was in the Levels dialog box, this is the easiest way to make corrections, but it doesn't use the subtle power of Curves any more than the Auto button did with the Levels command.

Another route is simply to drag the curve until the image looks the way you want it. If you click at any point on the curve other than the end points, a control point is added that shows your position. You can move a control point to change the shape of the curve. To remove a control point entirely, drag it downward until it is completely off the graph. The shape of the curve will seem to bend momentarily, but will spring back unaffected.

As you build experience using the Curves command, you'll find that adjusting the shape of the curve becomes easier. Flattening a curve lowers contrast. An S-shaped curve increases contrast, especially in the highlight and shadow area. Using a curve like this also helps to define the midtones.

You can also create a new curve, or portion of a curve, by clicking the Pencil icon in the lower-center portion of the dialog box and drawing a curve in the shape you want. Hold down the Shift key to constrain the Pencil tool to a straight line, clicking to create end points for the line. It's unlikely that you can draw a smooth curve freehand, so Photoshop provides you with a Smooth button. Click it and your pencil line is automatically smoothed.

Resetting Black and White Points with the Eyedropper

Select the black paint-filled Eyedropper tool in the Curves dialog box and click the darkest part of the image. This identifies a new black point, and the contrast immediately

starts to improve. Then select the white paint-filled Eyedropper tool and click the brightest part of the image. The contrast is now adjusted.

Using Curves to Adjust Midtones

Midtones are those parts of an image with color values from 25 percent to 75 percent of the total value range. After you've set a new white point and black point, you may want to manipulate the midtones by adding and moving additional control points, which are in between the two extremes.

Next Up

Adjusting the tonal values of an image is only part of the picture, so to speak. You also need to learn about the tools you'll use to adjust the color values for creating a balanced color rendition (or one that's creatively *un*balanced). We tackle those topics in the next chapter.

5

Adjusting Color

Adjusting color is often the single most challenging aspect of retouching a photo, or creating a composite out of two or more images (or portions thereof). Unless you're working with grayscale images, the colors in your pictures can be more important than many other aspects of the photos. A few dust spots may go unnoticed, but serious color errors leap out and grab the attention of even the casual viewer.

Good colors can make a photo pleasing, or produce a jarring, visual dissonance. Carefully applied retouching strokes that otherwise blend perfectly can stand out like a sore thumb if the colors don't match the rest of the image. As you'll see in Part III, matching colors when creating a composite can make the difference between a smooth blending of images and something that looks like a hastily-thrown-together collage.

To make things even more interesting, color has a wide range of psychological effects that you'll need to keep in mind as you manipulate photos. Fully saturated, rich colors may look great in a photo of a circus clown, but appear to be garish in a romantic portrait. A blue cast may be OK in a moonlit scene, but never in an autumn landscape.

This final chapter in the Part I section of the book arms you with two kinds of information that you'll find very useful later on. You'll learn something about how color works, and then master the tools that let you work with color. You don't need to understand internal combustion to drive around your neighborhood, but once you head for a high-performance racetrack, you'll find it helpful to understand not only mechanics, but also inertia, gravity, and a lot of other stuff. Retouching and compositing make up the Formula One circuit of image manipulation, and knowing how to take those difficult turns without rolling over can be *very* useful.

Color Your World

Walt Disney was a genius at packaging entertainment. He turned dry American history into the Davy Crockett craze in the '50s, and made science sexy (while reinventing the amusement park) with trips to the moon and the "house of the future." Yet, when he

CHAPTER 5

renamed his long-running Sunday television show in 1961, Disney didn't feature his top attractions such as Mickey Mouse or Peter Pan. He chose to call the show "The Wonderful World of Color." At a time when most of the world recalled World War II from black-and-white photos and newsreels, and were still watching *Leave it To Beaver* in monochrome, simply having a television show presented in full color was a significant draw.

Color is a powerful tool. It seizes our eyes and commands our attention. It tells us what to look at, and for how long. It provides clues that help us see flat things in three dimensions. If you don't believe *that*, cover up the bottom half of Figure 5.1 and look at it from a distance of a few inches. Then, cover up the top half and look at the bottom of the figure. Do it long enough and you'll end up with a headache, because our eyes must refocus drastically to look at a yellow space imposed on a red space. Because of that physiological effect, red tends to appear to be *in front* of a yellow card (as in the top half of the figure, which should look like a red circle on top of a yellow space to you). It's even true when you reverse the colors: In the bottom half of the figure, the yellow circle looks like a *hole* in a red card, allowing the yellow behind it to show through.

Figure 5.1
The top figure appears to be a red circle on a yellow background; the bottom figure appears to be a yellow hole in a red foreground

The example shows that color messes with our perceptions whether we want it to or not. It's also true that our minds modify the colors we see to match our expectations. I once attended a Kodak class in which a narrator told about a trip across country, showing various photos of a train as it progressed from the East Coast to the West Coast. Nothing seemed unusual about the illustrations until the presenter showed the first and last photos side by side. One had a strong blue cast, whereas the other was equally biased towards the red-orange. Each of the intervening photos were slightly more tinted towards the final, reddish image. The eyes of the audience (their brains, actually) automatically

adjusted their perceptions of the photos so that all of them looked "normal." The same thing happens when you view, for example, a shirt or dress you're wearing indoors under incandescent illumination that's quite reddish, and don't notice the difference when you step outdoors under the much bluer light of the sun.

Figure 5.2 shows how our minds accommodate changes in color. Cover up the bottom half of the figure. The car in the top half appears to be white. Now cover up the top half. The car still seems to be white. Only when you view the two together do you see that one image is much warmer than the other (or the other is much cooler). It's not until you look at the top of Figure 5.3, in which the car is truly neutral white, that you realize *both* of the images in Figure 5.2 are off-color. And you might not even suspect, until you saw the image at the bottom of Figure 5.3, that the car wasn't even sitting on that country lane. I photographed the car in my driveway, and composited it into the photo of the road. Because I added shadows, highlights, and made the colors match, you saw a white car parked on the roadside.

Figure 5.2
Compare both images of the car to see that each is slightly off-color

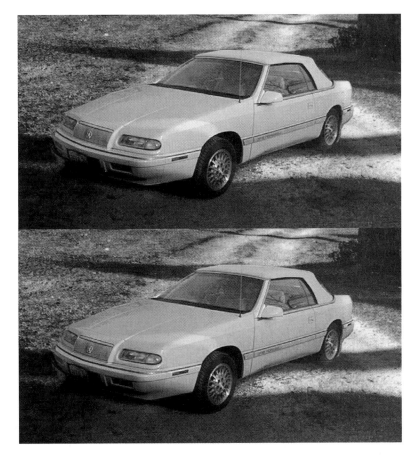

Figure 5.3
At the top is the truly neutral version of the car; at the bottom, you can see that the car was actually composited into the picture

Things that don't have brains aren't fooled so easily. Film doesn't have a brain, of course, which is why indoor pictures sometimes look red, and outdoor photos, especially of snow scenes, can look too blue. Digital cameras *do* have a brain, which is why, thanks to their automatic "white balance" controls, reddish and bluish photos are less common in the digicam realm.

But wait, there's more! Color can have significant *psychological* effects, too. We see bluish scenes as cool and reddish images as hot, warm, or emotional. So, the exact same color balance can be an attraction or a distraction, depending on the kind of image you're trying to create. A strong red cast may look terrible in a portrait of your boss, but be really hot stuff in a glamour picture posed in front of the glowing embers of a fireplace. Those weird green and magenta tinges that result from fads like cross-processing (developing slide film in chemicals meant for color negative film, or vice versa) would be a horrible disaster in your vacation pictures, but a prized special effect in a fashion shoot.

How Color Works

In one sense, "color" is just a way of referring to how human beings react to a very limited portion of the electromagnetic spectrum. Apparently, as our primate ancestors evolved, the ability to differentiate among different colors (for example, blood, orange sabre-tooth tigers hiding in green foliage, etc.) became a survival trait, and our eyes developed, in addition to the rod cells that are used for fine detail and for black-and-white vision when light levels are low, three different kinds of cone cells.

These cells are sensitive to red, green, and blue light, respectively. There's nothing inherent about these three colors that makes them the "primaries" for our vision; they just happen to be the three colors that were selected when color vision evolved. They enable us to respond to light in the 400 nanometer (violet) to 700 nanometer (red) range of the color spectrum. As you can see in Figure 5.4, the spectrum extends far beyond the range of our vision, into the infrared as the wavelengths become longer and to the ultraviolet as the distance between the waves narrows.

Figure 5.4
Human color vision extends from about 400 nanometers (violet) to 700 nanometers (red)

Far infrared

Near infrared

700 nanometers

Range of human vision

400 nanometers

Near ultraviolet

Far ultraviolet

All the computerized and mechanical color systems we use are designed to mimic, in one way or another, the way we see light. For example, color films use three sets of layers of emulsion, each sensitive to a different color of light: red, green, or blue. Computer displays, television screens, and the Jumbotron at the ballpark use phosphors, LCD pixels, LEDs, or other means to show those same red, green, or blue hues. Scanners and digital cameras have sensors that capture RGB images. Full-color printing systems, which use cyan, magenta, and yellow ink, also hinge on our ability to view colors in various combinations of red, green, and blue because the inks absorb some colors and allow the primaries to bounce back to our eyes.

Unfortunately, none of the artificial systems we've developed to reproduce colors are particularly accurate. There are two reasons for that. First, no phosphor, LCD, or LED emits

light in exactly the same way in all conditions. Monitors from different manufacturers show colors in different ways; even displays produced by a single vendor can vary, and a particular monitor may change its color display as it ages.

The same differences occur in the sensors used to capture color images and the inks used to reproduce them. Colors can vary widely from device to device, and from printed image to printed image. The color sensitivity of films varies by film type and manufacturer.

The second reason why the colors we capture and reproduce are inherently inaccurate is that the systems used to represent them *can't* represent all possible colors. Each has built-in limitations that keep them from displaying all possible colors, including some that the human eye can see. The range and particular colors that a system can reproduce is called its *color gamut*. No color gamut corresponds exactly with the color gamut the eye can see, so all of them have limitations. The colors that can be displayed on your computer display differ significantly from the colors that can be reproduced on a printing press. That's why what you see is often different from what you get. To classify and define the color gamuts of various types of artificial color systems, color scientists have developed what are called color models.

Color Models

Color models combine components of colors in different ways in an attempt to define the *color space* that each particular model is able to represent. Most color spaces use three different parameters (which vary from one model to another) to define the color space. By plotting the three parameters as x, y, and z coordinates (just like on a 3-D graph in high school), we can create a three-dimensional space that represents the color gamut of a particular model.

The international standard for specifying color was defined in 1931 by the Commission Internationale L'Eclairage (CIE); it is a scientific color model that can be used to define all the colors that humans can see. That model is chiefly of use to scientists, because no hardware system we use to capture or reproduce colors includes all the colors in the CIE model. Instead, computers, printers, image editing software such as Photoshop, scanners, and digital cameras all rely on three or four other color models that can, with fair accuracy, represent the colors that our hardware and software *can* work with. None of these color models generate all the colors we can see, but they're close enough to be workable.

In 1976, the CIE recognized the dependence on electronic and mechanical systems to reproduce color, and proposed two additional color models. One of them, called CIE L* a* b* (more on the weird name later), is used by Photoshop. Photoshop also does a good job with three other color models, RGB, CMY (or CMYK), and HLS.

I've already introduced RGB (red, green, blue) and CMYK (cyan, magenta, yellow, black), and we'll look at them in more detail shortly. The acronym HLS stands for hue-lightness-saturation, a model that is also called hue-saturation-brightness (HSB). The HLS/HSB model is the most natural for us to visualize, because it deals with a continuous range of colors (the hue) that may vary in its tone, measured using brightness (value) or richness (saturation). You use this type of model when you adjust colors with the Hue/Saturation dialog box.

However, RGB (also called additive color) and CMYK (also called subtractive color) are easier for computers to handle, because the individual components are nothing more than three basic colors of light. Additive color is commonly used in computer display monitors, scanners, or digital cameras, whereas subtractive color is used for output devices such as printers. As your main concern is probably working with Photoshop and printers, I'll explain the additive and subtractive models first.

Additive Color

Color monitors produce color by aiming three electronic guns at sets of red, green, and blue phosphors (compounds which give off photons when struck by beams of electrons) coated on the screen of your display. LCD and LED monitors use three sets of red, green, and blue pixels that are switched on or off, as required. If none of the colors are displayed, we see a black pixel. If all three glow in equal proportions, we see a neutral color—gray or white, depending on the intensity.

Such a color system uses the additive color model—so called because the colors are added together, as you can see in Figure 5.5. A huge selection of colors can be produced by varying the combinations of light. In addition to pure red, green, and blue, we can also produce cyan (green and blue together), magenta (red and blue), yellow (red and green), and all the colors in between. As with grayscale data, the number of bits used to store color information determines the number of different tones that can be reproduced.

Figure 5.5
The additive color system uses beams of light in red, green, and blue hues to produce all other colors

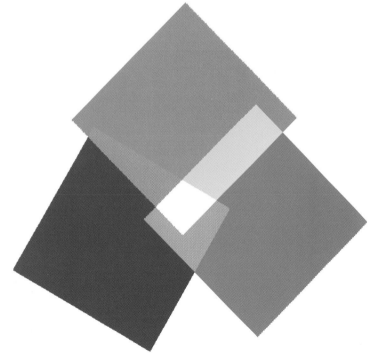

The largest patches represent squares of light in red, green, and blue. Where the squares overlap, they produce other colors. For example, red and green combine to produce yellow. Red and blue add up to magenta, and green and blue produce cyan. The center portion, in which all three colors overlap, is white. The only other factor to account for is the lightness or darkness of the color. Most of the colors we see can be represented by red, green, and blue light in various combinations and in various intensities.

Unfortunately, no display device available today produces pure red, green, or blue light, and no image capture device for scanners or digital cameras can capture pure red, green, or blue illumination. We see images through the glow of phosphors, LEDs, or LCD pixels, and capture them through CMOS, CCD, or CIS sensors. The colors captured and reproduced by these devices are limited, and can vary from brand to brand and even from one device to another within the same brand. The phosphors or LEDs aren't purely red, green, or blue, and the sensors view images through red, green, and blue filters that are themselves imperfect. Worse, the characteristics of a given device change as the electronic component ages. Even so, the RGB color model is the one we work with within Photoshop most of the time. You'll see how Adobe has tackled some of the inherent problems later in this chapter.

MORE ON BIT DEPTH

As I mentioned in Chapter 4, "Tools for Adjusting Tones," the number of colors or tones that can be represented by a given device is measured using a measurement called *bit depth*. For example, 8-bit color (00000000 to 11111111 in binary) can represent 256 different colors or grayscale tones, whereas 24-bit full color can represent 16.8 million different hues. Scanners and some high-end digital cameras can even capture 36-bits or 48-bits, for a staggering billions and billions of hues. However, within Photoshop, so-called 32-bit color usually refers to an extra 8 bits that is used to store grayscale alpha channel information (for selections and other kinds of masks).

Subtractive Color

Subtractive color is another way of producing color. You'll be most familiar with this model if you have made color prints on an inkjet printer, or, perhaps, had your color images reproduced on an offset press. The subtractive color model uses cyan, magenta, and yellow pigments (usually augmented by black) to reproduce most of the colors we see. Why cyan, magenta, yellow, and black? The answer is that cyan, magenta, and yellow each *reflect* red, green, and blue (and black is used to make the shadows darker). That becomes clear when you consider that when we view a printed piece, the light source doesn't come from the image itself (which is the case for a computer display). Instead, we view a printed image by light that strikes the paper and reflects back to our eyes. Only the colors that are not absorbed by the inks are seen; the others are subtracted from the white light we started out with. That's why this color model is called subtractive color.

Figure 5.6 illustrates the subtractive color model. Instead of three squares of light (as in Figure 5.5), imagine three patches of color printed in cyan, magenta, and yellow. They combine to produce red, green, and blue, and, where all three overlap, black.

Figure 5.6
The subtractive color system uses cyan, magenta, and yellow colors

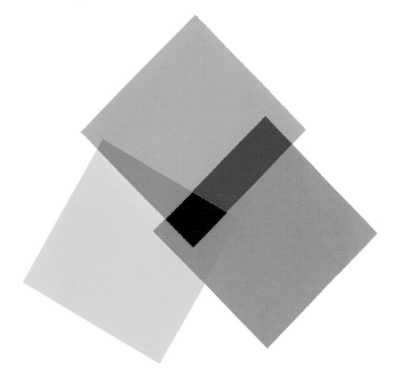

CHAPTER 5

In theory, the cyan pigment absorbs only red light and reflects both blue and green, producing the blue-green hue we see as cyan. Similarly, yellow pigment absorbs only blue light and reflects red and green. Magenta pigment absorbs only green, and reflects red and blue. Overlap any two of the subtractive primaries, and only one color remains. Magenta (red-blue) and yellow (red-green) together produce red, because the magenta pigment absorbs green and the yellow pigment absorbs blue. Their common color, red, is the only one remaining. Of course, each of the subtractive primaries can be present in various intensities or percentages, from 0 to 100%.

Notice that subtractive colors are represented in percentages rather than bits, primarily because they are generally reproduced by using inks or pigments in various percentages. So, applying magenta at a 50 percent strength and yellow at 100 percent means that only half the green light is soaked up by the magenta pigment but (theoretically) 100 percent of the blue is absorbed by the yellow pigment. The color you see is an intermediate color, orange, as in Figure 5.7. By varying the percentages of the subtractive primaries, we can produce a full range of colors.

Figure 5.7
Various percentages of
pigments produce
intermediate colors

You'll notice the word "theoretically" popping up from time to time. Inks are no more perfect than phosphors or sensors. A yellow ink that *should* absorb only blue light will absorb a little red and green, too, and probably won't absorb *all* the blue light, either. That means that 100 percent yellow, 100 percent cyan, and 100 percent magenta should produce black, but usually results in a muddy-looking brown. Black is added as a neutral color to absorb the smidge of light that the other inks should have absorbed, particularly in the darker, shadow areas of an image. That's why color separations have cyan, magenta, yellow, and black "printers," as shown in Figure 5.8.

Figure 5.8
Color separations
produce separate cyan,
magenta, yellow, and
black images

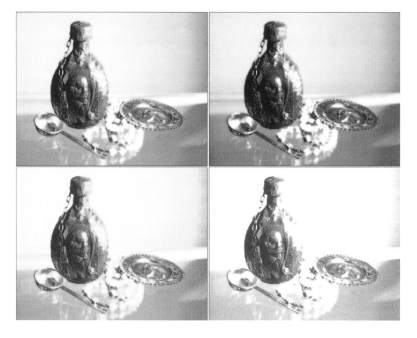

Color Models in Photoshop

Things get really interesting once you start mixing your color models in Photoshop. Most of us work with RGB images, captured by RGB-based devices, such as scanners or digital cameras, and viewed on an RGB monitor. Advanced workers may want to fiddle around in Photoshop using the CMYK color model, particularly if they are making their own color separations, or need to work with the cyan, magenta, yellow, or black layers separately.

Of course, Photoshop always *shows* you images in RGB, even when you're working with them using the CMYK color model, because an RGB monitor is all that Photoshop has available for display. So, Photoshop may be making calculations using the CMYK model, but it then must convert the colors to RGB to show you what they look like. Things can get a little messy. Photoshop can't accurately show you all the colors available in CMYK using an RGB display. You won't know for sure what you're going to get until you print out, or *proof* the image using the same hard copy device that will be used for the final image, or one that is known to reproduce colors in a very similar way.

The good news is that all the conversion back and forth between one color model to another is merely something that happens internally. If you have a file that has been saved in CMYK, Photoshop lets you work on it in CMYK without altering the colors. Only the *display*, converted to RGB, is inaccurate. The exception is, of course, when you use Photoshop's Image > Mode command to physically change the file itself from one color model to the other. In that case, some colors are invariably lost: Not all colors available in RGB can be represented in CMYK, and not all colors available in CMYK can be reproduced in RGB.

In general, CMYK colors seem less saturated and duller than RGB colors, as you can see in Figure 5.9. The top strip shows a rainbow of colors as they might appear in RGB mode; the bottom strip shows the same colors converted to CMYK (I've exaggerated the effect slightly for the printed page). RGB colors can always be made brighter by pumping more light through the device you're using to view them. CMYK colors are limited by the brightness of the substrate (a "whiter" paper reflects more light and brighter colors) and the amount of ink used.

Figure 5.9
At the top, a rainbow of RGB colors; at the bottom, the same colors when converted to the CMYK color model

Adobe's end run around most of the color model conversion problems is that new CIE L* a* b* (or simply Lab) color model I mentioned earlier. Lab color was developed by the CIE as a device-independent international standard. Lab consists of three components, a luminance channel, which defines the lightness of the color, plus a* and b* channels that represent green to magenta and blue to yellow, respectively. Because Lab can represent all

the colors found in *both* RGB and CMYK, it serves as a perfect intermediate format for Photoshop. Lab color is what Photoshop actually uses to process your images as you manipulate them, automatically converting to RGB for display, and to CMYK if you want to save a file in that format.

If you want to, for example, convert an RGB image file to CMYK, Photoshop first converts the RGB values to Lab mode. Then, it converts the image from Lab to CMYK colors. In each step, Photoshop can use the information you provide about color profiles for the devices you're using for display/output to ensure that the colors are as accurate as possible.

What about HSB/HLS?

The hue-saturation-brightness color model, also known as HSB or HLS (for hue-lightness-saturation) can be used for some types of color correction. You may, for example, have an image in which the colors are just fine, and you don't want to increase or decrease the brightness either. In that case, you can use Photoshop's Image > Adjustments > Hue/Saturation dialog box to redefine *only* the saturation component of the image, as shown in Figure 5.10. Or, you can fiddle with the hue without altering the brightness or saturation.

Figure 5.10
Adjust hue, saturation, or brightness separately using this dialog box

All colors can be represented by three parameters in this model. The hue is the particular position of a color in the color wheel. Hues are often represented by angles, beginning with red at 0° and progressing around in a counterclockwise direction to magenta at 60°, blue at 120°, and so forth. The saturation of the color is the degree to which that color is diluted with white. A hue with a great deal of white is muted; a red becomes a pink, for example. A hue with very little or no white is vivid and saturated. Brightness can be thought of as the degree to which a color is diluted with black. Add black to our desaturated red (pink), and you'll get a very dark pink. Various combinations of hue, saturation, and brightness can be used to produce just about any color we can see. Individual hues can be found along the edges of the hexagon. Moving from that edge toward the center within the same plane indicates a color that is less saturated. The center of the hexagon represents zero saturation, as you can see in Figure 5.11.

Figure 5.11
The HSB color model can be represented in two-dimensional form using a color "wheel"

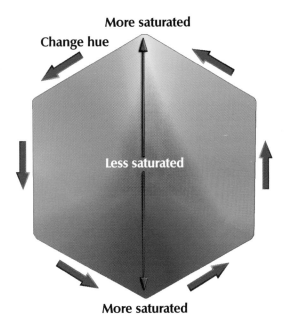

Color Calibration

The first step in color correcting your images is to calibrate all the devices used to capture, display, and output those images as well as you can. The goal is to provide some sort of relationship between the original image, the modified image in Photoshop, and the final image on the printed page. One problem, as we've seen, is that the color model used to capture and display images (RGB) provides a different color gamut than the model used to print images (CMYK). Add to that the difficulties of scanners and digital cameras that have their own notion of how colors should look, video displays that add their own bias, and printers that don't necessarily print colors in the exact relationships they should.

And there's more (as if you had to wonder). The response of any color system is rarely linear. Consider a color monitor as an example. Given 256 possible shades of a particular red, green, or blue color, you can safely assume that a value of 0 will be represented as no color at all, and a value of 255 will be shown as the maximum intensity of that color, given the limitations of the display itself. So far, so good.

You might also assume that values of 64, 128, and 192 would represent 25 percent, 50 percent, and 75 percent intensity, a *linear* relationship. In the real world, it rarely works out that way. A value of 64 might actually produce 20 percent intensity, 128 could equal 55 percent, and, if you're particularly unlucky, 192 might end up representing 84 percent intensity. This relationship between the colors is *non-linear*.

Color science uses a line called a *gamma curve* to represent the difference between the ideal relationship between colors and their real-world status. If you know the gamma

curve of a particular device, you can correct for it by increasing or decreasing the values produced at any given intensity level to what they should be to produce a linear result. A *gamma correction table* consists of values at each level that are substituted for the values otherwise produced by the device. Many vendors provide color profiles for their devices. You can plug these into Photoshop using the Edit > Color Settings dialog box and the instructions provided by the manufacturer of your device.

You can calibrate Photoshop for your monitor using the Adobe Gamma application. In Windows, it's a Control Panel that you can access from Start > Settings > Control Panel. Under Mac OS, you'll find the Adobe Gamma application in your System folder in the Control Panels folder. Just follow the instructions in the dialog boxes; the process is self-explanatory.

Making Color Corrections

We look at specific color-correction solutions in Parts II and III of this book. Before you get elbow deep in the nitty-gritty, however, you'll want to master the various tools available in Photoshop for correcting colors. This section serves as your introduction to the methods available for color correction. Some are easy, but not too precise, whereas others are a bit tougher to master but offer a great deal more control. You can use them to fix colors that are bad or to create outlandish color effects from images that didn't look so bad before you started to mess with them.

There are three different factors you'll be working with:

> ▶ **Color balance**. This is the relationship between the red, green, and blue hues in an image. An image may have an overall cast that makes it look too reddish, a bit sickly on the green side, or excessively cool. If more than one primary color is off, you can get magenta, yellow, or cyan casts as well. The information presented earlier in this chapter should help you understand why color imbalances occur and what steps you need to take to correct them.

> ▶ **Color saturation**. This is the richness of the colors. Are they too muted and soft, or perhaps a bit garish? By adjusting color saturation, you can correct these errors.

> ▶ **Brightness/contrast**. As you learned in Chapter 4, "Tools for Adjusting Tones," brightness and contrast refer to the relative lightness/darkness of the tones. When working with color images, you may have overall brightness/contrast issues to solve, or you may find that only one of the three color channels needs fixing. You'll find most of what you need to fix brightness and contrast in Chapter 4; simply apply those solutions using what you've learned about color in this chapter.

Another thing to keep in mind are the causes of imperfect color. Some can be fixed in Photoshop, and some can't. We'll work with various examples of each kind of bad color

in the practical chapters of this book. Here's a quick summary of some of the causes:

▶ **Mismatched light sources/incorrect white balance**. As I mentioned earlier in this chapter, indoor illumination is usually much redder than outdoor light. If your digital camera's white balance control has been set incorrectly, you can get reddish or bluish photos. The same thing can happen if you happen to use an outdoor film indoors. Photofinishers can often fix this problem, but they don't always. You can often fix the problem in Photoshop.

▶ **Fluorescent light**. Many fluorescent light sources have gaps in their color spectra, producing pictures that have a ghastly green cast. It's difficult to correct this in Photoshop, because some of the colors are missing entirely and can't be replaced. You're better off using a special fluorescent filter, available from camera stores for film and digital cameras, to make the correction when the photo is first taken.

▶ **Mixed light sources**. If you take a photo indoors with a lot of daylight streaming in from a window, you're likely to get a picture that has a mixture of color balance problems. Part of the photo will be too blue, whereas the rest may be too red. There's not a lot you can do, except avoid taking this kind of picture entirely.

▶ **Film disasters**. Your photofinisher goofed, sending all your color awry, or your prints are so old they've faded. Or, maybe you left your camera in the glove compartment for a year or two before the photo was developed. Photoshop can't fix these as good as new. Sometimes, you can create a nice black-and-white picture from the mess.

The important thing to remember when making color corrections is that no color correction method *adds* color to an image. All you're doing is changing one color to another; for every pixel you change to a particular color, a pixel in another color is lost. Color correction always *removes* color, one way or another. A photo that's faded so much that magenta is just about the only color visible can't be fixed by adding green. All that does is create a neutral gray. Do it enough, and you'll end up with a dark, monochrome picture. A *slight* magenta cast in a photo that has enough of the other colors can be fixed by changing some of the magenta to those other colors.

Using Photoshop's Color Balance Controls

The easiest way to correct the color of an image is with Photoshop's Color Balance controls, found in the Image > Adjustments > Color Balance dialog box, as shown in Figure 5.12. Note that Photoshop lets you set color balance separately for shadows, midtones, and highlights, using a set of slider controls.

Figure 5.12
Photoshop's Color
Balance controls let
you increase or
decrease any color

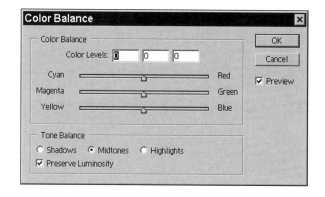

These let you adjust the proportions of a particular color, from 0 percent to 100 percent. You can either add one color, or subtract its two component colors. For example, moving the Cyan/Red slider to +20 (sliding it toward the red end) has the exact same effect as moving the Magenta/Green and Yellow/Red sliders both to the -20 position (toward the left). To know which way to move the slider, review the color wheel shown in Figure 5.13. Then, correct for a particular imbalance by:

▶ Adding the color opposite it on the color wheel

▶ Subtracting the color itself

▶ Subtracting equal amounts of the adjacent colors on the color wheel

▶ Adding equal amounts of the other two colors on its color wheel triangle

Figure 5.13
Use this color wheel to
decide which way to
move the Color
Balance sliders

If you keep the color wheel in mind, you won't find it difficult to know how to add or subtract one color from an image, whether you are working with red, green, blue or the cyan, magenta, yellow color models.

The biggest challenge is deciding in exactly which direction you need to add/subtract color. Magenta may look a lot like red, and it's difficult to tell cyan from green. You may need some correction of both red and magenta, or be working with a slightly cyanish-green. Your photo retailer has color printing guidebooks published by Kodak and others that contain red, green, blue, cyan, magenta, and yellow viewing filters. Use them to view your image until you find the right combination of colors.

Adjusting Hue/Saturation/Brightness

As I mentioned earlier in this chapter, some images can be fixed by changing only the hue, saturation, or brightness of one color. Photoshop lets you work with the HSB color model through the Image > Adjustments > Hue/Saturation dialog box, shown in Figure 5.14. This control lets you adjust these individual values for each color channel.

Figure 5.14
Photoshop's
Hue/Saturation dialog
box lets you work
with hue, saturation,
and brightness
components separately

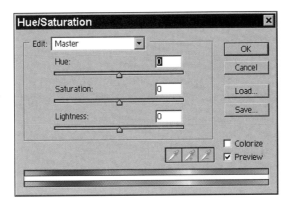

Using Photoshop's Variations

Photoshop's Variations mode, shown in Figure 5.15, presents you with a set of several versions of an image, arranged in a circle so you can view a small copy of each one and compare them.

Figure 5.15
Photoshop's Variations
mode presents different
versions of the same
image or selection

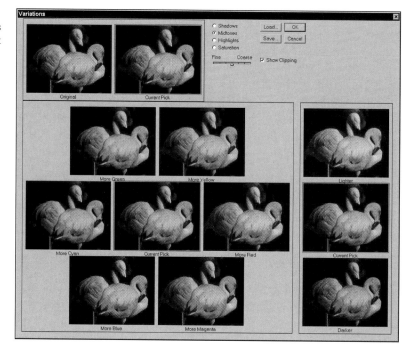

You'll find this dialog box by choosing Image > Adjustments > Variations. The dialog box
has several components:

▶ Thumbnail images of your original image are paired with a preview with
the changes you've made in the upper-left corner of the dialog box. As you
make corrections, the Current Pick thumbnail changes.

▶ The Variations panel displays the current pick surrounded by six different
versions, each balanced toward a different color: green, yellow, red,
magenta, blue, or cyan. These show what your current pick would look
like with that type of correction added. You can click on any of them to
apply that correction to the current pick.

▶ To the right of the Variations panel is a panel with three sample images:
the current pick in the center with a lighter version above and a darker
version below.

▶ In the upper-right corner of this window is a group of controls that modify
how the other samples are displayed.

▶ The radio buttons determine whether the correction options are applied to
the shadows, midtones, or highlights of the image, or only to saturation
characteristics. You may make adjustments for each of these separately.

▶ The Fine...Coarse scale determines the increment used for each of the
variations displayed in the two lower panels. If you select a finer increment,

the differences between the current pick and each of the options is much smaller. A coarser increment provides much grosser changes with each variation. You may need these to correct an original that is badly off-color. Because fine increments are difficult to detect on-screen, and coarse increments are often too drastic for tight control, I recommend keeping the pointer in the center of the scale.

▶ The Show Clipping box tells the program to show you in neon colors which areas will be converted to pure white or pure black if you apply a particular adjustment to highlight or shadow areas (midtones aren't clipped).

▶ You may Load or Save the adjustments you've made in a session (by clicking the appropriate button) so they can be applied to the image at any later time. You can use this option to create a file of settings that can be used with several similarly balanced images, thereby correcting all of them efficiently.

We'll use Color Balance, Hue/Saturation, and the Variations controls extensively in Parts II and III. I've got some wretched photos for you to fix using these powerful tools.

Next Up

This is the final chapter of Part I. By now, you should feel comfortable with the basic concepts of retouching and compositing, and have some familiarity with Photoshop's key tools. You can refer back to Part I if you need a refresher as you work through the rest of the book. However, you'll find ample instructions for using all the implements introduced in Chapters 2 through 5 in both Parts II and III. We're going to tackle a wide variety of typical retouching projects in Part II.

CHAPTER 5

Part II:

Practical Retouching

The first part of this book was your apprenticeship in image manipulation. Or, to mix up another metaphor, consider Part I as your first year of medical school. You learned a bit about retouching and compositing in a one-chapter survey course: what they are, why they're useful, and a little about how they're accomplished (both with traditional photographic methods and in the digital realm). Then, we moved on to General Anatomy (what tools go where, as in "the Paintbrush is connected to the Healing Brush…") and some Physiology (how the tools operate).

Part II guides you through the rest of medical school, and on into your internship, as you learn to manipulate images using real photographic "patients." I'm going to have you follow the time-honored med school procedure of "Watch one; do one; teach one." You'll learn how to perform ever more complex retouching tasks in the next four chapters by watching and reading through the steps in the exercises that follow. Then, you'll tackle the steps yourself using the sample images provided on the CD-ROM bundled with this book. Finally, you'll teach *yourself* exactly what you can do by taking on a few retouching tasks on your own.

By the time you finish Part II, you'll be ready for your surgical residency, and all set to slice and dice photos digitally in the compositing projects in Part III. But don't become too comfortable. I'm planning on abandoning both the carpentry metaphor that set the stage for Part I, and the medical mumbo-jumbo I'm using to introduce Part II, and cook up an entirely different scenario for the final chapters.

6

Simple Retouching Techniques

In one sense, retouching is making an image appear to be as you *wish* it looked, rather than how it really looks. If you're working on a scenic masterpiece, you may want to make a scraggly tree vanish. In a portrait, the need may be to hide skin blemishes, or make dental braces less obvious. Perhaps some glare marred the surface of your otherwise-pristine sports car, or some bad shadows made your interior photographs unsuitable for showcasing in *House Beautiful.*

Or, your family pet looks mangy; there's some dust and more than a few scratches on the only surviving print of your face-to-face handshake with Elvis after an early '70s concert. Worse, your great-great-grandfather's portrait has faded terribly and your great-great-grandmother wants to know why his portrait no longer resides on the mantle. You need retouching, and you need it badly.

As I mentioned in Chapter 1, retouching in the digital world is easier than ever. You don't need an artist's skills, although, if you have them, you can certainly put them to use. Those of you who have an artistic bent can more skillfully touch up photos using Photoshop's toolset, while the rest of us depend on the power of our image editor's versatile Undo features to keep going until we can say, "I *meant* to do that." Indeed, even the clumsiest retoucher can work like the sculptor who started with a block of marble and removed everything that didn't look like a statue. Retouch to your heart's content, removing or modifying everything in a photo that doesn't look the way you want it to look.

Photoshop really does have all the tools you need to fix your photos, and you learned a little about most of them in Part I. In this chapter, we start off with some simple retouching techniques. You'll learn how to remove small objects, eliminate dust and scratches, and put blurring and sharpening to work.

Photographic Techniques for Retouching

One of my favorite analogies involves philosopher/martial arts choreographer Bruce Lee's concept of the "art of fighting without fighting." Some of the most sophisticated "retouching" techniques involve taking the time to avoid the need for retouching in the first place. Of course, hindsight makes it easy to say that, if you'd taken your photo right, you wouldn't need to retouch. In fact, you'll probably get comments like that from every smart aleck who learns how much time you spent fixing up a particular photograph. What the wise folks don't realize is that the mistakes are already made, and the effort is worth it to come up with the finished product.

That being said, I'm going to provide some tips on the art of retouching without retouching. Sometimes, having a few of the often-broken rules spelled out for you can be enough to keep them closer to the forefront of your mind when you take your photos. For example, I was a professional photographer for more years than I deserved, with my photos used in newspapers, magazines, television ads, wedding albums, and so forth, ad nauseum. The only advantage my experience gives me when I set out to take photos at my daughter's soccer games or on family vacations is that when I, predictably, take a real clunker of a photograph, I can usually provide a detailed technical description of the terrible goof I made.

Keep in mind that most of the horrible example photos in this book were not taken intentionally as illustrations. They are real-live goofs, and I'm hoping to help you avoid my mistakes and show you how to fix them if you don't. This section lists some easy ways to avoid the worst of my errors, and reduce the amount of time you need to spend using the information you'll glean from this chapter.

> ▶ **Avoid the need for spotting out bits of dust and scratch removal.** Spots and scratches are most commonly a problem of photos taken with conventional film cameras (although digital cameras can suffer from flaky sensors that produce artifacts that look like dust). Keep the inside of your film camera clean, blowing out the inside with compressed air if you open it in a dusty environment. Be particularly attentive to the film gate area and pressure plate that holds your film tight during an exposure. Once scratched or embedded with a dust speck, these areas can mar every roll you take until the problem is fixed. Patronize only photofinishers who take good care of your film. If your film comes back scratched and dusty and your prints display the results of such maltreatment, consider changing labs. If you're using an Advanced Photo System (APS) camera, the original film will be safely stored inside the original cassette used in your camera. If using other types of film, hope your film comes back in protective envelopes, in case you need to print them again.

IDENTIFYING THE SOURCE OF DUST AND SCRATCHES

One key to preventing damaged film is knowing what caused the damage. Here are some tips:

▶ Long, straight, parallel scratches on the film that show up in your prints were probably caused as the film ran through your camera or through the lab's processing equipment. You can't check the processing gear, but you can examine your camera to look for a nick in the film path.

▶ A long parallel scratch on the shiny side of the film was probably caused by dust or a nick on the pressure plate that holds your film in place. It possibly could have been caused by a piece of sand stuck in the lip of your film cassette. Such scratches may show up in your prints as dark lines.

▶ A long parallel scratch on the dull (emulsion) side of the film may have been caused by dust or a nick in the film gate (the opening that "frames" your picture during exposure). It can also be caused by sand stuck in the lip of your film cassette. Such scratches often show up in your prints as colored lines, because they don't affect all the color layers of the film exactly the same.

▶ If you get the same pattern of scratches in several rolls over a period of time, the problem is probably with your camera. Sometimes, nicks can be fixed with a drop of black glossy paint.

▶ Irregularly-shaped scratches, half-moon-shaped image defects, or visible bits of dirt embedded in your film were probably caused by mistreatment at the photofinisher.

Store your film carefully in case you want to reprint your photos. You'll generally get better results reprinting from the original negative or slide than from making a copy print.

▶ **Avoid the need to sharpen or blur**. Focus carefully to make sure the part of the image you want to appear sharp really *is* sharp. When you're using your camera's autofocus, monitor its operation to make sure it's really focusing accurately. If necessary, lock in focus by depressing the shutter release button slightly before taking the picture. If your digital or film camera has a selection of exposure modes, choose Shutter Priority and select a high enough shutter speed to "freeze" the action so your subject does not appear to be blurry. Remember that camera motion can cause blur as easily as subject motion; if you shake the camera unintentionally as you take the photo, the image can be just as blurry as if your subject were racing past at 60 miles per hour. A high enough shutter speed will freeze both kinds of blur.

▶ **Eliminate the need to adjust brightness/contrast**. If your shadows are too dark, your highlights too light, or there is too much difference between them, consider using lighting with less contrast, using some sort of reflector to bounce light into the shadows, or another technique to make your lighting more even.

▶ **Reduce the need to adjust color**. Don't use light sources with mixed colors, such as window lighting and indoor lighting, in the same photo. Make sure your digital camera's white balance has been set properly (most cameras can be set to do this automatically).

▶ **Banish red-eye**. Modern cameras usually have some sort of red-eye "reduction" mode, usually a preflash that causes your subjects' irises to involuntarily close down a little, reducing the chance of this malady. The farther your flash is from the camera lens, the less chance you'll get red-eye, too, so if you have a removable flash unit, raise it a bit before taking the photo.

▶ **Minimize wrinkles and blemishes**. Don't use harsh lighting, and avoid lighting from the side (which can emphasize the texture of skin). If outdoors, favor photos in shadow over those taken in direct sunlight. For photos indoors, sometimes putting a white handkerchief or tissue over the flash can soften the light, particularly if the photograph is being taken fairly close to your subject.

Removing Small Objects

We'll make the first project an easy one. It's a photo of the Tower of Hercules, a Roman lighthouse on the Northwest coast of Spain. The original lighthouse has survived nicely for 2000 years (although extensive repairs and restoration were begun in the eighteenth century), but the photo is not so lucky. Here are the defects we're going to repair with our own digital restoration. You can see these defects in Figure 6.1.

Figure 6.1
Dust, scratches, some
utility poles, and other
defects detract from
this photo of an ancient
Roman lighthouse

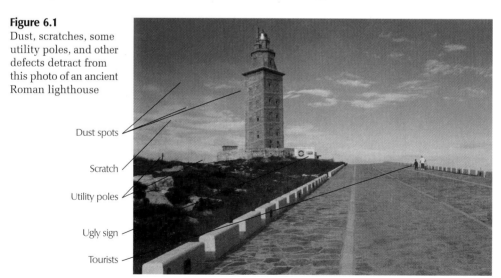

Dust spots

Scratch

Utility poles

Ugly sign

Tourists

▶ The tower is leaning slightly to the left. We're not in Pisa, so it's likely that the camera was tilted a little.

▶ There are numerous white dust spots, most visible to the left of the tower. These are likely artifacts that were on the film negative when the print was made. White spots on a print made from a negative result because the dust blocked the light that made the print during the exposure.

▶ The left side of the tower also has a few dark spots and a scratch or two. These could be pinholes or scratches in the negative itself, or perhaps some dark dirt on the scanner glass when the image was captured. It's too late now; we have to get rid of them.

▶ A few utility poles peeking over the horizon on the left side of the image provide a rather anachronistic look to the image.

▶ The clouds are unevenly distributed.

▶ Equally out-of-place is the big sign at the right side of the base.

▶ The tourists walking up the cobblestone road leading to the tower look neither Roman nor Spanish, so they've got to go, too. We can crop them out, or retouch them out.

Grab farol.pcx from the CD-ROM bundled with this book, and we'll begin to work on the repairs. When you open the file and zoom in, you'll see some of the problems shown in Figure 6.2.

Figure 6.2
Here's a close-up look at some of the problems we'll be fixing

Removing the Dust

The first step is to remove the dust spots, using the Clone Stamp tool. Just follow these steps:

1. Press Z to select the Zoom tool and click to the left of the top of the tower to zoom in on that portion of the image. It's easier to spot a print if you have a close-up look at what you're doing.

2. Press S to select the Clone Stamp tool.

3. In the Options bar, make sure Normal is chosen as the blending mode, and ensure Opacity and Flow are both set to 100 percent so that your cloning strokes will completely cover the dust. Also double-check to ensure that the Aligned check box is checked.

4. Choose a medium-sized fuzzy brush tip from the Brush palette (click the down-pointing arrow next to the Brush icon at the left of the Options bar). I selected a 35-pixel soft-edged brush.

5. Hold down the Alt/Option key and click in a clear area of sky to *sample* it (making it the source area that Photoshop will use to clone). The cursor changes to a crosshair, and the center of the cross area shows you the pixels that are selected when you click.

6. Begin stroking over the areas of the image containing dust spots. Notice that *two* cursors are visible, as shown in Figure 6.3. The cross-hair cursor shows the part of the image that is being sampled and copied, whereas the large circular cursor shows the size of the brush and the area being painted with the Clone Stamp tool.

7. Paint two or three strokes over dust spots, then resample a new origin, and continue cloning.

Figure 6.3
Paint over the dust spots with the Clone Stamp tool

8. Continue spotting over the entire picture. There are a few dust spots on the right side of the tower and on the tower itself.

SAMPLE FREQUENTLY
When creating a random texture such as the sky, you'll want to resample frequently so that large areas aren't copied. That would make the cloning painfully obvious. If you choose a new origin frequently, the area will have the random texture you want. When you get to areas that have features (such as clouds), sample from the cloud area, as shown in Figure 6.4.

Figure 6.4
Features such as clouds should be carefully cloned to provide a realistic look

Tearing Down the Utility Poles

We can remove the utility poles and power lines just as easily using the Clone Stamp tool. You just need to use a little more caution to avoid the "fake" look. For this bit, it's a good idea to resample after every one or two brush strokes. The "Before" image looks like Figure 6.5.

Just follow these steps:

1. Zoom in tightly on the utility pools and reselect the Clone Stamp tool.
2. A smaller brush will work better for this area. I selected the 21-pixel soft-edged brush.
3. Press Alt/Option and click in the area above the left utility pole. Then clone over it carefully.
4. Repeat to remove the right utility pole, and then delete the wires, too. Your image will look similar to Figure 6.6.

CHAPTER 6

Figure 6.5
These poles have
got to go

Figure 6.6
With careful cloning,
you can uproot both
utility poles

Evening Out the Clouds

At this point, your retouched image looks similar to Figure 6.7. The dust and utility poles are gone, the dust has been removed, and now the unevenness of the clouds stands out.

The picture might look better with a few extra clouds wafting over the upper-left portion of the image. We could add the clouds by cloning the clouds from the right side of the image, but having two sets of identical clouds would look odd. We could also composite in some clouds from an entirely different picture, but it would be hard to match up the shape and type of these particular cirrus clouds. Instead, let's duplicate some clouds from

the right side of the image, but make them look different enough that they don't appear to be an exact duplicate. Just follow these steps:

Figure 6.7
So far, so good. But we could use some more clouds in the upper-left corner

1. Press L to choose the Lasso tool, and select an area of the clouds at the right side of the tower, as shown in Figure 6.8.

Figure 6.8
Select some clouds from the right side of the image

2. Press Ctrl/Command+C to copy the selection, then Ctrl/Command+V to paste it down in the image.
3. Choose Edit > Transform > Flip Horizontal to reverse the cloud patch left to right. Reversing it gives the clouds a slightly different look.
4. Press V to activate the Move tool, and then drag the cloud patch over to the left side of the photo, as shown in Figure 6.9.

CHAPTER 6

Figure 6.9
Reverse the clouds left
to right and drag to the
left side of the image

5. The clouds still look too much like their "parents," so you'll want to stretch them out of shape. Choose Edit > Transform > Scale and drag the side handles of the selection to the right to elongate the clouds in that direction.

6. Use the Eraser tool (select a large, soft-edged eraser brush) and fade out the edges of the patch. Remove the cloud patch where it overlaps the light-house itself.

7. The patch is much lighter than the sky around it, so choose Image > Adjustments > Levels to darken it. First move the black point triangle under the histogram so it coincides with the first dark tones in the image. Leave the white point triangle alone. Then slide the gray point slider, as shown in Figure 6.10, until the sky tone of the patch more closely matches the sky around it. (Depending on what cloud area you selected, your histogram in the Levels dialog box may not look exactly like mine.)

Figure 6.10
Use the Levels dialog
box to darken the
clouds so they more
closely match the left
side of the image

8. Now, use the Clone Stamp tool to change the shape of the clouds slightly. I chose a 65-pixel soft-edged brush, and then changed the Opacity of the brush in the Options bar to 75 percent. As I cloned, the edges of the clouds I was painting tended to fade out, producing a more realistic effect, as you can see in Figure 6.11.

Figure 6.11
With the new clouds in place, the image looks like this

De-Signing the Sign

That pesky old sign is still messing up the picture. We'll put what we've learned so far in this chapter to work to remove it. A combination of cloning and duplicating part of another area of the image will do the trick. We just need a new section of wall to cover the sign. A wall is not quite as random as clouds, so we'll have to be more careful. Follow these steps:

1. Press M to select the Marquee tool, and choose a rectangular section of the wall, near its center. Press Ctrl/Command+C to copy the wall, and then press Ctrl/Command+V to paste it down.

2. Choose Edit > Transform > Flip Horizontal to flip the piece left to right, and then move the pasted area into position. Your image will look similar to Figure 6.12. The sign is partially covered, but the result looks distinctly cloned, because the duplicated parts of the wall look like a mirror image of each other.

Figure 6.12

Paste down a duplicate section of the wall, and then flip it horizontally

3. Use the Clone Stamp to replace the remaining visible portions of the sign in the layer under the new wall section with the surrounding sky.

4. Switch back to the wall patch layer. Press R to select the Blur tool, and set the strength of the tool to about 45 percent in the Options bar. Then, gently stroke the very top edge of the wall patch to make it seem a little blurry, like the rest of the top of the wall.

5. Press E to select the Eraser tool, and choose a medium-sized, soft-edged eraser brush. Erase around the edges of the patch to blend it in with the surrounding image.

6. If the blended edge is still too obvious for your taste, use the Clone Stamp tool to copy some pixels over the edge to blend it in further. The section of the image you just worked on will look similar to Figure 6.13.

7. Choose Layer > Flatten Image to combine all the layers you've worked on so far.

Straightening Up

You'll often need to realign images slightly when retouching. Perhaps your subject was leaning one way or another, like the lighthouse in our photo. Photoshop makes it easy to straighten up and fly right, because you don't have to rely on guesstimates. I'll show you the secret in the next set of steps.

1. Press Ctrl/Command+R, or choose View > Rulers to turn on Photoshop's Ruler feature.

Figure 6.13
The sign is gone, and that's a good sign

2. Click in the horizontal ruler at the top of the image and drag down, creating a guide line. Guides are used to align objects in your image, but they don't become part of the image themselves. They're strictly imaginary lines that don't print when you make a hard copy. Drag the guide down to the top of the wall surrounding the tower, as shown in Figure 6.14.

Figure 6.14
Guides can help you align elements in your image

3. Press Ctrl/Command+A to select the entire image.

4. Choose Edit > Transform > Rotate, and grab one of the rotation handles that appear at the edge of the image. Rotate the image a tiny bit clockwise so the top two sections of the wall are more or less parallel with the guide, as shown in Figure 6.15. This straightens up the tower of the lighthouse.

Figure 6.15
Choose an element that
should be horizontal
and align to that

Removing the Tourists

Here's a little more of that "art of fighting without fighting" I told you about. We're going to get rid of those pesky tourists at the right side of the image without using retouching at all. Here are the steps you need to take:

1. Press C to select the Crop tool.
2. Drag the cursor to create a square Crop selection around the lighthouse, stopping just short of the strolling tourists.
3. Adjust the Crop handles to get the composition you want, as shown in Figure 6.16.
4. Press Enter/Return to crop the photo.

Instead of tediously retouching the image, we eliminated a distraction by cropping it out.

Figure 6.16
A quick crop is much
faster than retouching

A Finishing Touch

During retouching, you may want to add a touch or two of interest to give the photo a special look. If you examined our picture carefully, you probably noticed that the sun was reflecting off a window at the top of the lighthouse. I thought that reflected light verged on the symbolic, but was disappointed that the reflection wasn't as obvious in the final picture as it was on-site. Photoshop can fix the problem. Just follow these steps:

1. Choose Filter > Render > Lens Flare from the menu bar.

2. In the Lens Flare dialog box, shown in Figure 6.17, choose the 105mm Prime option in the Lens Type area. This choice simulates the kind of lens flare you get with a short telephoto lens.

3. Set the Brightness slider at the top of the dialog box to about 50 percent. This keeps the flare from overpowering the entire image.

4. Drag the crosshair in the Preview area, which indicates where the lens flare will be applied, so it coincides with the top of the tower.

5. Click OK to apply the flare.

6. If the flare is too strong, you can press Shift+Ctrl/Command+F to produce the Fade Filter slider and dial back some of the effect.

The finished image is shown in Figure 6.18.

CHAPTER 6

Figure 6.17
The Lens Flare filter
can create reflections
for you

Figure 6.18
The finished image has
new clouds, a new
reflection of the sun,
and many fewer dust
spots and scratches

ABOUT LENS FLARE

The Lens Flare filter is one of the most useful filters in the Photoshop repertoire. You can use it to create a setting sun, stars in the sky, spotlights for concert photos, and for other effects. Lens Flare is actually a bug that's turned into a feature. When very strong light, especially that outside the image area, strikes the glass of a photographic lens, it bounces around inside the barrel of the lens, reducing the contrast of the image a little while adding streaks of light. The type and amount of flare produced depends on the number and kind of glass elements in the lens, the kinds of coatings applied to the surface of the glass (as well as to the interior surfaces of the barrel), and the focal length of the lens. Complex zoom lenses, such as the 50-300mm Zoom used as one Photoshop flare prototype, are among the worst offenders. Wide angles (such as the 35mm example Photoshop uses) tend to make the flare appear farther away, creating another effect entirely. A medium telephoto, such as the 105mm prime lens (a prime lens is simply a fixed focal length, non-zoom lens), generates an intermediate effect. You should learn the differences between them so you can select the right lens flare for your own projects.

Evening Out Highlights and Shadows

As you learned in Chapter 4, "Tools for Adjusting Tones," Photoshop has a variety of tools to help you adjust the tonal values in your images. In a typical image, some areas are too light, whereas others are too dark. Frequently, you can use the Levels command to adjust the tonal levels to a more satisfactory compromise. But, what do you do if the easiest to understand controls don't work for you? Are you forced to master complex tools such as Curves to get what you need? Don't panic just yet. There may be an easier way that gives you a bit of artistic control in the process. In this project, we're going to work with the photo of the frangipani blossom shown in Figure 6.19. Can you spot the problems we need to address? Use the frangi.pcx photo on the CD-ROM if you want to work along with me.

Figure 6.19
Can you spot the
problems with this
picture?

The main problem with the photo is that the blossom is quite washed out, compared to the rest of the photo. In this case, it may not even be possible to restore the detail that was lost in the very brightest sections of the petals, even using the Levels control. You can't bring back information that was never recorded. We could, however, improve the photo by decreasing the contrast between the blossom and the leaves. The leaves immediately under the blossom are properly exposed; the rest of the leaves are a bit too dark. Let's see what we can do with the Levels command first.

DO IT YOURSELF

The image also contains some dust spots and other minor artifacts. This is the "do one" part of your internship. You saw how to repair dust spots with the Clone Stamp earlier in this chapter, and I'm going to leave you to fix those in this image on your own, using what you learned.

Pressing Ctrl/Command+L produces the Levels dialog box, as shown in Figure 6.20. As you'll recall from Chapter 4, one way to fix the tonal values of an image is to move the black triangle closer to where the actual dark pixels in the image reside. Then, you can move the gray triangle in the middle left or right until the image visibly improves. In this case, the gray triangle can be adjusted to the left to produce the image shown in Figure 6.21. As you can see, the leaves are a lot lighter, but the sky has become too bright and the frangipani petals are even more washed out. This won't do at all.

Figure 6.20
Adjust the Levels
sliders to improve the
tonal values of the
image

Figure 6.21
Our first attempt
lightens the image, but
doesn't help the
washed-out portions

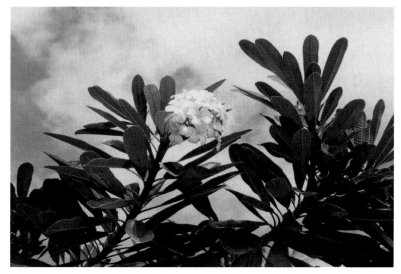

We can also try the same Levels command, but move the gray triangle to the right. That darkens the petals a little, but doesn't add any detail to the most washed-out petals. As a side benefit, it makes the sky darker and more dramatic. I'm starting to like the silhouette effect shown in Figure 6.22, and this gives me an idea. How about taking this particular look, but lightening only *some* of the leaves? That would make the one stem of the frangipani plant stand out in an otherworldly way, putting an unusual emphasis on it. We can do that.

Figure 6.22
Darkening the photo
doesn't help the
portions of the image
that were already
correctly exposed

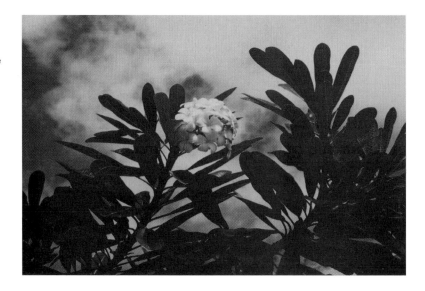

You can use this technique with other images that have drastic exposure differences. Have a portrait with half the face in dark shadow, but the rest of the face is properly exposed? Use the technique I'm about to show you. Just follow these steps:

1. Duplicate the layer by choosing Layer > Duplicate layer.

2. Select the original layer and apply the Levels command. Drag the black slider to the beginning of the area of the histogram that contains detail. Then drag the gray slider to the left to lighten the image. Don't worry about the sky or blossoms: You want to make the leaves light and translucent-looking. Your image should look like Figure 6.21.

3. Choose the duplicate layer and apply the Levels command again. Drag the black slider to the beginning of the area of the histogram that has detail. Then drag the gray slider to the right to darken the image, as you saw in Figure 6.22.

4. Now, working with the dark, duplicate layer, choose the Eraser tool (press E to select it) and gently begin to erase the dark portions of the leaves. Use a soft-edged brush. It's often easier to work around the edges first, and then move inward.

5. Continue erasing. You could erase *all* the dark leaves if you wanted, creating a photo with a much wider tonal range than the original. You'd have a dark sky, reasonably dark blossoms, and light colored leaves. I elected to erase only some of the leaves, making a particular branch and its blossoms stand out dramatically. The top layer will look something like Figure 6.23.

6. When you're done erasing, flatten the image (Layer > Flatten Image) and crop to produce the composition you want. I decided to remove some of the plant at the right and left sides of the image, cropping out some of the plain white sky background in the process. My finished image is shown in Figure 6.24.

Figure 6.23
Your partially-erased
layer looks like this

Figure 6.24
The final image
provides a view of the
blossom and its leaves
with a much longer
tonal range

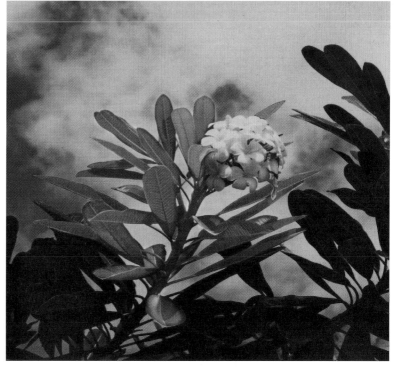

CHAPTER 6

Using Blurring and Sharpening

Photoshop's blurring and sharpening tools are simply two edges of the same contrast-manipulation sword. When Photoshop is commanded to sharpen an image or selection, it sends its nanotech pixel inspectors out to look at every pixel in an image and discover boundaries or edges where the contrast and tonal values between pixels changes relatively suddenly. (Actually, it's an algorithm that does the job, not subminiature pixel inspectors.)

In Figure 6.25, you can see an area that typically would be considered an edge (it happens to be a stripe on a white tiger). Sharpening is accomplished by increasing the contrast among those pixels, enhancing the edges, as shown in Figure 6.26. Blurring is nothing more than *decreasing* the contrast among the same pixels, making the edges less prominent, as you can see in Figure 6.27.

If you look closely at all three images, you'll see the shape and size of the pixels are identical in all cases. The sharper-appearing image has no greater resolution; the blurry image has not lost any resolution. The only difference is the contrast between the pixels.

Figure 6.25
Tiger stripes show up as an edge when examined closely

Figure 6.26
Increasing the contrast between the pixels makes the stripe look "sharper"

Figure 6.27
Decreasing the contrast between the pixels makes the stripe look "blurry"

There are a couple lessons to be learned from this. One of the most important is that when you use blurring or sharpening during retouching, you are changing the contrast of the area being worked on. For that reason, you should remember that any brightness/contrast adjustments you plan to make to an image should be made *before* you do blurring or sharpening. If you wait until after, you may find that the portion of the image you have manipulated may have too much contrast (or not enough) for the contrast adjustments you plan to make.

Obviously, you would want to use sharpening on portions of your image that aren't sharp enough. But what about blurring? Why would you *want* a blurry image? If you remember the two-edged sword analogy, you can see that blurring can actually make the unblurred portions of your image look sharper. If you have an image that won't tolerate much sharpening (perhaps because it already has too much contrast), you may be able to make it look sharper by blurring the rest of the image.

Tiger, Tiger, Looking Sharp

Let's try some blurring and sharpening on a couple pictures to see how this works. I'm going to start with the tiger04.pcx picture from the CD-ROM. Figure 6.28 shows the full picture. One thing that may not be obvious to you is some diffusion (a kind of blurring or spreading of the image) caused by a chain-link fence that the photograph was taken through. I used a telephoto lens, which threw the fence out of focus, but that didn't stop the links from making the tiger a little blurrier than I'd have liked.

Figure 6.28
Photographed through a chain-link fence, the tiger is a little blurrier than we want

One way to sharpen him up is to use Photoshop's Sharpen tool, which lets you "paint" areas of the tiger to make specific parts of him sharp while leaving the rest alone. In this case, though, we want the entire tiger sharper, so the Unsharp Mask filter is a better choice. Follow these steps to sharpen up the tiger the easy way:

1. Press Q to enter Quick Mask mode, and then press B to choose the Brush tool. Select a large, soft-edged brush and paint over the entire tiger. It's not necessary to paint over every single speck of him. You'll cover him with a mask, as shown in Figure 6.29. Don't forget to press Q to exit Quick Mask mode before going on to the next step.

2. Then choose Filter > Sharpen > Unsharp Mask and move the Amount slider to the right as much as you like. You'll sharpen the tiger significantly, but will also boost the contrast of his pelt considerably. In this case, the effect looks rather dramatic, so I'm going to leave the effect. You can see the effect in Figure 6.30.

3. To see how blurring might affect the image, invert the selection so everything except the tiger is selected. Press Shift+Ctrl/Command+I or choose Select > Inverse.

Figure 6.29
Quick Mask mode can quickly mask off the tiger (natch)

Figure 6.30
Sharpened up, the tiger already looks more dramatic (even though he's about to fall asleep)

4. Choose Filter > Blur > Gaussian Blur. When the Gaussian Blur dialog box appears, apply a little blur. I applied a *lot* of blur by setting the Radius slider to a value of 7, but that was primarily so the effect would appear more clearly on the printed page. You might not need so much blur. The final picture is shown in Figure 6.31. If you compare that image with the earlier shot, you should see that the tiger looks a bit sharper, even though the only change was made to the background.

Figure 6.31
A blurry background creates an even sharper tiger

CHAPTER 6

Blurring and Sharpening for Dramatic Effect

Let's do something similar, but using a different Photoshop tool, the Extract Filter. This next project shows you how blurring and sharpening can be used purely for a dramatic

effect, while giving you a chance to master another "selection" tool. We're going to use the file hut.pcx from the CD-ROM. The original photo looks like Figure 6.32.

Figure 6.32
We're going to
"extract" this hut
from the photograph

The Extract command provides a sophisticated way to select an area by removing it from its surroundings. It works especially well with fuzzy edges, such as the fringes of this grass hut. The tool lets you carefully paint a mask around the edges of your object, adjust the borders, and preview your result before extracting the object. Follow these steps:

1. Create a duplicate of the background layer by choosing Layer > Duplicate Layer.

2. Activate the Extract command by choosing Filter > Extract, or by pressing Alt/Option+Ctrl/Command+X. The dialog box shown in Figure 6.33 appears.

Figure 6.33

The Extract command makes it easy to remove an object from its background

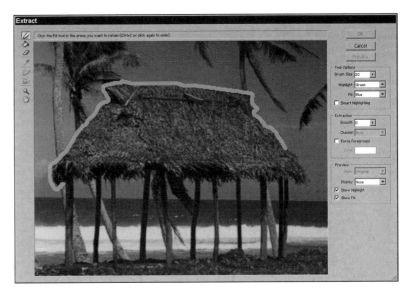

3. Zoom in on the portion of the image you want to extract. In this case, focus on the upper edge of the hut. Zooming within the Extract dialog box is done in exactly the same way as within Photoshop. Use the Zoom tool (available from the dialog box's Tool palette at the left edge) or simply press Ctrl/Command+space to zoom in or Alt/Option+space to zoom out.

4. Click the Edge Highlighter/Marker tool at the top of the Tool palette. Choose a brush size of 20 from the Tool Options area on the right side of the dialog box. That's large enough to paint along the edges of the hut comfortably.

5. Paint the edges of the hut with the Marker tool. Use the Eraser tool to remove markings you may have applied by mistake, or press Ctrl/Command+Z to undo any highlighting you've drawn since you last clicked the mouse. The Hand tool can be used to slide the image area within the preview window.

6. When you've finished outlining the hut, click the Paint Bucket tool and fill the area of the hut you want to preserve.

7. Click the Preview button to see what the hut will look like when extracted.

8. If necessary, use the Cleanup tool (press C to activate it) to subtract opacity from any areas you may have erased too enthusiastically. This returns some of the texture of the hut's grassy roof along the edge. Hold down the Alt/Option key while using the Cleanup tool to make an area more opaque.

9. Use the Edge Touchup tool (press T to activate it) to sharpen edges.

10. Click OK when satisfied to apply the extraction to the hut. You'll end up with a hut on a transparent layer, as shown in Figure 6.34.

CHAPTER 6

SHARPENING FIRST

The Extract command works best with images that are sharp, so with some photos, your first step might be to sharpen the entire image. Use Filter > Sharpen > Unsharp Mask, and adjust the Amount slider until the image is tack-sharp. Don't be afraid to use a setting of 100 percent or more.

Figure 6.34
You'll end up with a hut, separated from the rest of the Samoan beach

11. Apply the Unsharp Mask filter to the layer with the hut to sharpen it up.

12. Create another duplicate of the background layer containing the beach. You'll now have three layers: On top is the extracted hut, and underneath are two copies of the entire image.

13. Select the new copy (which is in the middle of the three layers). It also contains the hut, but you won't be able to see it underneath the "extracted" hut layer. Apply a little Gaussian Blur to blur the palm trees behind the hut and the beach. Don't overdo it, or your image won't look realistic.

14. The foreground foliage is also blurred. Counter that by erasing the blurred foreground and allow the unblurred version in the layer beneath to show through. Choose the Eraser tool (press E) and erase the foreground from the middle layer.

15. Flatten the image using Layer > Flatten Image. Your final version should look similar to Figure 6.35.

Figure 6.35
A little blurring and sharpening produces a more dramatic effect

Next Up

Although I intentionally kept the retouching techniques in this chapter simple to let you get your feet wet slowly, I don't plan to make the chapters that follow complex or confusing, by any means. You'll find that as we go, you'll add better and more advanced techniques to your repertoire as painlessly as possible. Next up is a chapter that concentrates on one of the most challenging types of retouching: portraits.

CHAPTER 6

7

Retouching Portraits

Retouching posed photos of human beings is one of the most challenging of retouching tasks. No other photo manipulation process is so prone to errors, and so likely to be met with criticism. You'll be struggling not only with reality (how your subject really looks to the camera), but also perceived reality (what the viewer *thinks* the subject looks like) and idealized reality (what the viewer *would like* the portrait subject to look like). If you can retouch portraits well within Photoshop, you're ready for the big-time.

This chapter tackles some of the most common portrait retouching situations, and shows how to handle them effectively and quickly, while matching, as well as possible, each of the three kinds of reality that are likely to be imposed on your work.

Portrait Challenges

A lot can go wrong when a portrait is taken in the first place, and even more mishaps may occur when you try to fix the mistakes. Everyone has a notion of what they and other people look like, or should look like, so you'll find many more critics for your finished portraits than for any other kind of photo. Here's a quick checklist of the challenges you're facing.

▶ **Expectations are high**. Almost by definition, a portrait is supposed to represent a true and flattering rendition of the subject, even though a true rendition is often not very flattering. Portraits are expected to minimize physical defects (such as a wide or thin face), emphasize strong features (ranging from a steely glint in an executive's eye to full, sensuous lips on a model), while providing a glimpse at the personality of the subject. No wonder portraits are subjected to so much criticism!

▶ **Proportions must be right**. If a full-face photo was taken too close to the subject with a relatively wide zoom setting (or with a wide-angle lens), the nose appears too large in relation to the ears. Other goofs by the photographer can make a face appear wider or narrower than it really is. The two

images shown in Figure 7.1 were taken within minutes of each other; the photo on the left was made with a wide-angle zoom setting on a digital camera, whereas the photo on the right was taken with a telephoto setting. The face is narrower and nose larger in the version on the left, with a more natural appearance in the version on the right.

Figure 7.1
The lens zoom setting you choose can make a drastic difference in a portrait's appearance, as with this wide-angle shot (at left) and a more conventional photo (at right) taken with a short telephoto setting

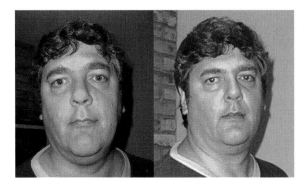

▶ **Eyes and mouth must appear exactly right**. Even small changes to the eyes or mouth in a portrait can make the photo look "odd," even though the viewer may not know exactly what's wrong. Getting these features right can mean the success of a portrait.

▶ **Color balance must be right**. Small variations in color in nonhuman objects that we would never notice loom large in a portrait. You can get away with a photo that is slightly too reddish, but even a hint of a bluish or greenish cast can impart a ghastly pallor on your subject. You can test this for yourself by covering up all but one of the portraits shown in Figure 7.2 and viewing them in turn. When you don't compare each version directly with the others, the greenish version at left and the reddish rendition at right may look OK, but the one with the green cast definitely appears to be cooler. The tinge is particularly objectionable when you compare it to the neutral version in the center. Yet, an equal amount of red cast (at right) doesn't look particularly bad.

▶ **The smallest detail is up for scrutiny**. Facial expressions, complexion, even the catchlights (reflections) in the eye may make the difference between an acceptable portrait and one that's rejected.

Let's move on and fix some of these problems using some typical sample portraits, both formal and informal.

Figure 7.2

The greenish cast (at left) looks ghastly when compared to the neutral rendition (middle) and the version with a reddish tinge (at right)

Solving Age Old (and Old Age) Problems

Old age, and its effects, are relative. A 38-year-old NBA player or NFL wide receiver is ancient, but a significant number of baseball players, especially pitchers, reach that milestone. (Nolan Ryan pitched his *sixth* and *seventh* no-hitters when he was 43 and 44 years old, respectively.) A U.S. President in his (or, soon, her) forties is considered young; a company president aged 50 brings the vision of youth to the job; a cleric elected as head of a world-wide religion at age 60 may be several decades younger than his or her predecessor.

So, your job as a retoucher of photographs frequently depends on input from the subject of the photograph when it comes time to eradicate (or, perhaps, emphasize) the ravages of time. For some, facial wrinkles are part of who they are. A company executive may count those creases as hard-won character marks. Can you even *imagine* Johnny Cash without a furrowed brow? On the other hand, some young men and women see the first appearance of tiny crow's feet at the corners of their eyes as a sign of impending doom. When I am shooting a portrait that matters, I always give the subjects or the people close to them the chance to decide just how much or how little retouching will be done, especially when the "defects" are age-related.

In this section, I show you several ways to retouch portraits of a few people who, let's say, no longer worry about producing identification when purchasing alcoholic beverages. You'll learn several ways to remove wrinkles and other defects. We'll start with a photo you can find on the CD-ROM bundled with this book under the name fran.pcx. It's shown in Figure 7.3. Among its other problems, there are a few dust spots remaining. I won't provide explicit instructions for removing the dust; you're expected to know how to use the Clone Stamp tool or Healing Brush to touch these up by now. Instead, we're going to concentrate on some more challenging defects.

Figure 7.3
We're going to remove
some wrinkles from
this portrait

Removing Wrinkles

We're going to remove some very slight wrinkles in the forehead and around the mouth first. Just follow these steps:

1. Enter Quick Mask mode (press Q) and select the Brush tool. Choose a medium-sized, fuzzy brush. I selected the 35-pixel brush.

2. Paint a selection over the forehead and around the mouth, as shown in Figure 7.4.

3. Press Q again to exit Quick Mask mode.

4. Choose Filter > Blur > Gaussian Blur and move the Radius slider to the 3.5 pixel mark. You can see in Figure 7.5 that the forehead and area around the mouth are significantly blurred. The idea is to blur the character lines, but not remove them entirely; that would look seriously phony.

5. The texture of the blurred skin *does* look phony, so we need to make it match the rest of the face. For small blurred areas like this, the easiest way to do this is to add some noise. Choose Filter > Noise > Add Noise and in the dialog box that appears, choose an Amount of about 2.5 percent. Mark the Gaussian and Monochromatic check boxes to give the noise a random appearance without adding any color to the blurred section.

Figure 7.4
Paint a selection over
the wrinkles

Figure 7.5
Blur the character
lines, but don't obscure
them entirely

6. Click OK to apply the noise. The image now looks like Figure 7.6.

Figure 7.6
With the wrinkles
gone and texture
matched, the portrait
looks like this

Fixing Up the Eyes

Our subject's beautiful eyes need to be enhanced just a little. Follow these steps:

1. Use the Clone Stamp tool to copy pixels from under the right side of the right eyebrow (our right, not hers) to cover up a shiny spot under the center of the brow. I used a 13-pixel, fuzzy brush.

2. Select the Dodge tool, set the Range to Midtones and the Exposure to about 13 percent. Then lighten up the area under the eyes. I used a 27-pixel, fuzzy brush for this.

3. Enter Quick Mask mode again and select the eyes. Exit Quick Mask mode when you've finished the selection.

4. Press Ctrl/Command+J (or Layer > New Layer > Layer Via Copy if you're a glutton for menus) to copy the eyes to their own layer.

5. Use the Levels control to lighten the eyes a little, as shown in Figure 7.7.

6. If you want, use the Image > Adjustments > Hue/Saturation command to change the color of the eyes. Just use the Hue slider until you get the color you want.

7. When working on the eyes, we noticed that they had unnatural-looking double catchlights (caused by the two light sources used to take the portrait). Use the Clone Stamp tool to blot out the brighter of the two catchlights, on the right side of the pupil.

8. As a finishing touch, I'm going to show you a quick way to disguise a wrinkled neck. If the subject's outfit has a fairly high collar, just copy the collar to a layer of its own (use Ctrl/Command+J after selecting the collar by your favorite method) and move it up a bit. We don't need to move the collar up much, because our model doesn't have many wrinkles to cover.

9. Choose Layer > Flatten Image to combine the layers. The portrait now looks like Figure 7.8.

Figure 7.7
Lighten the eyes using
the Levels control

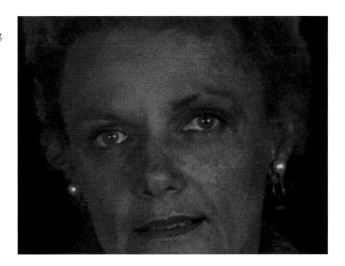

Figure 7.8
With the collar moved
up, the portrait looks
like this

Whitening and Straightening Teeth

Sometimes, you'll need to do some quick dental work, making teeth brighter that are
probably pretty white on their own, but which don't show up well in the photo because
of how the shadows fall. You can also fix gaps and straighten any teeth that aren't quite
perfect. Follow these steps to finish up our portrait:

1. Use the Clone Stamp tool to fill in rough edges around the bottom of
 the teeth.

2. When you're satisfied with the teeth, enter Quick Mask mode and select
 the teeth, as shown in Figure 7.9. Then, exit Quick Mask mode.

3. Overall whitening is what we're looking for, so use Image > Adjustments >
 Brightness/Contrast and manipulate the Brightness slider to whiten
 the teeth.

4. Click OK to apply the tonal change. Our finished portrait is shown in Figure 7.10.

Figure 7.9
Select the teeth so you can whiten them

Figure 7.10
Our finished portrait looks like this

Retouching Group Portraits

For our purposes, a group portrait is any portrait with more than one person in it. Such retouching jobs are challenging because you are often called to apply different techniques to each person in the photo. In this example, we're going to work with a family portrait of a 42-year-old mother posing with her two-year-old daughter. As the last of four children, the daughter has obviously caused more than a few wrinkles (and possibly some gray hairs) to

appear on her mother. We can fix up this photo with what you've learned so far, plus some new techniques. The original photo, 2blondes.pcx, can be found on the CD-ROM accompanying this book. The original, shown in Figure 7.11, has a few problems—some easy to fix, some not so easy.

Figure 7.11
The original portrait has some ills to fix, including some tonal problems

Eliminating Distracting Backgrounds and Foregrounds

The first thing to do is to crop this picture, eliminate a distracting sofa in the background, and fix some tonal problems. Although the photo is cropped perhaps a little too tightly on the left, it could have been cropped better at the bottom. The little girl's legs and her mom's hand are trailing out of the picture area and look distracting.

1. Use the Crop tool to excise the lower portion of the photo and the right edge, as shown in Figure 7.12.

2. Next, choose the Brush tool and select a medium-sized, fuzzy brush. I used a 40-pixel brush.

3. With the Brush tool still active, hold down the Option/Alt key (this temporarily converts the Brush to the Eyedropper tool) and click to sample the dark background just above the couch at the far right. This changes the foreground color the brush will paint with to the color you sampled.

4. Paint out the distracting couch. Be careful around the edges of the mother's sleeve, so you don't paint over her outfit. The image now looks similar to Figure 7.12.

Figure 7.12
We've cropped the figure and eliminated the distracting background

Fixing Tonal Values and Facial Features

The photo is a bit washed out, but we can fix that with the Levels command. Follow these steps:

1. Choose Image > Adjustments > Levels. The Levels dialog box appears.

2. By now, you probably realize that the big spike of pixels near the far left edge of the histogram represents all those dark, but not-quite-black pixels of the background. We can eliminate them and concentrate the tones on the dark areas of the mother's outfit. Move the black point slider to the right, past the spikes. You can adjust the gray slider to the left a little if the image looks too dark to you, as shown in Figure 7.13.

3. Click OK to apply the Levels changes.

4. The little girl is still too light, so select her in Quick Mask mode, and use the Levels command on her separately to darken her a bit more, as shown in Figure 7.14.

5. Use the wrinkle-removing technique we applied to the mom's older sister in the first example in this chapter. Select the wrinkles around the mouth and chin, blur them, and then apply a little noise to produce an even texture.

6. Use the Clone Stamp tool to copy lighter pixels from the cheek over the slight bags under the mom's eyes. The photo now looks similar to Figure 7.15.

Figure 7.13
Use the Levels
command to adjust
tonal values of the
portrait

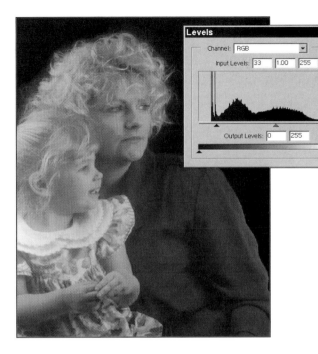

Figure 7.14
Darken the little girl
a bit more

Figure 7.15
Remove the bags under mom's eyes with the Clone Stamp tool

Touching Up the Eyes and Lips

Now, we need to finish off the mom's eyes and lips. (Notice that the daughter doesn't need any more retouching. Ah, youth!)

1. Create a new, transparent layer (use Shift+Ctrl/Command+N) and call the layer Lips when the New Layer dialog box appears.

2. Choose a lipstick color from the Swatches or Colors palettes, and then zoom in on the mom's mouth. Paint some brighter lipstick on the transparent layer.

3. Set the transparent layer's mode to Overlay in the Layers palette. In this mode, the color overlays any color underneath without obscuring the detail.

4. Drag the Opacity slider for this layer in the Layers palette to reduce the amount of "lipstick" you've applied. I set the Opacity to about 10 percent to provide brighter lips without looking garish.

5. Create another transparent layer and call it Eyes. Paint some blue around the mom's eyes to brighten them a little. Set the Eyes layer's mode to Overlay and dial down the Opacity, as before, until the eyes have a nice blue tint to them, but nothing overpowering. The portrait now looks similar to Figure 7.16.

Figure 7.16
Paint on transparent layers to add color to eyes and lips

Taming Wild Hair

The portrait is virtually finished at this point, but if you think the mom's hair is a bit unruly at the top and sides, I'll show you a quick trick for taming wild hair.

1. Create yet another transparent layer.

2. Choose the Brush tool, press the Alt/Option key, and sample the background.

3. Paint around the edges of the hair, covering any strands you feel are especially wild. I've made the underlying portrait partially transparent so you can see what's been done in Figure 7.17.

4. Change the hair touch-up layer's mode to Soft Light. In this mode, the background you painted over the edges of the hair covers only the very lightest (and, most likely, the unruliest) strands. You'll end up with a soft edge around the hair that doesn't look painted-over, as you can see in Figure 7.18.

Figure 7.17
Paint around the
edges of the hair

Figure 7.18
Soft Light mode
blends the painted
area with the hair,
covering only the
lightest strands

Compositing as Retouching

Consider this short section a preview of Part III. I wanted to introduce the idea of using compositing as a portrait retouching technique so you'll keep that option in mind as you work through the rest of this chapter. When photographing groups, especially when kids are involved, you'll routinely end up with photos in which one person looks good, and the other one doesn't. Invariably, the next picture taken shows the second person in a flattering pose, whereas the first person has decided to stick out a tongue or something.

The solution is to *combine* the two images, melding the two good poses together into one satisfactory image. Check out Figure 7.19. The little boy is shown best in the upper picture, whereas the little girl is most attractively posed in the *bottom* image. Can we combine the two?

Figure 7.19
Alas! There's one good picture hidden in these two shots. Can retouching save them?

Figure 7.20 shows a composite image in which the little girl's face in the lower shot has been pasted into the upper picture. You'll learn all the compositing techniques for doing this seamlessly in Part III.

Of course, once you get *really* adept at compositing, you can do some really complicated things, such as combining the mom's face and daughter's face from the lower picture with the boy's face and body and daughter's lower body from the upper photo. I do this almost routinely now that most of my photos are taken with a digital camera. After I shoot some family portraits, my spouse will question this pose or that, or whether we should have used a different background, or whatever, and I just say, "It doesn't matter. When I get done, you'll have the background and poses you want, no matter what I've got at the moment." Figure 7.21 shows the final conglomeration (prior to normal retouching; this is only a composite image).

Figure 7.20
We've moved the little girl's head to the other photo

Figure 7.21
In this photo, we've combined two different lower bodies and three heads

Adding a Glamour Look

I made my living for awhile as a fashion photographer and photoposing instructor for a New York modeling agency, so I'm probably inured to our society's preoccupation with youth and glamour. I liked one of my model's work enough to marry her, and, although her modeling career ended long before she reached her present 40+ age, I can understand the desire she has, along with many other women and more than a few men of all ages, to look glamorous. So, I can say with experience that, if you gain the ability to add a glamour look to portraits with your retouching skills, you'll have all the friends you can handle for the rest of your life.

This section covers a few easy techniques for giving a romantic or glamorous appearance to portraits. We're going to start off with blond42.pcx, which you can find on the CD-ROM that is bundled with this book. It's a profile shot, as you can see in Figure 7.22, so we need to spruce up the look a little.

Figure 7.22
We can make this photo a little more glamorous

Fixing Sagging Necks and Chins

Put on a few pounds, and bingo! your neck starts to sag a little. At least, that's what happened to me. We'll fix that first in our glamour-portrait-to-be.

1. Use the Lasso tool to copy our subject's neck, below the chin. Press Ctrl/Command+J to copy it to a layer of its own.
2. Use the Move tool to move the neckline back a bit.
3. Feather the edges of the relocated neck with a large, fuzzy brush and the Eraser tool.

4. Repeat Steps 1–3 using the chin to provide a slight chin lift. Your image starts to look like Figure 7.23.

Figure 7.23
The "chin lift" looks like this

Making Noses Smaller

Most people, aside from Cyrano de Bergerac, wish their nose looked a little, er, *noselike,* usually in the smaller department. I can't emphasize enough that you should change people's noses only with extreme caution, and then only to a very minor degree. Giving someone with a real schnozz a pixie nose won't improve their appearance; it makes them look ridiculous. If you want to proceed, try this technique:

1. Use the Lasso tool to select the nose (in this case, the nose is in profile, but the same technique works when retouching a nose shown full face). Include some area outside the nose itself, such as part of the background or the rest of the face, so as you distort the selection, the image area bordering the nose will not be empty. (Even so, you may still have to use the Clone tool to fill in some gaps.)

2. Choose Edit > Transform > Distort. A bounding box with eight handles appears around your selection, as shown in Figure 7.24. Drag the handles until you create the shape you want for the nose. You can decrease it or increase it in size, and remodel the contours. Don't do anything too drastic!

3. Press Enter/Return when you're satisfied with the nose.

4. If necessary, use the Clone Stamp tool to merge any edges that aren't well-aligned or if any gaps have appeared. Your image will look something like Figure 7.25.

Figure 7.24
Reshape the nose with the Distort command

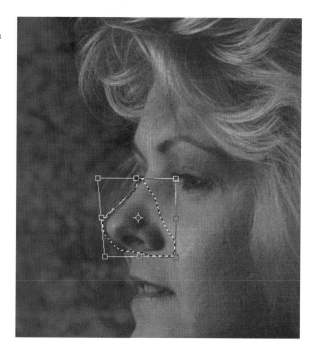

Figure 7.25
Now we've added a nose job

Fixing the Complexion

We're going to add a little diffusion to this image in a later step, but it can't hurt to smooth out our subject's complexion first.

1. Choose the Clone Stamp tool, and set an Opacity of about 40 percent in the Options bar.

2. Work around the face removing stray hairs and evening out the complexion.

3. Remove the eyelid wrinkles using the Clone Stamp tool, too.

4. Create a new transparent layer and apply a very light touch of blue eye shadow, lipstick, and maybe some blush on the cheeks.

5. Set the mode of the transparent layer to Overlay, and dial down the Opacity until the color you've added is barely detectable. Your image should look similar to Figure 7.26. Don't worry if the results are a bit garish at this point. The diffusion we'll be adding will tone things down a bit.

6. Finally, lighten the teeth as you learned to do earlier in this chapter. Select the teeth in Quick Mask mode, and lighten them with the Brightness/ Contrast control.

Figure 7.26
We've fixed the complexion and are ready to add a glow

Adding a Romantic Glow

You'll find that a romantic glowing effect can enhance any glamour photo. There are several ways to achieve this look. Here is one to try out:

1. Press D to make sure Photoshop's default colors are black and white. Otherwise, the filter used in the next step won't operate as you want.

2. Working with the image from the last section, choose Filter > Distort > Diffuse Glow.

3. Set the Graininess slider to 4 to provide a moderate amount of diffusion, set the Glow Amount to 11, and set the Clear Amount (the nonhighlight areas) to 10 to give us a good balance of glow in the shadows and highlights. You can see the Diffuse Glow dialog box in Figure 7.27.

4. Click OK to apply the effect.

5. We need to combine the glow effect with the underlying image, so press Shift+Ctrl/Command+F to produce the Fade dialog box. Dial the Opacity back to about 60 percent, and choose Screen as the mode.

6. Click OK to fade the filter.

7. Use the Levels command (Ctrl/Command+L) to adjust the tones. Move the black point slider to the point on the histogram where the blacks actually begin. Click OK to apply the tonal change. Your image now looks like Figure 7.28.

Figure 7.27
Apply the Diffuse Glow filter

Figure 7.28
The romantic glow
looks like this

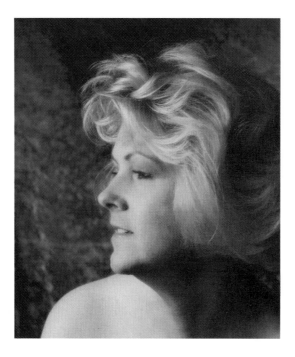

Here's an alternative method that produces a different look:

1. Instead of following the previous steps, take the same image and enter Quick Mask mode.

2. Choose a very large, fuzzy brush, one that's large enough to cover the face with one stroke (press the right bracket key until the brush grows large enough; you'll be well over 1000 pixels).

3. Dab a selection that covers the face, and then exit Quick Mask mode.

4. Press Shift+Ctrl/Command+I to invert the selection, so that everything in the image *except* the face is selected.

5. Apply a severe Gaussian Blur to the selection. (Choose Filter > Blur > Gaussian Blur.) Set the Radius slider to about 5 pixels. Click OK to apply the blur.

6. Apply the Diffuse Glow filter to the selection you just blurred. Use the same settings of Graininess 4, Glow Amount 11, and Clear Amount 10.

7. Press Shift+Ctrl/Command+F to access the Fade dialog box again. Set the Opacity to about 50 percent, but don't change the blending mode (as you did in the previous effect).

8. Click OK to apply the fading. Your image should look like Figure 7.29.

Figure 7.29
The alternative method
produces a glow with
more blur

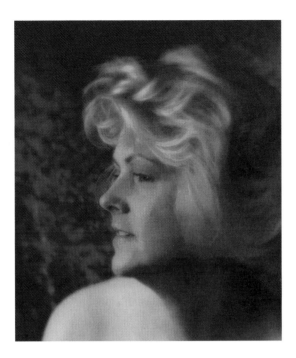

Four Tricks for Removing Braces

Everyone who has ever worn braces looked forward to the day when the braces could be removed. If the day hasn't arrived yet, you can remove them digitally, using Photoshop. You already know all the techniques you need to apply, but I'm going to share a few tricks with you that make the job even easier.

We're going to work with the file kristen.pcx, which you can find on the CD-ROM that is bundled with this book. We're fortunate (and so is Kristen), because we have to deal with braces only on the upper teeth, as you can see in Figure 7.30. The technique is similar for a full set of braces, but takes twice as long (at least).

▶ **Trick #1**. It's often easier to use a simple paintbrush rather than try to *clone* over the braces with pixels from the other teeth. You don't really want to duplicate the texture of the teeth, anyway. What you really want are plain, evenly colored teeth. So, use the paintbrush with a small, fuzzy brush to paint over the braces, as you can see in Figure 7.31. Choose a color using the next trick in the list.

Figure 7.30
Luckily, we have
only one row of
braces to remove

▶ **Trick #2**. The key to using this technique successfully is to change the
foreground color you use to paint frequently. Hold down the Alt/Option
key to sample the tooth color nearest a section of braces, and paint using
that tone. As you move on, resample an adjacent color and continue paint-
ing. This is a little like cloning, except you're not copying the texture of
the teeth, only their color.

▶ **Trick #3**. Find a good tooth, select it, copy it to its own layer (press
Ctrl/Command+J), and then use the good tooth to replace teeth that are
uneven or which have braces showing. The "good" tooth may even be one
that you've created by painting over parts of the braces. After you have a
good tooth, you can copy it, flip it horizontally, resize it, and otherwise
use it to create even teeth.

▶ **Trick #4**. If the teeth are a little yellowed or have some other tinge, select
the teeth and then use Image > Adjustments > Hue/Saturation to neutralize
the cast. Just move the Saturation slider to the left until the unwanted
tinge vanishes.

Our photo of Kristen without her braces looks like Figure 7.32.

Figure 7.31
Paint over the teeth
with a sampled color

Figure 7.32
Sans braces, this
portrait is already
starting to look better

Canceling Red-Eye

Red-eye is that awful reddish reflection off the retinas that you get when the flash is located too close to the taking lens. The effect is sometimes yellowish or greenish in animals. The best way to get rid of it is to neutralize the red color and clone over any excessive brightness the reflection caused. The photo we used in the last project also has some red-eye, so we can use it to remove this effect.

1. Zoom in on one of the eyes, as shown in Figure 7.33.

2. Enter Quick Mask mode and carefully paint to select the pupil of the eye.

3. Exit Quick Mask mode.

4. Choose Image > Adjustments > Hue/Saturation to produce the dialog box shown in Figure 7.34.

5. Move the Saturation slider to the left. This removes the red color from the pupil.

6. Move the Lightness slider to the left; this darkens any reflection, making the pupil effectively black again.

7. Repeat for the other pupil.

8. You may want to select the iris around the eye and lighten it, which may be necessary with some cases of red-eye. If the red-eye extends beyond the pupil, you may also need to clone some iris pixels to replace those lost in the red glare.

Figure 7.35 shows the finished portrait of Kristen. I've also used the techniques described previously in this chapter to even out her complexion and remove some of the glare from the frames of her glasses.

Figure 7.33
Zoom in on one eye to
make fixing the red
tone easier

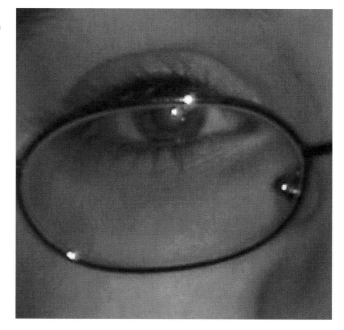

Figure 7.34
Set the Saturation to zero, and reduce brightness until the red-eye effect vanishes

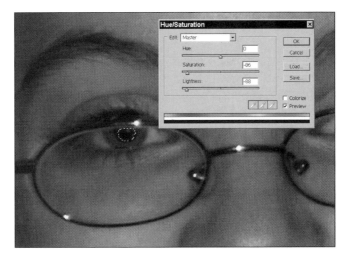

Figure 7.35
The finished portrait looks a lot better

Next Up

There's a lot more that can be done with portraits, as you'll find out in the final three chapters of this part. In our next thrill-packed episode, you're going to learn how to create accurate grayscale images from color photos and ways to create and use duotones, tritones, quadtones (and so on).

8

Creating Great Grayscale Photos from Color

It's a long day's journey into black-and-white. And the trip back is even worse. However, it never fails. You've got a really great picture, but it's black-and-white. How do you add color that isn't there? Or, you may have a color image and would prefer a grayscale rendition. That, at least, sounds easy—until you try it. If you want to convert a good color photo into a bad black-and-white image, or a great grayscale picture into a terrible-looking colorization, you can do the job in minutes.

In practice, converting a color photo to a grayscale picture that accurately represents all the tones of the original is trickier than you might think, and adding color to a photo that was created in black and white is just as tricky as you imagine. This chapter helps you understand both processes and provides some tips for performing the transformation from color to black and white. Then, in the next chapter, we venture into another form of image alchemy: creating colorizations, duotones, tritones, and *n*-tones from your images.

Converting Color to Grayscale

I'm going to approach the color-to-grayscale question from a different angle than you'll find in most Photoshop books, which means, I hope, that you'll *understand* the problems better. Before we make our first conversion, I'm going to explain why the process is so difficult, using some visual examples to demonstrate.

Photoshop offers several ways to convert color images to grayscale. Several are fast, easy, and produce terrible results much of the time. Others take a little more time, but give you better results. I'm going to show you all the common ways to convert full-color images to black and white, and offer tips on which you should use and when. But first, it's important to understand why removing all the color from an image doesn't automatically yield a good grayscale version of the image.

Black-and-white images are not just color photos without any color in them. Photographers and, especially, cinematographers, knew that back in the days when color photos and color

movies were not available. Black-and-white movies such as *Casablanca* look as good as they do because the cinematographer knew to avoid certain colors that photographed as the same tone in black and white, and would tend to merge. So, the colors of the costumes, backgrounds, and even the makeup in movies from the pre-color era were carefully chosen to look their best in black and white. Lighting was also used effectively to provide the right kind of separation between objects in a scene.

As late as the 1950s, our favorite superhero burst onto television clad in a reddish-brown and gray supersuit, because his familiar blue, red, and yellow garb simply did not photograph realistically for black-and-white televisions. Because Superman's costume is trademarked, we had to raid the closet of one of his superfriends, NoCopyright Man, whose insignia is the copyright symbol bisected by the diagonal bar that means NO internationally. The color version of NoCopyright Man's jersey is shown in Figure 8.1.

Figure 8.1
This superhero's costume and insignia can be seen with no problem in full color

Unfortunately, when we convert the costume to grayscale using Photoshop's default method of choosing Image > Mode > Grayscale from the menu bar, quicker than you can

say "Shazam!" your color image has been converted to an inaccurate black-and-white rendition. Or, perhaps, you decide to use Image > Adjustments > Desaturate on the costume, which does much the same thing, but only operates on a particular layer or selection. The icky results are shown in Figure 8.2.

Figure 8.2
Photoshop's default
color to grayscale
algorithms produce
this bland result

Images converted this way always seem to have low contrast. So, the typical response of the neophyte is to do the worst possible thing: Use the Image > Adjustments > Brightness/Contrast controls to increase the brightness, contrast, or both. Wow! This is really fast. It took us only 20 seconds to create a grayscale version of the original image that looks *nothing* at all like the original. Now, it has too much contrast, and the tones of the insignia don't represent the real relationship very well. The red edging around the collar and sleeves have become almost invisible, as you can see in Figure 8.3.

Figure 8.3
Boosting the contrast
doesn't make the colors
any more accurate

What went wrong? We were led astray by thinking that the apparent differences in tone between parts of the costume were determined only by the relationship between the light and dark tones of our converted grayscale image. In the real world, the hue (color), saturation (richness), and brightness of the tones determine the apparent contrast that we see in color. When hue and saturation are removed from an image by converting it to grayscale, all we're left with is the relative brightness of the tones. That may not be enough to differentiate them, as you were able to see in Figure 8.2.

If you need additional proof, check out Figure 8.4. In the bottom row, you'll see three versions of the insignia that are virtually identical. Each example in the bottom row was produced from the version immediately above it, and it's easy to see just how much *they* differ.

The left pair (top and bottom) are the original insignia, reduced to grayscale using Photoshop's Mode conversion process. The grayscale version, as I said earlier, is low in apparent contrast. The yellow C tends to merge with the blue of the jersey underneath.

Figure 8.4
Modifying the
saturation and hue has
no effect on the
grayscale result

For the middle pair, I used Photoshop's saturation controls to reduce the richness of the colors in the insignia. You can see that the yellow, red, and blue have become quite muted, as if NoCopyright Man has washed his supersuit a few too many times. Even with the diminished saturation, the grayscale conversion (below, middle) looks about the same as the version to the left. In actual color images, some colors may have exactly the same brightness and hue, and vary only in their degree of saturation. We still have no difficulty differentiating the objects in the image—until the image is converted to grayscale and the distinction is lost.

For the pair on the right, I adjusted the Hue slider while leaving saturation and brightness alone. But although the colors are different from either of the other two color examples, the grayscale version is, again, just about the same. Moving the Hue slider rotates all the colors in an image simultaneously in one direction or another around an imaginary color wheel. That's why the Hue slider begins in a neutral middle position and can move 180 increments (degrees) positive (clockwise) to the opposite side of the color wheel, or a negative 180 degrees counterclockwise to the same position on the wheel. All the colors move equal amounts, so as far as Photoshop is concerned, their relationships haven't changed and the results are the same after the image is converted to grayscale.

All three grayscale images on the bottom row look alike because Photoshop doesn't take hue or saturation into account when making a conversion to grayscale using the default settings of the Mode > Grayscale or Desaturate functions. Instead, it uses an algorithm calculated to provide a workable compromise, which uses approximately 60 percent of the green component of your image, 30 percent of the red, and 10 percent of the blue. However, as you've seen in the previous examples, while this algorithm provides results that are often acceptable, the finished product is not particularly accurate. The acceptability varies from image to image. Those which rely on hue or saturation to distinguish shape and form in an image are transformed particularly poorly.

So, how did the producers of our superhero's television show choose a set of colors that would show up properly on black-and-white televisions of the day? In the TV Superman's case, George Reeves wore a gray and reddish-brown costume (not all gray, as some

CHAPTER 8

report). However, NoCopyright Man wore all gray, with the grays especially chosen to help his "colors" stand out, as you can see in Figure 8.5.

Figure 8.5
Choosing the right grays provides a more accurate representation

In the next several sections, I'm going to show you several better ways to convert from color to grayscale. We're going to use the file frutto.pcx, which shows a collection of different colored fruit, with lots of reds, oranges, yellows, greens, and a bit of blue. This veritable spectrum of plant life has lots of saturation and contrast, too. If you want to work along, locate the file on the CD-ROM. The original image and a conversion using the Mode command is shown in Figure 8.6. It's not too bad, actually, except when you examine the deep reds of the peppers near the top of the photo. They're much too dark a shade of gray.

Figure 8.6
At left, the unmodified
photo; at right,
Photoshop's default
grayscale conversion

Converting to Grayscale with Channels

If you want a pleasing rendition that differentiates all the tones cleanly, even if it isn't necessarily the most accurate version possible, using one of the color channels is a highly viable procedure. By working with the Channels palette, you can look at each of the red, green, and blue layers separately (or cyan, magenta, yellow, and black, if you're working with the CMYK color model) and choose the one that looks the best. You can make your selection visually and not have to spend a lot of time fiddling with various controls.

Using the frutto.pcx file, follow the procedure outlined next to make a color to grayscale conversion. First, make sure you're set up properly by completing the following steps:

1. Click on the Channels palette's tab to make it visible (if necessary) or choose Window > Channels from the menu bar.

2. Next, make sure your Channels palette has been configured to make your job easier. Click the flyout menu in the upper-right corner of the Channels palette and choose Palette Options. Then make sure the largest thumbnail size is selected, as you can see in Figure 8.7.

3. If your color channels are shown in color, as in Figure 8.7, you'll want to switch them to grayscale display so you can better gauge how the black-and-white conversion is going. Choose Edit > Preferences > Display & Cursors, and deselect the Display Color Channels in Color check box, as shown in Figure 8.8.

Figure 8.7
Change to large
thumbnails

Figure 8.8
Turn off display of
channels in color

Using RGB Channels

Now, let's begin to examine the colors in each RGB channel individually. Complete the
following steps:

1. In the Channels palette, click the eyeball icon next to the Green and Blue
 channels. This turns them off leaving only the Red channel visible. You
 can examine the red layer's grayscale rendition in the main document win-
 dow. You can see that the red peppers are much lighter, and so are the
 oranges underneath them. The apples and tomatoes near the bottom of the
 photo may be too light, if anything.

2. Click the eyeball column next to the Green channel to make it visible, and then click the eyeball next to the Red channel. The Green channel becomes visible all by itself. This version also looks OK in a different sort of way, except for the red peppers, which have become almost completely black.

3. Click the eyeball column next to the Blue channel to turn it on, and then click the eyeball next to the Green channel to turn it off. The Blue channel is the worst of all, because there is relatively little blue in this photo. All the fruit has turned black. You can compare the original color image and the three channels in Figure 8.9.

4. When you've decided which channel looks the best, make sure the other channels are invisible (turn off their eyeball icons if necessary) and click in the Channels palette to select the channel you want to use for the conversion.

5. Choose Image > Mode > Grayscale. A dialog box appears asking you, "Discard Other Channels?" Click OK and the new grayscale image is created using only the channel you selected.

WORKING FASTER

Hold down the Ctrl/Command key and press 1, 2, or 3 to switch between the Red, Green, and Blue channels, respectively. That's faster than clicking eyeball icons. If you're working in CMYK mode, use Ctrl/Command+4 to access the Black channel. Ctrl/Command+~ (the tilde character) returns you to the display of all the channels (RGB or CMYK, respectively).

In the previous example, the Red channel provided the most acceptable result (but just barely). In many cases, you'll find that the Green channel works best. You'll have to choose visually.

USING A COMPARISON VIEW

If you keep a second, full-color version of the image available for comparison, you'll find it easier to choose the best version. You *don't* have to create a duplicate file. Opening a new window on the same file works just fine. The channel manipulations you perform on the active window won't be applied to the duplicate window, which remains in full color for comparison purposes. Use Window > Document > New Window to create an additional view of the same document.

Figure 8.9
Top row (left to right):
the unmodified photo
and the Red channel;
bottom row: the Green
and Blue channels

Using CMYK Channels

Would we get different results if we break the image into cyan, magenta, yellow, and black layers, instead? Let's find out. Just complete the following steps:

1. Using a fresh copy of the frutto.pcx file, choose Image > Mode > CMYK Color to convert the file to the CMYK color model. The Channels palette now shows four channels instead of three, as shown in Figure 8.10.

2. In the Channels palette, view the Cyan, Magenta, Yellow, and Black channels individually by pressing Ctrl/Command+1, 2, 3, and 4, respectively. For this particular photo, none of the individual CMYK channels look particularly good. The shadow areas are uniformly a bland gray, because each shadow contains equal amounts of cyan, magenta, and yellow. The detail in the shadows is provided by the black channel. You can compare the four channels in Figure 8.11.

3. Although in this case, none of the CMYK channels look very good, that won't be true of every photo you work with. If you do find a channel you can use, you can produce a grayscale image from it as you did previously. (Turn off the other channels, make the channel you want active, use Image > Mode > Grayscale, and then discard the other channels.)

Figure 8.10
In CMYK mode, there are four color channels

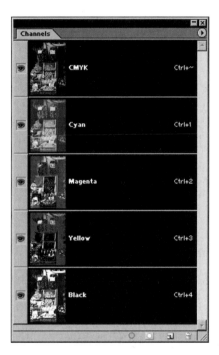

Using Luminance

Another way to convert an image to grayscale is to use the lightness, or luminance channel that's available in the mysterious Lab color mode. You may recall the Lab mode from Chapter 5, or, more likely, you've forgotten about it entirely as Lab is used so infrequently by most Photoshop users (at least to their knowledge).

Figure 8.11
Top row: Cyan and
Magenta channels;
bottom row: Yellow
and Black channels

Lab divides the color information into three components: L (for luminance or lightness), a (the colors from green to red on the color wheel), and b (the colors from blue to yellow on the color wheel). You can see a representation of the model in Figure 8.12. The vertical axis represents the lightness component, whereas the color wheel shows the distribution of the red-to-green and blue-to-yellow colors. Notice that the red/green and blue/yellow components overlap. That overlap helps explain why Lab is able to represent all colors of other color models: There are two different ways to address a particular color, and, further, the luminance value can be accessed without changing any of the hues.

Figure 8.12
In L*a*b mode, the L channel represents lightness, as shown by the vertical arrow; the a and b channels represent the overlapping red-to-green and blue-to-yellow color components

To convert our frutto.pcx photo to grayscale using Lab mode and luminance, just complete the following steps:

1. Use Image > Mode > Lab Color to convert the image into the magical world of L*a*b. (Don't worry: You can always return to Kansas by clicking your heels three times, or by using Photoshop's Undo feature.) The photo won't look any different. It shouldn't, as Lab is fully capable of reproducing all the colors of the RGB original. The Channels palette now looks like Figure 8.13.

2. You can view each of the Lab channels individually, if you want (in this mode, Ctrl/Command+1, 2, and 3 invoke the Luminance, a, and b channels, respectively). As you might guess, the a and b channels look rather strange, but the luminance channel offers a pretty good representation of the image, as you can see in Figure 8.14.

3. If you like, you can fiddle with the luminance/lightness channel by choosing Image > Adjustments > Hue/Saturation, and moving the Lightness slider.

4. You can save a grayscale version of the image as you did previously, by selecting the luminance/lightness channel (only) and choosing Image > Mode > Grayscale. Discard the other channels when asked for confirmation.

Figure 8.13
When you convert to Lab, the Channels palette looks like this

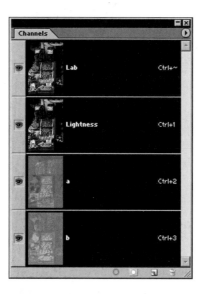

Putting Things Together with the Channel Mixer

As you've seen by now, no one solution for converting color images to grayscale is ideal. The three methods I've shown you so far allow you a bit of control as you select the channel to be used. However, you'll find there is a better way. Photoshop's Channel Mixer adjustment layer makes it easy to *combine* several channels that may each have part of the grayscale information, so you'll end up with a single channel that looks better than any of the individual channels alone.

If you look back at Figure 8.9, which shows the Red, Green, and Blue channels of our frutto.pcx file, you'll recall that the Red channel had the best image of the red peppers, but the Green channel made the oranges, apples, and tomatoes look their best. Now, we'll use the Channel Mixer to combine some of the effects of those two channels to produce a compromise that looks better than either channel alone. Just complete the following steps:

1. Choose Layer > New Adjustment Layer > Channel Mixer from the menu bar.

Figure 8.14
Top row: the
unmodified photo
and the Luminance
channel; bottom row,
a and b channels

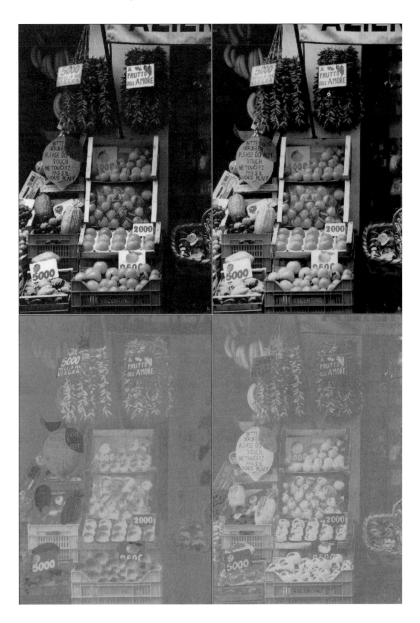

CHAPTER 8

2. Click OK when the New Layer dialog box appears, as shown at the left in Figure 8.15.

3. The Channel Mixer dialog box appears. Mark the Monochrome check box in the lower-left corner. This converts the Output Channel setting at the top of the dialog box to Gray, which means you'll be creating a grayscale image from your channel selections.

4. Adjust the Source Channel sliders until you're satisfied with the image. In this case, I used 65% for the Red channel and 35% for the Green channel. You can apply up to 200 percent of each channel, but if the total of all the settings you make is more than 100 percent, you'll also change the relative brightness of the image. You can always use the Levels or other controls to adjust the tonality later. The Constant slider brightens or darkens the overall image (much like Photoshop's Brightness control), and so should be avoided for most images (which usually don't need brightening or darkening across the board).

5. Click OK when you're satisfied.

6. Choose Layer > Flatten Image to merge the Channel Mixer adjustment layer and the underlying image layer.

7. Use Image > Mode > Grayscale to convert the image to black and white. The finished image is shown in Figure 8.16.

Figure 8.15
Add a new Channel Mixer adjustment layer with these dialog boxes

Mixing Channels with Calculations

A more advanced way of mixing channels uses Photoshop's Calculations feature. The advantage of this method is that you can use Photoshop's various blending modes to combine the channels in interesting ways. You'll need to practice this technique to learn how to visualize what the various modes do, but the Calculations feature provides you with the greatest degree of control when assembling your grayscale image.

We're going to use a different picture for this one. Find santa.pcx on the CD-ROM bundled with this book if you want to play along. The original image looks like Figure 8.17. Then follow these steps to learn what to do.

The first thing we're going to do is compare the individual color channels to see how they represent the colors in this image. I'm going to show you a new trick that will give you separate documents, each representing one of the Red, Green, and Blue channels. You'll be able to examine the individual channels' renditions at your leisure, which is an advantage when you're mixing channels using the Calculations feature.

1. Activate the Channels palette and press Ctrl/Command+1 to make (only) the Red channel visible.

Figure 8.16
The resulting grayscale
image made from the
Luminance channel

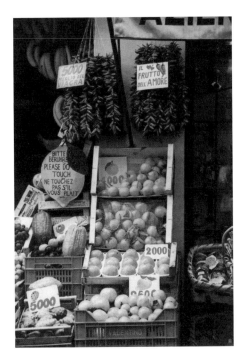

Figure 8.17
The unmodified photo
looks like this

2. Click the Channels palette's pop-up menu in the upper-right corner of the dialog box and choose Duplicate Channel from the menu. The Duplicate Channel dialog box, shown in Figure 8.18, appears.

3. In the Duplicate Channel dialog box, choose New from the Document drop-down list. This tells Photoshop to create a brand-new document from the selected Red channel. If you don't choose New, Photoshop instead discards the other channels, leaving only the Red channel in santa.pcx. This can be a handy shortcut when you *do* want to discard the other channels.

4. Supply a name for the new document in the Name box, such as Red Channel.

5. Click OK to create the new document from the Red channel.

6. Repeat Steps 1 through 5 for each of the other two channels. Don't forget the Ctrl/Command+2 and Ctrl/Command+3 shortcuts to quickly switch to the Green and Blue channels, respectively. You'll end up with three new files, each representing one of the three color channels, as shown in Figure 8.19.

Figure 8.18

You can create a duplicate of a channel in a new document

Figure 8.19
Top row: unmodified photo and Red channel; bottom row: Green and Blue channels

You can see from the different views of the color channels that the Red channel makes the girl's sweater and cap appear too light, whereas the Green and Blue channels make them look too dark. We could probably live with the Green version, if it didn't make Santa's suit appear almost black. Let's see what we can do with the Calculations feature. Follow these steps:

1. Choose Image > Calculations to produce the dialog box shown in Figure 8.20. This is the dreaded Calculations dialog box. I'm going to pick it apart for you.

 —**Source 1**. This is the name of the file we're going to use for the first channel to be combined. In this particular case, we'll be using the santa.pcx file. You *can* use a channel from an entirely different file if you want, but it must have exactly the same dimensions and color depth as the destination file. When Photoshop says it is going to *merge* two channels, it means that the channels must match in size, pixel for pixel.

 —**Layer**. This is the name of the layer where the channel resides. Our santa.pcx file has only one layer, the background layer, so that's what we'll use. You can choose other layers in an image, and you might want to in order to provide different renditions for different parts of the image. For example, we can put Santa's suit in a separate layer of its own if we want to give it special treatment. For this exercise, we won't add that extra layer (so to speak) of complexity.

 —**Channel**. This is the name of the first channel that you want to merge.

—**Source 2, Layer, Channel**. These three are the same as the items described previously, but represent the source for the second channel to be merged.

—**Blending**. These are Photoshop's blending modes, which we've already used in this book, and which we're about to use again. As you gain experience using these modes, you'll find them easier to understand, and more useful, too.

—**Opacity**. You can *partially* blend the channels by setting the opacity to something other than 100 percent.

—**Mask**. Mark this check box if you want to blend the channels through a mask, such as a selection mask you've already created. When this check box is checked (and only then), three additional check boxes appear (they're the next three shown in Figure 8.20). You can choose the name of the file containing the mask, the layer, and the channel to be used as a mask. A check box also appears that you can mark to invert the mask. If the Mask check box is unchecked, these options aren't visible.

—**Result**. This list lets you choose whether the two merged channels will become a new channel, a new document, or a selection.

2. For this image, set the Source 1 to santa.pcx, the background layer, and the Green channel. This lets us start with the Green channel, which has lots of detail in Santa's beard and a relatively dark sweater and cap on the girl.

3. Set Source 2 to santa.pcx, the background layer, and the Red channel. We're going to blend the Green and Red channels so the cap and sweater appear to be a little lighter, but Santa's suit doesn't get any darker, and his beard retains the detail.

4. Choose the Pin Light blending mode. The Pin Light blending mode first looks at the pixels in the Source 1 channel (in this case, the Green Channel). Then, it compares each pixel with its counterpart in the Source 2 channel (in this case, the Red Channel). If the Source 2 pixel is lighter than 50 percent gray, any pixels in Source 1 that are darker are used instead. If the Source 2 pixel is darker than 50 percent gray, any pixels in Source 1 that are lighter are used instead. I know this sounds like gobbledygook, but it means that the lighter sweater and cap pixels in the Red channel are partially replaced by darker pixels from the Green channel, while leaving other pixels alone. In the real world, you're often better off just trying the various blending modes to see what they do.

5. In the Result box, choose New Document to create a new image from our blended channels.

6. Click OK to apply the blending.

7. The new document will be created in Multichannel mode (as it's built from multiple channels), so convert it to grayscale by choosing Image > Mode > Grayscale. You can see the result in Figure 8.21.

Figure 8.20
The Calculations
dialog box lets you
merge two channels
together

Calculations

Source 1: santa.pcx

Layer: Background

Channel: Red ☐ Invert

Source 2: santa.pcx

Layer: Background

Channel: Red ☐ Invert

Blending: Multiply

Opacity: 100 %

☑ Mask: santa.pcx

Layer: Background

Channel: Selection ☐ Invert

Result: New Channel

OK

Cancel

☑ Preview

Figure 8.21
The merged photo
looks like this

Using Blending Modes to Create Other Grayscale Effects

Sometimes, you don't want an accurate grayscale rendition of a color photo. Perhaps you'd like to have an antique look, as if the image were created a long time ago and gradually faded over the years. In this next section, we're going to use Photoshop's blending modes to create a particular type of special effect.

If you want to learn more about Photoshop's blending modes and what they do, check out the section in Chapter 3 titled "Choosing a Brush Mode," in which I provide a list of the most common blending modes, along with a description of their effects. As you're learning, Photoshop's blending modes combine pixels in sophisticated ways. They can be used to combine channels, as we did in this chapter, when you're merging layers, or when you're applying "paint" using a brush or other retouching tool, as you learned earlier in this book. In this case, we use the Exclusion mode to produce a weathered, old-timey look to the photograph, taking advantage of the way Exclusion combines pixels.

If you want to follow along, load amphitheater.pcx from the CD-ROM bundled with this book, and follow the steps outlined next. The picture, as you can see in Figure 8.22, shows one of the entrances to a well-preserved Roman amphitheater in Merida, Spain. The photo has a few defects, such as excessive contrast and a bunch of dust spots; however, in this case, I'm going to let them be. They'll add to the antique-y look we're going for. We'll be using the Calculations feature again.

1. Choose Image > Calculations to access the Calculations dialog box shown in Figure 8.23.

2. In the Source 1 and Source 2 areas, make sure the Background layer from the amphitheater photo is selected. Unless you've added layers to the image, this is your only choice, in fact.

3. For Channel in Source 1, select the Red channel. We'll be using it as the base channel for the merger.

4. For the Channel in Source 2, select the Green channel, making it the blend channel.

5. For Blending, choose Exclusion from the drop-down list.

6. For Opacity, choose 50 percent. This blends the Red and Green channels evenly, using the rules of the Exclusion blending mode.

7. In the Result box, choose New Document from the drop-down list. This creates a new image containing the blended photo.

Figure 8.22
We're going to age
this photo

Figure 8.23
This time we'll use
the Exclusion mode

8. Click OK to create the new document, which should look similar to
 Figure 8.24.

9. As before, the new document is created in Multichannel mode. You'll want to convert it to a grayscale document by choosing Image > Mode > Grayscale to create a valid document.

10. Save your file, and then read on to see what happened.

Figure 8.24
By merging the Red and Green channels, we created a faux antique photo that has a lean and hungry (and faded) look

You may find this technique especially helpful for old photos that actually *are* faded. There's no way you can resurrect them to their former glory, especially if they are color pictures that have turned some awful shade of magenta or green. So, you might as well adopt an "I *meant* to do that!" attitude and have your viewers wondering exactly how you achieved your magical effect.

What happened to our Roman amphitheater? Exclusion mode is a special variation on Photoshop's Difference mode. The Difference mode examines the brightness information of each channel, and subtracts one from the other, depending on whichever is brighter. That sounds confusing, but it's not difficult to understand if you think in terms of individual pixels.

Figure 8.25 is a sort of visual metaphor for what happens when we use Exclusion mode to combine the red and green layers. The top, Red channel is Source 1. The bottom, Green channel is Source 2. When blending pixels, Photoshop looks at a particular pixel in the Source 1 base (Red) channel and compares it with the same pixel in the Source 2 blend (Green) channel.

In Difference mode, the sire of Exclusion mode (so to speak), if a pixel in the Source 1 or Source 2 channel has a value of 150 (it doesn't matter in which channel the pixel resides) and the same pixel in the other channel has a value of 50, the result is a new pixel with a value of 100. Photoshop takes the value of each pixel and finds the difference between them, and uses that result as the value for the final, merged pixel.

To visualize how pixels are flipped, imagine a pixel in either channel that is completely white (that is, its value is 255). The result pixel is always a darker pixel, because 255 minus *anything* will be darker than pure white. For example, if the alternate pixel is very dark, for example, 10, the result pixel is 245, which, while it is almost white, is not *pure* white. The lighter the other channel's pixel is, the darker the result is. A very light pixel with a value of 230 yields a very dark pixel with a value of 25. And the inverse is true, as well. A dark base pixel yields a light blended pixel. Difference mode on its own produces an image that looks much like a photographic negative.

Exclusion works similarly to Difference mode, *except* that it converts any mid-toned pixels to gray, creating a final image that isn't a negative, but is something in between negative and positive, with the kind of reduced contrast that smacks of a faded, old photograph. Indeed, that's why I specified a setting of 50 percent for the blend in the previous exercise. When you apply Difference mode 100 percent to our amphitheater picture, you end up with a strange, solarized look, like that in Figure 8.26.

Figure 8.25
When Photoshop blends pixels, it looks at the corresponding pixel from each channel or layer, and performs calculations based on the rules for that blending mode

Next Up

We look at other grayscale and color effects you can apply to both color and black-and-white photos in the next chapter, which looks at techniques for creating colorizations, duotones, and tritones. The techniques in Chapter 9 are, in a way, the reverse of the ones I showed you in this chapter. You'll learn how to create color effects from photos that originated as black-and-white pictures, and how to produce interesting color looks from pictures that may have begun their lives as color photos, too.

Figure 8.26
When Exclusion mode
is applied 100 percent,
you get this weird,
solarized look

9

Creating Duotones, Tritones, *n*-tones, and Colorizations

"The world is not black and white. More like black and grey."

The *London Observer* thought enough of that cryptic quote by Graham Greene (the dead British novelist, not the living Native American actor) to publish it, leaving us to wonder whether Greene was talking about morality or English weather. But no matter. Greene's quotation applies well enough to the realm of photography, too. Some of the most interesting images in our photographic heritage are not really black-and-white pictures, although that's what we call them. The best work by Ansel Adams, Dorothea Lange, or Edward Weston generally have more deep blacks and rich, nuanced tones of gray in them than actual white. The blacks, the grays, the shadows, the midtones—all have a power that gaudy colors and blank, empty whites do not.

That's why black-and-white, still photography remains a strong medium today, and modern movies from *Schindler's List* to *The Elephant Man* are still produced in monochrome. Some say grayscale strips the image down to its bare essentials; others say black and white allows the communication of messages without the misleading emotions that color adds.

There are plenty of good reasons to use black-and-white images. You may want an old-timey look to your photos. Or, perhaps your picture is destined for print in black and white in a newspaper or magazine. In some cases, color can be distracting, leading our eyes to a big, yellow blob that has nothing to do with the picture. Color can destroy a mood. Many times, your reason for working with a grayscale image may be as simple as the obstacles of working with the faded colors of an original picture.

In the last chapter, I showed you how to convert color images *into* black and white. Now, it's time to learn some ways to enhance photos that are already colorless (so to speak), creating interesting variations that are not black and gray but, instead, shades of brown, blue, or another hue: duotones, tritones, and *n*-tones. I'm also going to show you ways to spice up grayscale photos with full or partial colorizations. Sometimes, a little color can go a long way.

Working with Multiple Tones

Some people can't leave well enough alone. Why take a perfectly good black-and-white photograph and daub it with fake colors? If that's all we did, it would indeed be a dumb idea. However, just as a plain grayscale photograph can make a powerful unadorned image, adding a little color can take advantage of the inevitable ways that a little tint can color our viewpoint. The next couple projects show you just how far you can go with only a limited amount of color.

A Spoonful of Color…

We view with our eyes, but see with our brains. For reasons well-known to color scientists, but a mystery to those of us who skipped that class in physics (or was it Psych 101?), we see certain colors in certain ways. Particular hues evoke particular moods. Some are easy to fathom: We see reddish tones as "warm" and bluish casts as "cool." Anyone who's snuggled up to the glowing embers of a fireplace or frozen their feet tromping through snow on a moonlit night can figure that one out.

Physiologists have even discovered that reddish light makes our blood pressure, heart beat, respiration, and eye blinking increase, whereas blue light reduces them. Less obvious are the reasons why pink is calming and yellow alarming. Nor can we explain cultural differences; in the West, red means rage and white is the color of a joyous wedding; in China, red means happiness and white is associated with funerals. Clearly, we have a lot to learn.

If you want proof, look at the three images in Figure 9.1. Which one is more realistic?

Figure 9.1
Which of these three images looks more realistic to you?

Viewed side-by-side like that, probably none of the trio really looks like an actual snow scene. The garish, green version at far left could pass, perhaps, for a "snow on Venus" sci-fi rendition. The sepia-toned image in the middle might be an old-timey winter photo

if a sleigh and a few Norman Rockwell folks in long scarves were shown. The blue version at right might remind you a bit of a snow scene—but only if you covered up the other two. Viewed together, our winter triptych looks more like a holiday greeting card from Andy Warhol than anything else. Let's see what we can do with this picture. Retrieve snow.pcx from the CD-ROM bundled with this book. The original is shown in Figure 9.2. Unfortunately, it's in full, glorious color, which sort of thwarts our colorization aspirations. We can fix that.

Figure 9.2
Here's the full-color version of our snow scene

The first thing to do is change this to a black-and-white image, using the techniques we learned in Chapter 8, "Creating Great Grayscale Photos from Color." This only takes a second, but I'll list the steps for you anyway. We're going to convert one of the three RGB color channels to a grayscale image. (You need not have read Chapter 8 to proceed, but if you want explanations of what's going on here, you'll have to review those pages.) Just follow these steps:

1. Activate the Channels palette. If it's not visible already, click its tab or choose Window > Channels from the menu bar.

2. Hold down the Ctrl/Command key and press 1, 2, and 3 in succession. The full image cycles through the Red, Green, and Blue channels one by one. View the channels to see which one looks best. We want the blue sky to look as dark as possible, so the red layer should be your choice. The Red channel has lots of detail in the shadows, and the sky is reasonably dark.

3. Make sure the Red channel (and only the Red channel) is highlighted. If eyeball icons appear next to any of the other channels, click the eyeball(s) to deactivate them.

4. Choose Image > Mode > Grayscale. A dialog box appears asking if you want to discard the other channels. Click OK to banish the green and blue information from the photo forever. You'll end up with the grayscale image shown in Figure 9.3.

5. We're going to be *adding* color, so you'll need to choose Image > Mode > RGB Color to give us a grayscale image ready for adding color.

Figure 9.3
This grayscale version is actually a little more interesting than the original color photo

Now, we've got our grayscale image and are ready to spice it up with a little color. Just follow these steps to produce a moonlit winter scene:

1. Choose Image > Adjustments > Levels, and when the Levels dialog box (shown in Figure 9.4) appears, move the black slider toward the right, so the overall tones become darker, as if it were night. If you've been watching old Zorro reruns on the Disney channel recently, you'll recognize the "day for night" trick cinematographers used to film night scenes during broad daylight before the advent of extra-sensitive motion picture films.

Figure 9.4
Now it's really starting to look like night!

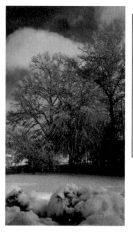

2. Press B to activate the Brush tool, choose a large, soft-edged brush (I chose the 65-pixel brush), and then paint over the upper-right corner of the image with black to make the night sky a little less cloudy.

3. It's time to add our blue tint. Choose Image > Adjustments > Hue/Saturation to produce Photoshop's Hue/Saturation dialog box.

4. Click the Colorize check box so the hue you're about to add will apply to the entire image. Then set the Hue slider to about 216. Leave the Saturation slider at 25, and move the Lightness slider to -12. You can use a lower saturation setting to make the effect a little more subtle. I used 25 percent so the effect would show up clearly on the printed page. Anything higher than 25 percent is likely to make the image too garish.

5. You'll end up with an image that really does look like it could have been taken at night under a full moon, as you can see in Figure 9.5.

Figure 9.5
Our moonlit scene
lacks only a moon

If you like, you can add a moon and make the sky resemble a night scene even more. Grab your CD again, and copy moon.pcx to your hard disk. Then follow these steps:

1. Open moon.pcx and then press W to activate the Magic Wand. Click in the black area outside the moon to select the sky, and then press Shift+Ctrl/Command+I to invert your selection. Only the moon will be selected.

2. Press Ctrl/Command+C to copy the moon selection, click the snow scene, and then press Ctrl/Command+V to paste the moon in the photo.

3. The moon will be a lot larger than you need, so choose Edit > Scale, and drag the handles that appear around the moon to make it about the size you see in Figure 9.6. That's still larger than it would appear in real life, but we all know the moon can really loom huge in Halloween pictures, so we'll use a little artistic license.

4. With the moon layer still active, choose Image > Adjustments > Desaturate to change the moon image to grayscale. But now, there's a big problem with the image. See if you can spot it. Ah, yes. The moon is *in front* of the clouds, which wouldn't happen in real life. (See Figure 9.6.) We don't

CHAPTER 9

want to move the moon higher into the sky, because it would spoil the composition. So, instead, we'll mute some of the clouds.

Figure 9.6
Uh-oh—the moon has somehow gotten in front of the clouds

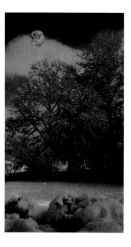

5. Press S to choose the Clone Stamp tool, and then choose a large, soft-edged brush (I used the 65-pixel brush again). Set the Opacity in the Options bar to 25 percent so we can create some wispy, semitransparent clouds.

6. Select the background (snow scene) layer, and then hold down the Alt/Option key and click in the dark sky above the moon. Then, gently paint around the moon so the clouds no longer appear directly behind it, as shown in Figure 9.7. Luna now looks as if it's peeking through the clouds.

Figure 9.7
Now the moon is behind the clouds

7. To make the image realistic, we'll need some clouds in *front* of the moon, too. Select the moon layer and then choose Layer > New Layer to create a new, transparent layer above the moon.

8. With the Clone Stamp tool still active, Alt/Option-click in the snow scene's layer in the Layers palette. Use an open cloud area so you can copy some cloud pixels into your new, empty layer.

9. Click the new, empty layer in the Layers palette, and then paint some wispy clouds over the moon. Your image should now look almost like Figure 9.8. (I'm going to make one small addition that might not show up on the printed page.)

There are lots of ways to customize from this point forward. You can use the Image > Adjustments > Brightness/Contrast controls in the moon's layer to make the moon brighter or dimmer. Select Filter > Blur > Gaussian Blur to smear the moon a little, or set the Opacity of the moon in the Layers palette to less than 100%. (The Opacity slider is in the upper-right corner of the palette.) You could even apply the Image > Adjustments > Hue/Saturation command to colorize the moon to a deep indigo (but do this only once in a blue moon).

I added one more step that's going to be difficult to show on the printed page, but it looks nice in the image.

1. With the moon layer active in the Layers palette, choose Layer > New Layer and create yet another empty transparent layer.

2. Press D to make sure Photoshop's default colors are black and white, and then choose Edit > Fill. When the Fill dialog box appears, make sure Foreground Color is selected in the Contents area. Deselect the Preserve Transparency check box if it is checked, and change the Opacity to 40 percent. Then click OK. The new layer fills up with a 40 percent gray.

3. Then, choose Filter > Noise > Add Noise. When the dialog box appears, choose Gaussian in the Distribution area, select the Monochromatic check box, and use about 25 percent as the value for the noise you'll be adding. The noise will appear in your image as a sky full of stars.

4. Unfortunately, the foreground is full of stars, too. Press E to choose the Eraser tool, and use a large brush to erase all the stars from the densest clouds, the trees, and the foreground. You can leave some stars in the wispiest clouds, as if they are showing through.

Partial Color

Partial color, in which most of the image is grayscale, but a single object appears in full or pastel color has almost been overused lately in films, television commercials, and TV shows. I think they must be teaching it as a trendy effect in film schools. You've seen the effect: Someone in a commercial walks through a black-and-white world, but are themselves shown in full color. Or, in the television series, the hero is completely color blind, but sees isolated objects in full color. For a full-length treatment of this effect, you need only look as far as Tobey "Spiderman" Maguire's 1998 film *Pleasantville* in which a sitcomlike black-and-white suburban town gradually turns to color, (literally) bit by bit.

CHAPTER 9

Figure 9.8
Your finished night
snow scene will look
like this

This is an easy one. All you need to do is create grayscale and color versions of the same image on separate layers, and then erase the color anywhere that you want the black-and-white version to appear. I'll lead you through the steps anyway, so you can see just how simple this effect is. You can use any picture, but it helps to have one in which the subject can be isolated from a reasonably detailed background by means of color. Don't choose something like a portrait with a plain colored background. The viewer will have no way of knowing that it wasn't taken with a black or gray backdrop. We'll use the photo shown in Figure 9.9. You can find pumpkin.pcx on the CD-ROM bundled with this book. As you can see, one of the main things this photo has going for it is the huge mass of orange pumpkins. We can make that work for us. Just follow these steps:

1. Make a duplicate of the image and create a grayscale version using the technique outlined in Steps 1 through 5 in the very first list of instructions in this chapter. Use the Green channel; the Red channel is too light, and the Blue channel is very, very dark. Don't forget to convert your grayscale image to RGB as your last step. Your image should look similar to Figure 9.10.

2. Switch to the original, full-color image and press Ctrl/Command+A to select the entire layer. Then press Ctrl/Command+C to copy it.

3. Switch back to the grayscale version and press Ctrl/Command+V to paste the color layer down on top of the grayscale version. If you remembered to change the black-and-white file to RGB, the color and grayscale images will peacefully coexist.

Figure 9.9
These jack-o-lanterns-
to-be seem to be saying
"Pick me!" How can
one aspirant stand out
over the others?

Figure 9.10
Dark and foreboding
pumpkins…

CHAPTER 9

4. In the color layer, use your Eraser tool to erase everything that you *don't* want to appear in full color, creating your own *Pumpkinville* scene like the one shown in Figure 9.11.

Figure 9.11
Erasing everything but these three pumpkins creates this view

You don't have to stop there, of course. Here are a few variations I prepared:

▶ Frequently, partial-color images are presented with the color portions in pastel tones. You can accomplish that by using the Opacity slider in the Layers palette to adjust the transparency of the color portion, as you can see in Figure 9.12.

▶ Use the Image > Adjustments > Hue/Saturation command to colorize the grayscale layer and produce Pumpkins from Mars to visit their Earth cousins, as shown in Figure 9.13.

▶ Colorize the grayscale version so it's a deep brown or orange, and then apply the Filter > Distort > Diffuse Glow filter to give the majority of the pumpkins a different look, as you can see in Figure 9.14. The grainy "background" pumpkins stand out next to the unmodified bright orange pumpkins.

Figure 9.12
Try out a pastel effect

Figure 9.13
Create some Pumpkins
from Mars

CHAPTER 9

Figure 9.14
Provide a subtle texture
difference between
your pumpkins

Creating *n*-tones

You probably think you know about duotones—images that incorporate several shades of the same color to create a monochrome image. You may even have some guesses about tritones, quadtones, and hexadecimaltones. They're just more shades of the same color, right? You can use this technique to create sepia-toned, old-timey photographs, eh?

Ah, close but no cigar. First, duotones are *not* necessarily (or even frequently) images with two similar tones. Anyway, if all you wanted to do was create a brownish (or bluish, or whatever) image, you could do that with the Image > Adjustments > Hue/Saturation dialog box.

The duotone process was created for a different, more technical, and highly useful reason: to overcome the limitations of the printing press. You've probably seen duotone or tritone techniques used in photographic art books and didn't even know what you were looking at. After all, the images therein weren't necessarily sepia or blue. They might have been in plain old grayscale—you think.

Duotone enables printers to create images that more closely resemble photographs despite the restrictions of the printing press. A scanned grayscale photograph may contain 256 different tones when we view it on our computer monitors. But when it comes off the press, it may have only 50 different levels of gray. You see, the printing press

doesn't have 256 different shades of ink to use for black-and-white photos. It must, under ordinary circumstances, rely on just one color: black. The image is broken up into tiny halftone dots, and the differing amount of white space between them fools our eyes into *thinking* we are seeing gray.

This phenomenon is similar to what goes on when you think you see a person with gray hair. There are no gray hairs. There are only brown, or black, or blond, or red hairs and white hairs. The more white hairs a person has, the grayer their hair appears, until, eventually (for some of us) the hair is completely white.

The size and number of the little white dots used to simulate gray by a printing press is limited by several factors, including how much the ink soaks into the paper to fill in the white space (called *dot gain*), and the resolution of the halftone screen used to create the printing plate. A newspaper may be printed using an 85 line screen (about 85 dots per inch), whereas the very best art books might use a 300 line screen (think 300 dpi). Recent technologies have made the equivalent of 380 line screens possible. These screens are combined with whiter paper (so the white spaces aren't themselves on the gray side) and direct computer-to-plate techniques for improved quality. There are even methods that use randomly scattered microdots in a process called *stochastic printing* instead of line screens to yield excellent results.

Duotones are a reliable, proven method of improving image quality on the press. With a duotone, the image is printed both with a black ink (or an ink of some other color) for the shadows and, usually, a lighter ink in the same or similar color (such as a gray ink) to provide detail in the highlights. Frequently, the second ink is colored, producing an image with a tint. More than two inks can be used to create tritones, quadtones, or *whatever*tones. Each additional color of ink adds 50 levels of gray to the number used to reproduce the image.

The duotone process not only increases the quality of a printed monochrome image, it can be an economical alternative to printing in full color when a client wants a classy image, but can't spring for printing using the cyan, magenta, yellow, and black process color inks. A duotone can be printed using black and one spot color, giving you an image with more depth and punch at a lower cost than full color.

Creating a Duotone

We'll start by creating a duotone. Tritones, quadtones, etc. are merely a matter of adding more colors. Find gangsters.pcx on your CD-ROM and then follow along with these steps. The original image is shown in Figure 9.15.

Figure 9.15
These ugly mobsters
seem to be seated in a
Roaring 20's parlor

1. Open the gangsters.pcx file and choose Image > Mode > Duotone to convert it to full color. The Duotone Options dialog box, shown in Figure 9.16, appears.

2. The Type box shows Monotone, which is what the grayscale image currently is. Note that the Ink columns under the Type box shows only one ink being used, black. Choose Duotone from the Type box. (Tritone and Quadtone are also available here for when you decide to get fancy.) A second Ink row becomes active. You can now choose the two inks that you want to use. You can choose gray ink to accompany the black to produce an ordinary duotone. We're going to colorize the image by using two inks, neither of which is black. The box in the second column shows the current ink chosen. In the second row, because no ink has been chosen yet, that box is white and the name of the ink in the third column is blank.

3. Click in the white box to summon the Custom Colors dialog box, shown in Figure 9.17. There are lots of things to choose from this dialog box, so I'll go over them one by one.

 —Under Book (so called because printers use books of swatch samples for reference), you'll find a bewildering array of names of color models. These represent standard spot color inks printers can choose from. Their clients can specify a particular color by name, and the printer will know what is meant. Not all printers use all these systems. In fact, many standardize on Pantone's various offerings. There are others, such as ANPA (American Newspaper Publisher's Association) and the Trumatch system. Pantone's default colors come up, so that's what we'll use.

—Underneath the Book list are a series of color swatches, showing a scrolling list of color choices. The list is very long, and the particular range of colors you are looking at is shown by a marker in the color slider to the right of the swatches.

—The color slider can be moved to quickly change to the range of colors you want to use. Click the arrows at top or bottom to move quickly through the spectrum, or move the slider arrows themselves. You can also begin typing the name of the color, if you know it, to jump quickly to that color (try typing Red, Green, or Blue to see what happens).

—The current color and the patch you've selected are shown in swatches to the right of the color slider, and the values for the color model are listed underneath that.

—There's a Picker button you can click if you'd rather use the Photoshop Color Picker to choose a color. However, your choice will not correspond to one of the standard colors from one of the books and their swatches, so you would not be able to print your image using those standard colors.

Figure 9.16
Set your Duotone options

4. I chose Pantone 1495 C for the highlight color for my duotone, as I wanted to create a sepia-toned image. You can choose another color if you want.

5. Click OK to apply the hue. At this point, the image is shown in black and sepia-orange.

That's a good choice, because the black provides the detail and the sepia adds the color effect. Choosing another color to replace black, even a very dark brown, yields a washed-out effect with not enough detail. In Figure 9.18, the left half is shown in black and sepia, whereas the right side is dark brown and sepia. Not nearly as nice an effect, you'll agree.

Figure 9.17
Choose your
colors here

However, you *can* control the amount of each ink applied to the image by using the Duotone Curve dialog box (shown in Figure 9.19) that pops up when you click in the first column next to each ink's row. You can make any of the changes you would using Photoshop's ordinary Curves command, except the tonal modifications apply only to the particular ink you are adjusting. Don't worry about fooling with the Curves if you don't have experience using this command; in most cases, the default values work fine. Our finished duotone is shown in Figure 9.20.

Figure 9.18
At left, black and
sepia; at right, dark
brown and sepia.
Obviously, black is
needed for detail!

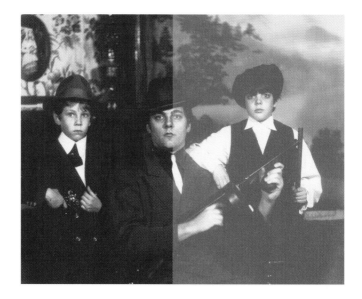

Figure 9.19
Control the amount of
each color ink applied
with this dialog box

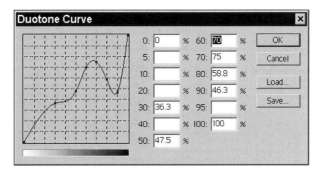

Figure 9.20
The finished duotone
looks like this

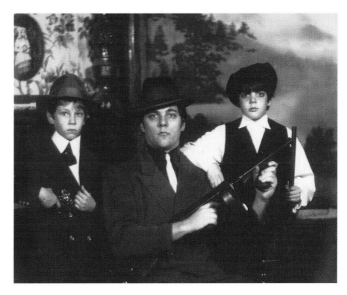

Tritones, Quadtones, and Beyond

Theoretically, I could have skipped this section and simply told you that tritones and
quadtones are just duotones with more colors. But there are plenty of Photoshop books
that tell you that. Certainly, you can create tritones and quadtones in that way, but I'd be
remiss if I didn't show you some of the things you can do. I won't be providing step-by-
step instructions here, just some examples and an outline of what I did.

For example, Figure 9.21 is a quadtone using black, sepia, red, and a dark beige, with the
Curves manipulated to partially invert some of the tones, as you can see in the first col-
umn of the dialog box in the figure. You can create some spectacular psychedelic effects
using this feature.

Figure 9.22 is a more traditional quadtone, using one of the Pantone presets supplied with
Photoshop. In the Duotone Options dialog box, click the Load button and navigate to the
Presets folder in Photoshop, where you'll find some folders full of duotone/tritone/quadtone
presets. I applied the preset to a portrait that had been dappled using one of Photoshop's

filters. Although the subtle tones won't show up on this printed page, I wanted to mention this capability so you could experiment with the canned settings yourself.

Figure 9.21
Manipulate the Curves to get a psychedelic effect

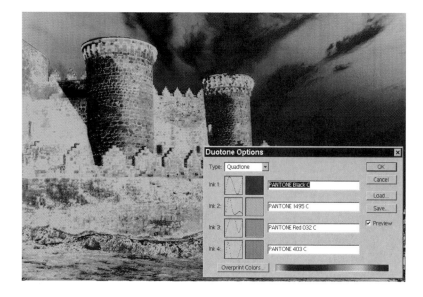

Figure 9.22
This is a more traditional quadtone, using presets supplied with Photoshop

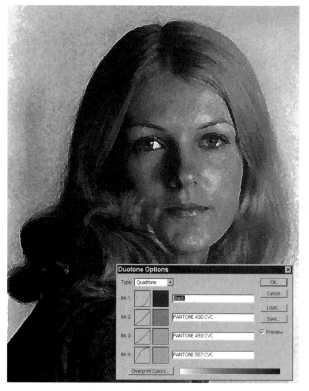

Colorizing Images

The modern system of computerized colorization was invented by a fellow named Wilson Markle, who probably didn't realize the controversy for which he would be responsible. The process was first used in 1970 to colorize some Apollo moon landing footage (Neil Armstrong forgot to pack the color film), and was seen as having great promise in creating "new" television series from old black-and-white shows that couldn't be syndicated easily in their present form. The idea apparently fizzled, because the only series it was seriously applied to turned out to be McHale's Navy.

Ted Turner began the waves of controversy by colorizing some of his library of old black-and-white films, which included classics from MGM Studios and RKO. Movie critics screamed their heads off when *Casablanca* was colorized, spurring the establishment of the National Film Registry, which was created by Congress to select films that *couldn't* be colorized without being accompanied by a disclaimer. By 1995, the interest in colorization seemed to have vanished, along with the controversy.

In the still photography world, no such moral issues exist. No one would seriously suggest colorizing some Ansel Adams landscapes. Instead, colorization is used as an artistic outlet or as a practical matter. Perhaps the picture is a personal photo of a relative, taken before color film was widely used, and you'd like to colorize it. Or, you may come across a monochrome image that would look even better in color. Sometimes, colorizing can provide a new look you can't really get with color film.

Hand-tinting with oil paints was popular in the '50s and before as a way of creating color portraits. I can still remember the screams when my mother saw her first colorized portrait of me. There I was, two years old, with my red hair and green plaid shorts when, in fact, my hair was brown and the shorts red plaid. Colorization can not only add a realistic or artistic touch to a grayscale image, it can create a color scheme that didn't exist in real life.

In this section, we're going to use a black-and-white picture of a porcelain basket of flowers, shown in Figure 9.23. It's quite appropriate that we use Photoshop to add color to this particular image, because the flowers in question were themselves hand-painted by an artisan in Valencia, Spain. We'll use Photoshop to add the yellow centers to the white flowers, which rest in a brown basket surrounded by green leaves and a light blue porcelain "cloth." If you want to work along, find flowerbowl.pcx on the CD-ROM accompanying this book.

Figure 9.23
This basket of porcelain flowers has delicate pastel hues that don't show up in this black-and-white photo

1. Load your grayscale image flowerbowl.pcx into Photoshop.

2. Choose Image > Mode > RGB Color to convert the grayscale image to a full-color image (even though it presently still lacks any color).

3. Choose Layer > New Layer. This creates a new transparent layer to paint on. Although you could paint directly on an image layer or a copy of an image layer, using an empty layer is safer and gives you more flexibility in backtracking when you make a mistake.

4. Select the Overlay mode from the Modes drop-down list in the Layers palette, as shown in Figure 9.24. This blending mode is used by Photoshop to combine the painting layer with the image layer underneath, and lets you apply colors on top of the detail in the grayscale image without obscuring it entirely.

Figure 9.24
Choose the Overlay mode to blend the color layer with the grayscale image underneath

5. Select a color, such as green for the leaves, or yellow for the flower centers, from the Swatches palette.

6. Click the down arrow next to the Brush icon in the Options bar and choose a small, fuzzy brush from the array shown in Figure 9.25. (The top row shows hard-edged brushes; the soft-edged brushes start in the second row.) You might want to start with a 9- or 13-pixel-wide brush.

7. Paint over all the parts of the image that contain that color. If you make a mistake, you can erase the misstrokes without affecting the underlying grayscale image, as you're painting on a separate transparent layer.

8. Change brushes as necessary by clicking the Brush icon in the Options bar and choosing a larger or smaller brush. You can also make your brush larger or smaller one size at a time by pressing the left and right bracket keys on your keyboard.

9. When you've finished with one color, choose another color in the Swatches palette, and paint those areas of the image.

10. When you're finished, you can experiment with different opacity levels for your colorized layer to see if more transparent hues might look better. The painted overlay layer for a half-finished example might look like Figure 9.26.

Figure 9.25
Select a small,
soft-edged brush

Figure 9.26
The color layer and
underlying grayscale
layer look like this

For added control, try painting each color on a separate transparent layer. You can then adjust the opacity of each layer separately to get the exact color scheme you want. You can even fiddle with parameters such as saturation to get the exact effect you want. The finished example, with slightly more muted (and realistic) colors, is shown in Figure 9.27.

Figure 9.27
Here's our bowl,
colorized

Next Up

You'll be able to apply everything you've learned so far in Part II to the next chapter, in which I show you how to make photo restorations. You'll learn how to fix tears, camouflage cracks, and minimize stains. You can even create whole new backgrounds if you need to.

10

Photo Restorations

Ah, finally you've reached your last year of medical school! You've completed your rotations in reconstructive surgery (simple retouching), dermatology (retouching portraits), and worked your way through elective surgery (converting color to grayscale, and back). I've saved the best for last. Welcome to the ER. Here's where you'll find photographs that are on their last legs. Many of them are only a pale reminder of their past selves and there's some doubt that you'll be able to save them. Even so, photo restoration can be one of the most interesting and rewarding of the whole panoply of retouching tasks. Not until you've brought someone's faded grandmother back to vibrant life will you understand exactly how useful your newly gained retouching skills can be.

In this chapter, we're going to tackle a variety of old pictures, using what we've learned so far, plus some new skills and tricks, to create new pictures from old. You'll learn how to mend torn photos, fix wrinkles and folds, remove halftone patterns, and restore faded photographs. Once you can handle the challenges in this chapter, you'll be ready to hang that PhD (Photo Doctor) diploma on your wall.

Why Restore?

There are many reasons why photographs need to be restored. First and foremost is the fact that the photographs themselves don't age very well. Remember, the images were captured on materials that were designed to be sensitive to light. After a piece of film or paper has been developed, theoretically that sensitivity is supposed to cease. It just doesn't work that way. Perhaps a black-and-white print wasn't washed enough to remove all the processing chemicals from its surface. Those chemicals can cause stains as the print ages.

Or, consider that color images derive their color from different colored dyes. We all know from experience that dyes fade and colors change, especially when exposed to sunlight. Compare the drapery in the north and south windows of your home, or perhaps some carpet in your family room that gets a daily visit from Mr. Sunbeam. So, too, do color prints that are exposed to light fade over time.

Of course, color prints will also fade if you keep them locked in a drawer. The longevity of color photos is tracked by color scientists in terms of both their "light keeping" and "dark keeping" characteristics. It's even possible to predict how much a particular picture will fade over time, when the storage conditions are known, using complicated-sounding math involving something called the *Arrhenius equations*. All you need to know is that fading is inevitable, so you'd better be prepared for it. Although conventional color photographic materials are more stable today, they are rapidly being supplanted by prints made with inkjet printers, which, unfortunately, themselves fade on a schedule entirely predictable by Dr. Arrhenius' math.

Photographs also are susceptible to physical damage. Prints are folded or torn. They are carried around in wallets and become scuffed. Water splashes on them. Mold grows on them. Bugs think the gelatin used in their emulsion tastes good. People place their photos in scrapbooks with clingy overlays that trap moisture or stick to the print through some wacky migration of the molecules. A lot of this physical damage can also plague color slides and negatives, too. Eventually, over sufficient time, virtually every photograph is going to suffer some sort of damage. The only near-exception to that rule are archival prints produced using special methods on special papers, and stored in ideal environments. Most of us don't have the time or money for such preventive measures.

Instead, we must deal with several corollaries to Murphy's Law:

> ▶ The more important or valuable a photograph is, the less likely that the original negative used to make it will be available. Negatives tend to stand up to the rigors of time better than prints, so the simplest form of photo restoration is simply to take the original negative and make a new print. Store the negative in a cool, dark, nonhumid place, and you can keep doing this every 25 years for a thousand years or so. However, in the real world, most people manage to lose their negatives on the way home from the minilab. Film vendors have done their best to help us keep our negatives (to make it easier to reorder extra prints), but we lose them anyway. If a picture is really, really important, the negative was probably eaten by the family dog or used as kindling in the fireplace.

> ▶ If a photograph is really, really important, the copy you have will be the only copy in existence, and it will be damaged in some way. I've *never* seen an instance where somebody had a spare copy of an important picture. A few years ago, a fellow in New York turned up what appeared to be the earliest known photograph of Abraham Lincoln and—you guessed it— it was the only copy and, worse, they didn't even *have* negatives back then. Once you begin working on photo restorations, be prepared to handle precious or priceless images on a regular basis.

Avoiding Restorations

Remember Bruce Lee's art of fighting without fighting? The easiest way to restore a photograph is to avoid the need for it in the first place. In the past, that meant cataloging and storing your negatives and slides, and keeping them in a safe place. Of course, safe places can burn to the ground as easily as unsafe places, so, even if you resorted to a safe deposit box in a bank, your photos weren't really protected from damage 100 percent.

However, in the digital age, we have another option. First, an increasing percentage of photographs are created by digital cameras, and stored on digital media. Such photos are converted to analog media, such as prints or film, only when the photographer wants a print or needs a digitally created color slide for submission to a client or publication. Nobody really cares what happens to these prints or slides: The digital original can (theoretically) be kept safe from harm and a new print or slide produced at any time.

Second, most of us now have the capability to preserve our conventional prints and slides in digital form, thanks to the ready availability of scanners and CD burners. Here are some tips on how to avoid restorations by permanently archiving your own digital and scanned images:

- ▶ Digital camera images should be backed up just like scanned images.

- ▶ When scanning prints or slides, use a scanner resolution that's slightly higher than you think you might need. This helps ensure that you have as much of the detail of the original as possible. For example, you'd rarely need to scan a photograph at more than 200 samples per inch (spi) for most reproduction purposes, but when scanning for archiving, you might want to use 300 spi or a little higher. You'll end up with larger file sizes, but the files will reside on a CD-R, CD-RW, or a recordable DVD, anyway. Media is so cheap, it's OK to waste a little space to get higher resolution.

- ▶ As you scan, take the time to manipulate the scanner's controls to get the best color and tonality you can, rather than planning to fix the photo in Photoshop. For a critical photo, the original image source is the best source for archiving.

- ▶ Even if you fix up the photo in Photoshop, archive an unmodified version. I have some scans I made back in the early 1990s that could be fixed even better than I did back then, using today's technology and techniques. But, alas, I "fixed" them then and don't have a copy of the "original."

- ▶ Consider scanning some grayscale images in full color, particularly if there are stains on them. You may want to use color editing techniques to fix those stains in the future.

- ▶ Don't archive onto magnetic media, such as Zip disks. Such media costs more than optical media, such as CD-Rs, and is more susceptible to damage.

- ▶ If possible, make a copy of each archive CD or DVD that you make, and store them in different locations. I make at least three copies of my important photos. I keep one handy by my computer, a second in a fireproof safe in my basement, and a third off-site.

▶ Remember that even optical media won't last forever. Plan to make a fresh copy in five or ten years. Digital data remains bit-for-bit perfect as long as the media is intact, but CD-Rs and CD-RWs, especially, may degrade over time. Nobody knows for sure how long they'll last, so you should take no chances.

▶ Count on migrating your current digital photo files to new digital storage media in the future. At one time, I had all my images from 1987 onward stored on 1.44 MB floppy disks. I still have those disks, but copied most of them to CD-R in 1996. Eventually, I'll copy the CD-Rs to DVD or whatever comes next. Unfortunately, the stuff I didn't move from my 8-inch and 5 1/4-inch floppy disks is probably gone forever.

▶ You can assume that, at least through the DVD age, drives will remain backward compatible with CD-ROM formats. Even when everyone is using DVDs, you'll still be able to read your old CDs. However, their 700 MB capacity will seem laughably paltry in a few years.

Scanning Your Photos

Whether you're scanning prints or negatives as fodder for composites, grabbing images so you can retouch the defects, or simply scanning treasured photographs so they can be archived safely, the process is easy (although time-consuming).

Just about any scanner (even those under-$100 models you see on sale) does a decent job with prints. Even though low-end scanners rarely deliver the image quality and resolution they claim, it usually doesn't matter that much. You'll rarely need to use resolutions higher than 200 samples per inch for photographs, so the difference between a 600 × 600 spi and a 2400 × 2400 spi scanner isn't much of a difference. If you can scan a sample with the scanner you plan on buying to make sure it delivers decent sharpness and good contrast (which is very important), you can usually choose a scanner yourself with no trouble. If you're serious about scanning; however, I recommend spending at least $200-$300 and getting a good, name-brand model from companies such as Hewlett-Packard, Epson, or Canon. Their models offer extra quality, but also operate faster (important when you're scanning a whole stack of photos) and come with a more versatile selection of software.

Dedicated slide scanners are required for scanning transparencies and negatives, but I've gotten great results from my Epson scanner with a slide-scanning light source built into its lid.

Here are some tips for making the best scans:

▶ Always work from the best available original. This reduces the amount of retouching you'll have to do. Make a fresh print from the original negative, if possible (but unlikely).

▶ Use the largest available print that fits on your scanner's bed. A 5 × 7 or 8 × 10 print has more detail than a 4 × 6-inch snapshot.

▶ Remove the dust from your print and your scanner's glass before you scan.

▶ Align the image so you won't have to rotate in Photoshop.

▶ Use an appropriate resolution. Too much resolution wastes hard disk space, takes forever to complete a scan, and slows you down when it comes time to edit or make a composite. 200 spi is usually plenty for photographic prints. Jump up to 300 spi if you're scanning a small original, or drop down to 150 spi if you're scanning a noncritical 8 × 10-inch print. You'll find formulas for calculating "correct" capture resolution in some scanner books (and I've written eight books on scanners myself), but other factors, such as the quality of the scanner's sensor and optical system, are more important than resolution in the image sharpness equation.

Most scanners have an automated mode that works great for most photos. You'll probably want to learn about your scanner's manual controls, too, because troublesome images can often be captured better using manual settings. Some of the controls you need to learn about include:

▶ **Sharpening**. A scanner's built-in sharpening control can sometimes do a better job than Photoshop, because the scanner is working with the original image. Most scanners automatically apply some sharpening to every scan.

▶ **Blurring/Descreening**. Blurring is the opposite of sharpening, and in a scanner is most often used to descreen images that already have a halftone pattern. The descreening settings in most scanners tend to overdo the blurring, and you can get much better scans of halftones by doing the blur yourself in Photoshop or another image editor, as described later in this chapter. Descreening can also help you avoid the moiré effect, a pattern caused by interference between the arrangement of the original halftone screen and the pixels in the scanned image.

▶ **Halftoning**. Some scanners have a halftone setting that lets you apply a halftone dot pattern when scanning. This feature works only if you already know what size your printed image will be and the device that will be used to print it. You're usually better off letting your printer or other output device apply its own halftone screen.

▶ **Manual Exposure/Tonal controls**. Some scanners are furnished with software that includes manual exposure and tonal controls. These can include brightness/contrast sliders, histograms that are the equivalent of Photoshop's Levels command, or even a built-in "densitometer" that measures the lightness, darkness, and color values in an image.

▶ **Color controls**. Manual color controls can help you remove casts during a scan, but you're usually better off performing this task in Photoshop. However, some scanners let you scan through a "filter," so you can use, for example, a light green filter when scanning to remove a greenish stain or to darken faded red printing.

Restoring Old Black-and-White Prints

Many of the old prints you'll need to restore will be black-and-white prints. You'll find a variety of problems to diagnose and cure, ranging from wrinkles, cuts, and tears, to faded tones or stains. This next section shows you how to fix these problems. We'll start with an image on the CD-ROM called oldcar.pcx, shown in Figure 10.1. It's a nostalgic photo for me, because it was taken by a police photographer (my father) after a car crashed in front of my family homestead (seen just behind the Brittain sign on the tow truck) before I was born. We're going to make this old photo as good as new, in several different steps. Just follow along.

Figure 10.1
Not a pretty sight, in more ways than one

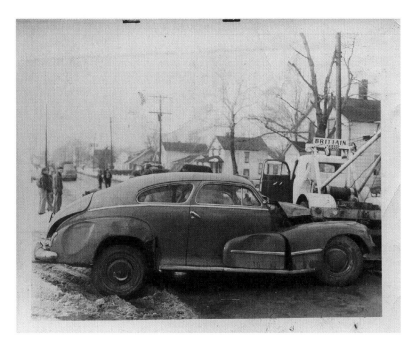

Removing Discoloration

The photo has yellowed over the years, so the first step is to neutralize the discoloration. You can do that yourself by completing the following steps:

1. Choose Image > Mode > Grayscale to convert the color image to black and white. The image is in color, so converting it to grayscale automatically gets rid of the yellow color.

2. Next, use Image > Mode > Duotone. Choose a dark blue for the second ink color, and bend the blue ink's curve downward, as shown in Figure 10.2. Go back to Chapter 9, "Creating Duotones, Tritones, *n*-tones, and Colorizations," if you need a review on how to create a duotone. This gives the photo an interesting steely-blue tone that's almost unnoticable, but which

goes well with the snowy winter environment. I like the look better than plain black and white, much better than the results you get by simply using the Hue/Saturation command to colorize the photo blue.

3. After you're happy with the duotone version, use Image > Mode > RGB Color to convert it to full color. In duotone mode, you don't have access to all the controls available in RGB, and we're not going to print this as a duotone, anyway.

4. Next, crop out the extraneous border around the photo. The photo should look similar to Figure 10.3.

Figure 10.2
Create a steely-blue look by converting the image to a duotone

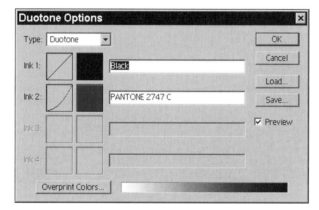

Figure 10.3
Cropped, the photo looks like this

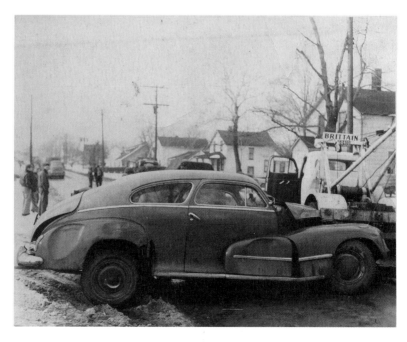

Adjusting the Tonal Values

The photo can be improved by adjusting the tonal values a little. The background is a bit faded. There's no way to retrieve all the detail, but we can even it out a little. Follow these steps:

1. Press Q to enter Quick Mask mode, and then press B to switch to the Brush tool.

2. Choose a large, fuzzy-edged brush. I used the 100-pixel brush.

3. It's easier to paint the car as a selection, and then invert it, so go ahead and daub carefully over the car.

4. If necessary, switch to the Eraser tool (press E) and remove any mask area that extends outside the boundaries of the car and the snow area in front of it. The mask should look something like Figure 10.4.

Figure 10.4
Your selection should look similar to this

5. Press Q to exit Quick Mask mode, and then press Ctrl/Command+I to invert the selection, so that everything except the car is selected.

6. Choose Image > Adjustments > Levels (or press Shift+Ctrl/Command+L) to access the Levels dialog box.

7. Move the black point slider to the right, to a point where the histogram shows an increase in dark pixels in the image, and then move the gray point slider to a point at the bottom of the curve that marks the "mountain" of white pixels in this image, as shown in Figure 10.5. Then click OK to apply the Levels modification.

Figure 10.5
Evening out the tones gives the photo a stark, wintry look

Fixing Folds, Molds, Stains, and Strains

There are a several cracks, folds, and stains in the photo, chiefly in the area above the old automobile. We can use Photoshop's cloning tools to fix these defects. This multitude of sins shows up plainly when you zoom in, as in Figure 10.6. The sky is truly a mess, but there is so little area of "clean" sky to use for cloning that, in this case, the Healing Brush makes a better choice. All you need to do is establish a clean area to use for the healing source. Then, the Healing Brush blends in the pixels you choose with the other sky areas, adjusting the tones and texture to match the area you're fixing. Trust me, this works. Just follow these steps:

Figure 10.6
Lots of dust, mold, and cracks in this photo

1. Press J to select the Healing Brush.
2. Choose a medium-sized, fuzzy-tipped brush. I selected a 38-pixel brush.

3. Find a relatively clean area of the sky without many dust spots or other defects. Alt/Option-click in that area to choose a source for healing, and then move out from that spot to clean up a larger area.

4. In the Options bar, deselect the Aligned check box, and then Alt/Option-click in your newly cleaned area. Now, when you use the Healing Brush, it samples only from the area you've cleaned, and does not move outside that area as you heal the photo.

5. Use the Healing Brush to clean up the sky areas that don't have detail you want to preserve (such as tree tops or telephone poles). You should be able to cover up most of the dust and folds in this way. The Healing Brush adjusts the tone and texture so the strokes blend in smoothly.

6. If necessary, switch to a smaller brush to heal between branches. Press the left bracket key to change to the next smallest brush, or press the right bracket key to enlarge your brush.

7. When you've removed most of the defects, heal the smaller spots among the branches of the tree. Change your origin spot frequently, using a clean nearby area. Eventually, the photo begins to look like Figure 10.7.

Figure 10.7
After a little work, the photo looks like this

8. If you're really adventurous, experiment with the Patch tool to apply some Bondo to the injured portions of the car, as I did in Figure 10.8. I won't provide any instructions for this; see if you've learned enough to do it on your own. The hood of the car is still a mess, but at least I've made this old jalopy driveable.

USING THE PATCH TOOL

To patch up this car, I cut and pasted a few pieces (such as the trunk) to realign them. Then, I used the Patch tool in both Source and Destination modes to apply some new sheet metal. In Source mode, you define the area to be used as the patch in roughly the shape you need, and then drag it over to the area to be patched. If you think you'll have trouble creating a patch of the right shape and size, use Destination mode instead. The Patch tool is used to outline the area of the image to be fixed. Then, you drag that area over to a clean piece of sheet metal that serves as a patch. Photoshop applies that area's texture to the injured area while you watch.

Figure 10.8
Even auto repair can be included in your photo restoration repertoire

Fixing a Torn Photo

Torn photos are not hard to fix, if you know a few tricks. The photo shown in Figure 10.9 was in decent shape after 60 years, except for some fading around the edges where it was placed in a frame, and a minor tear that turned into a major tear when we removed it from its backing in the frame. I carefully fit the pieces together and scanned them as a whole, with hopes of repairing the tear. Fortunately, the tear doesn't cross any areas of the face, so it is relatively simple to mend. Find navy.pcx on the CD-ROM that accompanies this book, and follow along, if you like.

Figure 10.9
Removed from its frame, this photo has a big tear and a few other defects to be mended

1. Press L to choose the Lasso tool, and select the upper-right corner of the background, as shown in Figure 10.10. We're going to copy and flip this area to patch over the tear.

2. Press Ctrl/Command+J. This is the nifty Layer via Copy command that you should learn to use as a valuable shortcut. It takes the current selection, and deposits it in a new layer of its own. This is much faster than the Ctrl/Command+C/Ctrl/Command+V copy-and-paste sequence you probably have used in the past.

3. Choose Edit > Transform > Flip Horizontal to flip the corner in its new layer.

4. Press V to activate the Move tool, and drag the corner to the left side of the image, as shown in Figure 10.11.

5. Choose Image > Adjustments > Brightness/Contrast and use the Brightness and Contrast sliders to adjust the tones of the patch so they closely match those of the surrounding area. This is one of the rare occasions when the Brightness/Contrast controls work fine. We're not trying to adjust the tonality portions of the patch, so we don't need the Levels or Curves command. Instead, we just want to change the overall brightness and contrast, so the lack of control provided by this command doesn't matter.

6. Press E to activate the Eraser tool and remove the edges of the patch. If necessary, use the Clone Stamp tool to merge the edges smoothly.

Figure 10.10
Copy the corner
of the photo

Figure 10.11
Then flip it
horizontally and move
it to the other side

7. Choose Layer > Flatten image to combine the corner patch and the rest of the image. Your photo should look similar to Figure 10.12.

8. There's a faded patch across the sailor's chest, and the outer borders of the image are also faded from being attached to a cardboard matte inside the frame. Crop the image to exclude the border, and use the Burn tool to darken the chest.

9. Touch up any dust spots with the Clone Stamp tool. The finished photo looks similar to Figure 10.13.

Figure 10.12
We're almost done—you can see a few dust spots to fix

Figure 10.13
The finished photo looks like this

Resurrecting an Old Tintype

Every once in awhile, you'll encounter a photo that's almost certainly lost to the ravages of time, so that little of the original image remains. The old tintype shown in Figure 10.14 is such an example. If I'd found it at a garage sale, I probably would not have given it a second look. Tintypes, also known as ferrotypes, aren't particularly rare. They aren't made on tin, either. The process was introduced in 1853. It was fast and cheap, and tintypes were rugged. The process was outmoded by the 1880s, but street photographers continued to produce tintypes well into the middle of the twentieth century.

As I said, I wouldn't have given this one a second glance if I hadn't found it in a stack of family photos from the early 1900s. It is very likely that one of the kids in this class photo was my great-grandmother or great-grandfather. I decided to see what I could do. I won't be providing instructions for you on this one, as you probably wouldn't be able to fix this one any more than I was. I just needed an excuse to describe tintypes and what you can do with them in case you encounter one in better shape than this.

Figure 10.14
This old tintype is
barely viewable

1. First, try to rescan, relying on your scanner software's controls to capture the best version of the image possible. My SilverFast scanner application has its own histogram, which I used much like Photoshop's Levels dialog box to adjust the white and black points of the scan so all 256 tones would be allocated to the available tones in the image. Your own scanner software may have a dialog box similar to the one shown in Figure 10.15. I managed to get a slightly more viewable photo, shown in Figure 10.16.

Figure 10.15
Your scanner software
may have a histogram
control that's similar to
Photoshop's Levels
command

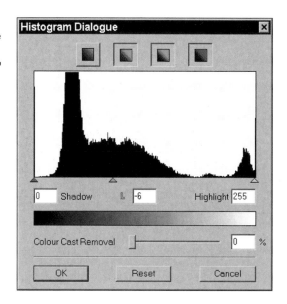

Figure 10.16
Adjusting the tonal
range in the scanner
yielded this image

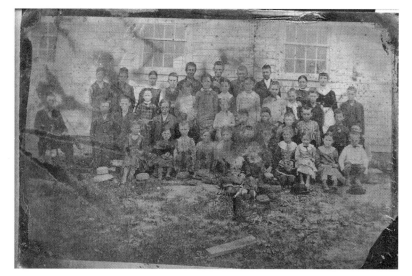

2. Next, flip the image horizontally. Because of the way tintypes were created, they were always reversed left to right. Tintypes were so cheap that folks put up with this idiosyncrasy. But there's no reason we have to. I used Photoshop's Edit > Transform > Flip Horizontal to create a reversed image.

3. There are so many spots on this photo that cloning or healing would only obscure detail. You'd think that the Dust & Scratches filter would do nothing but blur the image. You're almost correct. The reversed image, treated with the Dust & Scratches filter in default mode, looks like Figure 10.17. Ack!

Figure 10.17
The Dust & Scratches
filter doesn't help!

4. However, most Photoshop users never play with the Dust & Scratches filter's Threshold slider, which controls how different the pixels found in the artifacts must be before they are eliminated. Boosting this value eliminates a lot of the dust while not blurring the image significantly, as you can see in Figure 10.18, which shows a section of the photo in both its original form (top) and partially descratched version (bottom).

Although I can't make this old photo as good as new, I was able to fix it enough that many of the faces are recognizable—or at least they would be to anyone who knew them at the turn of the last century.

Figure 10.18
The final image—not
perfect, but better

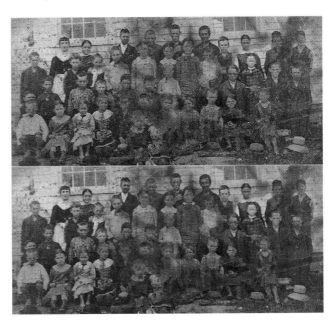

Removing a Halftone Screen

We looked at removing a halftone screen earlier in this book, in terms of uses for blurring and sharpening. However, trying to get decent photos from halftones can be a serious concern. Sometimes, the only existing version of a photo may be a halftoned version. That can be a problem.

In Chapter 9, you learned a bit about the limitations of printing photographs in newspapers, magazines, and books. As a refresher, keep in mind that for a black-and-white image, every tone you see must be reproduced using pure black ink and the white of the paper. Any photograph must be converted to a series of dots called a halftone. Our eyes blend these dots together to produce the illusion of a grayscale (or color) image with smooth gradations of tone. A problem arises when you want to reuse a photograph and don't have access to the original. Scanners can capture the halftone dots, but the resulting image usually has an unpleasant pattern, called moiré. You can see this effect in Figure 10.19.

Figure 10.19
The dreaded moiré effect is caused by interference patterns

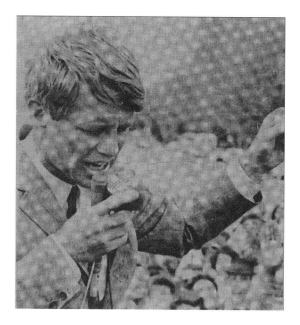

Moiré is caused when two patterns with different frequencies (that is, the intervals between the dots) are overlaid on each other. The original halftone screen pattern for the previous figure used a series of repeating lines, probably somewhere between 85 and 133 lines per inch. When you scan a halftone, a second pattern results when the image is displayed on your computer screen (at, for example, 72 to 120 "lines" per inch) or printed again (at 300 to 600 dots per inch). The two patterns interfere with each other at regular intervals, producing the unpleasant moiré look.

There are several ways to reduce the moiré effect, usually by blurring the image so the dots merge and the underlying pattern vanishes. Many scanners have a "descreen" setting that partially eliminates the effect, but may blur your image more than you want. Figure 10.20 shows the same picture scanned using my Epson scanner's descreening feature. (The line across the speaker's brow is caused by a fold in the newspaper clipping from which the scan was made.) I almost never use this feature, because it produces nothing but a blurry image.

Figure 10.20
Scanner descreening features usually just produce a blurry image

Another way to reduce very heavy moiré effects in Photoshop is to scan the halftone at an angle at a high resolution. Just rotate the image on the scanner bed, and then rotate the image back to its normal orientation and reduce the resolution. You'll spend a lot of time trying out different angles before you come up with the best compromise.

However, I wanted to fix the scan of this clipping. It was of a photo I took of Senator and presidential candidate Robert F. Kennedy in May, 1968, while I was a precocious two-year-old college student. A local newspaper liked the photo well enough to publish it, but over the years, I managed to lose the original negative and print. A yellowed clipping was all I had left. You can see the dreadful moiré pattern that results when the clip is scanned. Here's what I did. You can follow along using RFK.pcx, which can be found on the CD-ROM bundled with this book.

1. Load the image into Photoshop.
2. Zoom in so you can see the halftone pattern clearly as you work, as shown in Figure 10.21.

Figure 10.21
Zoom in to view
the halftone pattern
close up

3. Choose Filter > Blur > Gaussian Blur to produce the dialog box shown in Figure 10.22.

4. Move the Radius slider to the right until the halftone pattern is blurred. I used a value of 1.7 pixels. Click OK to apply the blur.

5. Next, choose Filter > Sharpen > Unsharp Mask to restore some of the image's sharpness now that the pattern has been eliminated.

6. Move the Amount slider to the right to sharpen the image. A setting of about 175 percent fixes the image without making the photo appear unnaturally sharp or with too much contrast.

7. Click OK to apply the sharpness.

8. Choose Image > Mode > Grayscale to change the image to black and white.

9. Next, use Image > Mode > Duotone, as we did for the first project in this chapter. I chose the same dark blue for the second ink color, and bent the blue ink's curve downward as before. You can flip back to Figure 10.2 if you need a reminder.

10. Use Image > Mode > RGB Color to convert it back to full color.

11. If necessary, use the Image > Adjustments > Levels control to adjust the tonality to your taste. My final image looks like Figure 10.23.

Figure 10.22
Apply Gaussian blur
to eliminate the
halftone screen

Figure 10.23
Cropped for dramatic
effect, descreened,
and duotoned, RFK
lives again

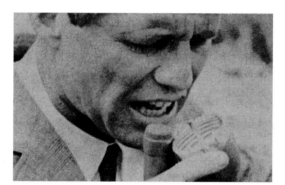

Next Up

There are a few more photo restoration techniques to cover, but they can also be used when making composite images, so I'm going to leave them for Part III, which, coincidentally enough, begins with the very next chapter. As much as I love retouching photos, I enjoy making composites even more. It's a real thrill to create an image that never existed before, one that no camera ever captured, and which existed only in the mind before Photoshop got into the act. I think you'll enjoy Part III, too. We kick it off with the next chapter and some tips for some simple combination techniques.

Part III:

Compositing Magic

Are you just about ready to put out your shingle? You've learned all the basic features of your tools and how to apply them to mend images. You've had quite a bit of practice in providing some of the easier solutions to common photo maladies. You can mend broken table legs, or suture wounds with the best of them, so you now qualify as either a journeyman carpenter or a resident physician, depending on whether the metaphors of Part I or Part II appeal to you the most. (You may also be a *journeywoman* carpenter, if the title fits; the trades haven't yet caught up to medicine in terms of nonsexist designations.) All you need is additional experience in more complex challenges. That's what you'll find in the compositing projects in this part.

These five chapters deal with ways to combine images seamlessly to create new pictures from parts of one or more photos. You'll learn how to stitch images together, blend edges, create new textures, and match colors so that your composites are undetectable.

The procedure is slightly different in this part. I'm still going to provide step-by-step instructions, but the emphasis is on the techniques that you haven't employed yet. I spell out what you need to do for the new procedures using as much detail as required. However, I don't describe all the steps for tasks that you should have mastered by now. For example, I may say, "Select the Rectangular Marquee," rather than "Press M to select the Rectangular Marquee (if necessary, hold down the Shift key and press M until its icon becomes visible)." In fact, I may even simply instruct you to "Select the window using the Rectangular Marquee" or "Select the window" (leaving you to decide which of Photoshop's selection tools to use).

Similarly, I usually don't spend a lot of time telling you how to spot out dust specks, how to use the Levels command, or how to apply a Sharpen or Blur filter. This part of the book is all meat; I trust you to know the basics of preparing the meat for cooking. If you have any questions about how to do something that has already been covered, check out the Table of Contents, the Index, or the illustrated Glossary.

11

Simple Cropping and Fix-up Techniques

Compositing encompasses many different techniques. You'll need to crop photos so only the image area important to your photo is included. Often, you'll need to straighten images that were photographed or scanned askew. The perspective of an image may be odd. That is, the viewpoint might be too low, too high, or appear "wrong" in relation to other components in the image in some three-dimensional way. Images must be corrected in many ways before they can be combined.

Another component of compositing is combining images. You may want to stack image parts on top of each other and blend them so the merger is undetectable. In other cases, the goal may be to stitch multiple images together side by side to produce a panorama. As you might suspect, these tasks are all a bit more complex than the retouching tasks you tackled in Part II. This chapter serves as your introduction to some of the easier fix-up techniques. I'm going to start with some groundwork on the kinds of attributes in photos that you'll be trying to match as you combine images.

CHAPTER 11

The Matching Game

Unless you're deliberately creating a fantasy image that is supposed to have a surrealistic look, you'll always want the portions of your images that you are combining to match as closely as possible. Mismatches of lighting, texture, perspective, or any of a dozen other factors is a dead giveaway that an image is a composite. Although it's unlikely that you'll learn to create an image that will fool a forensic scientist, you can still create composites that are believable on first glance, second glance, or even close study by a lay person. This next section outlines some of the things to keep in mind when attempting to match image components. I'll expand on most of these in later chapters, but it doesn't hurt to give each of them some thought now.

Matching Lighting

With some interesting exceptions, most of the images we see are illuminated primarily from a single light source. Outdoors, that light may be from the sun or, at night, from the moon or some outdoor lighting fixture. Those light sources provide what photographers call the *main light*. There are almost never two main lights (that is, two light sources that are equal). You'll see these at times in low-budget movies (the ones in which there are two strong shadows falling in different directions behind each person in the shot), or in some amateur photos.

Most photos also have secondary light sources, what photographers call *fill light*. These lights may be intentional, applied by the photographer, or, in the case of motion pictures/video, by the *lighting director* or *lighting cameraman* (in the UK and some other places). Fill light, which illuminates the dark shadows, may also be a lucky accident, caused by reflection of light off other objects in the environment, or from dimmer secondary light sources.

Other secondary light sources may be directed at the background, the subject's hair, or other objects in the image. Lighting in any scene can be fairly complex, and for your composite to work, the lighting must match in several different ways:

▶ **Direction**. The main light source, at least, must come from the same direction in all components of your image. If not, the composite looks fake. If the object you're compositing into a scene is symmetrical, you may be able to flip it using Photoshop's Edit > Transform > Flip Horizontal command. Other times, especially if the object has printing on it, you can't flip it. Watch for lighting differences in photos taken at high noon and at dusk.

▶ **Intensity/Contrast**. Some kinds of light are very harsh. Direct sunlight, direct flash, or incandescent floodlights are examples of harsh illumination, with bright highlights and deep, inky shadows. Other kinds of light are softer, and less intense. Examples include photos taken on overcast days, or objects standing in the shade. It's difficult to match intensity when mixing objects photographed under such different lighting conditions, but I'll show you a few tricks later on.

▶ **Color**. As I showed you in Chapter 5, "Adjusting Color," light can vary greatly in color, even when it looks "normal" to us. Only the extremes are readily apparent to us; candlelight generally looks reddish and snow scenes often look bluish. Table 11.1 shows the color temperature of many kinds of light, measured in degrees Kelvin. The color temperatures are averages; household lamp bulbs may range from 2800 K for a 75 watt bulb to 3000 K for a 200 watt lamp. You can use the table as you make composites to help form an estimate, in your own mind, of how "blue" or "red" an object needs to be in your assemblage. The most confusing thing about color temperature is that cooler objects are red, and warmer objects are white (think red-hot and white-hot).

IS KELVIN SPACEY?

Kelvin is that scientific temperature scale that starts with absolute zero at 0. On Lord Kelvin's scale, water freezes at 273.15 degrees and boils at 373.15 degrees. So, you can see that a color temperature of 5500 K must be quite hot! Color temperatures are measured using the Kelvin temperature of a mythical *black body radiator*, an object that theoretically absorbs 100 percent of the light that hits it, reflecting *nothing*. The closest thing to a true black body radiator in our everyday experience is a star. At a particular temperature, such objects *emit* light of a predictable color in the spectrum, and this reliable measure is used to state the color temperature (color) of light. Actual star temperatures range from 2500 K (reddish) to 50,000 K (really, really blue).

NOTE: Fluorescent lights don't have a true color temperature, as their illumination is not generated by heat. Instead, the color of fluorescent tubes is expressed in approximate or equivalent color temperature.

Table 11.1
Color temperatures, in degrees Kelvin

Light Source	Color Temperature
Match flame	1700 K
Candle	1800 K
Table lamp	2800 K
Quartz-halogen bulb	3200 K
Photoflood bulb	3400 K
Sunrise/Sunset	3750 K
Flashlight	4000 K
Daylight	5000 K
Daylight, noon	5500 K
Electronic flash	5800 K
Overcast sky	7000 K
Open Shade	8500 K
Blue skylight	12000 K+

Matching Reflections

The best composite images take into account not only the light created by the main light source, but also light and reflections that bounce off objects in an image. Fill light, reflections in a person's eyes, or reflections on other shiny objects in an image must be accounted for. Don't place an object in water, for example, unless you plan to account for the reflections that object causes in the water. Computer graphics programs, such as those that created *Toy Story*, use a technique called *ray tracing* to ensure that reflections are handled accurately in lighting a computer-generated object. Ray tracing follows each ray of light from the eye back into the image plane, looking to see if the ray intersects any object, and how it would bounce off an object it touches. Ray tracing is used in this way in video games, too, to handle shadows, reflections, and texture mapping. Don't forget that reflections must be *colored* properly, too. Figure 11.1 shows an image that includes a reflection of the Eiffel Tower in the water in the foreground, which, of course, makes the photo instantly credible.

Figure 11.1
Putting reflections where they belong adds credibility to your images—usually

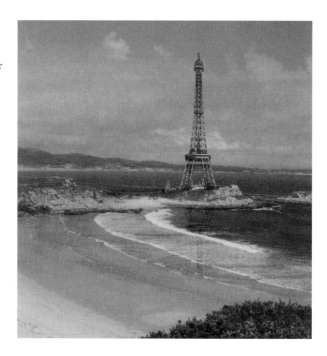

Matching Color of Objects

If you're inserting an object in a photo that has a known color, or if its color can be compared to another object in the composite, the colors should match. For example, it's obvious that grass should be green and the sky should be blue, but if there is already other grass in the scene, your transplanted flora should be the *same* green. Nor can you insert a patch of deep blue sky into a late afternoon sky scene. American flags should always be the shades of red, white, and blue that we associate with that banner.

Matching Perspective and Size

Our brains use visual clues such as relative size and proportion to help us gauge distance. If two similar objects are arranged in an image and one is smaller, our minds assume the smaller one is farther away. Converging lines remind us that objects not only seem smaller, but have a certain perspective as they approach a vanishing point at the horizon. You'll need to arrange objects in your composites so they have the relationships we expect in both size and position. Breaking the rules of perspective and size can help produce visual paradoxes or visual puns when done intentionally. However, accidents make the image look "wrong."

Matching Sharpness

All the components of your composite should have the same sharpness as the objects around them. In photographs, sharpness is determined, in part, by depth-of-field—the area in front of and behind the area of sharpest focus in an image. For example, if a full-face portrait is taken with the camera focused on the nose and the depth-of-field is scant, the eyes may be a little less sharp, and the ears blurrier yet.

In addition, the edges of components pasted into a composite must blend in naturally with their surroundings. In many cases, that means soft edges.

Figure 11.2 shows the effect of ignoring the perspective and size rules, while adhering to the sharpness guideline. The human finger pointing to the guitar is slightly out of focus, because the camera lens was focused on the guitar. However, the size of the digit lets us know right away that either the guitar and urns are miniatures, or that the finger was composited in. (In this case, both suppositions are correct.)

Figure 11.2
Is the guitar a miniature? Or was the finger composited into this photo? Actually, both suppositions are correct.

Matching Environment

Other parts of the environment, whether indoors or outdoors, should match. If a picture was taken in a smoky jazz club, the air will be thick and heavy. Objects will be partially blurred; you may even be able to see dust particles in beams of light. Outdoors, the air can be full of mist on a rainy day, or wind may be changing the shape or direction of billowing or loose items. Even in clear air, objects in the distance will have a blue cast that closer objects don't have. In urban areas, smog may be a factor. Matching the environment is often overlooked, but it's not something you should miss when combining images. Figure 11.3 shows the environment angle ignored in a big way. (Those aren't snow or rain clouds in either photo, and there are no wet spots on the ground, as you'd expect to see on such a bright, snowy or rainy day.)

Matching Texture

Many fledgling compositors miss the matchup between a pasted object and its surroundings in terms of texture. One object may be very grainy, whereas another may display only a little grain or noise. Texture mismatches are particularly noticeable in large areas of fairly uniform color with no distinct texture of its own, such as sky. Other mismatches can occur when a texture forms a pattern, such as brick or wallpaper, and a mismatched pattern clearly stands out. Matching textures of elements that have detailed, but random texture is a bit easier. You can usually blend in any particular patch of grass with any other patch of grass, as long as the other factors, such as size (of the blades), color, and sharpness are similar.

Figure 11.3
Neither rain, nor snow, nor sleet of night shall make this picture believable

Matching Reality

Shakespeare wasn't afraid of anachronism—like the clock striking in *Julius Caesar*—if it was convenient or dramatically effective. Perhaps Shakespeare knew that an element obviously out of time wouldn't be noticed by his audience, or he was sharing some joke with his audience. However, unreal elements in an otherwise realistic picture tips your viewers off that they are not seeing something that actually existed before Photoshop got a hold of it. Transplant the Eiffel Tower to London only if you mean to make a visual joke. Don't put palm trees on a rocky, Maine seashore. Avoid snowmen in July, or, as in Chapter 9, "Creating Duotones, Tritones, *n*-tones, and Colorizations," have clouds wafting in *front* of the moon. Sunrises over the Pacific in Malibu also destroy any realistic effect. The Eiffel Tower in Figure 11.1 is an example of warped reality.

Compositing is also a tool for avoiding reality busters that really were in the picture in the first place. One of my favorite photographic subjects is the castles in Spain. No one in their right mind would imagine that my photos were taken in the sixteenth century, but I still spend a lot of time removing utility poles from the periphery of such photos, or compositing disguising elements on top of the satellite dishes the caretakers of these monuments have grafted onto their museum abodes.

I may not photograph tigers in their natural habitats, but removing the chain link fence and plastic water buckets from their photos makes the image more "realistic." Adding a bit of jungle foliage through compositing may make the picture more realistic yet.

As you work through Part III, I'll show you ways to make all the elements of your composites match in logical ways.

CHAPTER 11

Fixing Compositions with Cropping

The first thing you'll probably do with any image that you plan to use as the basis for a composite is to crop it carefully. Cropping eliminates extraneous subject matter from the photo, enhances the overall composition, and neatly eliminates the need to retouch anything that's in the area cropped out. For example, there's a nasty old chuckhole in the foreground of the photo of the castle at Alarcon, Spain, shown in Figure 11.4. Your choices are to use a combination of darkening and retouching, as I did in the left portion of Figure 11.5, or simply crop it out, as I did in the right portion of Figure 11.5. You'll notice I composited in some clouds. We'll experiment with clouds in a later chapter.

Figure 11.4
How to get rid of the chuckhole in the foreground?

Figure 11.5
Retouch it out (left) or crop it out (right)

A slightly more complicated project can be undertaken using the photo in Figure 11.6. It was taken outside the well-preserved medieval walls that surround the Spanish provincial capital, Avila. There are lots of things to fix with this picture, and you can try your luck using avilawall.pcx, found on the CD-ROM that accompanies this book. A pair of tourists appear along the base of the wall, but they aren't the main problem. There's a road and footpath along the lower edge of the slope, neither of them looking very medieval. Those lumps halfway up the slope are high-powered spotlights that illuminate the wall at night. The nighttime display is spectacular, but the spotlights are ugly distractions in the daytime.

There are also a few tonal problems with the photo: Several turrets of the wall are too light, and the sky is a bit washed out. Simple compositing and retouching techniques can take care of all these problems. Just follow these steps:

Figure 11.6
Lots of things in this photo that we don't want, all of them easy to remove

1. First, use the Crop tool to crop the image at the top, along the right side to clip out most of the road, and along the bottom to remove the closest lighting fixture.

2. Next, zoom in on the second tower from the left, and use the Lasso tool to capture a bit of the tower and grass located above the two tourists' heads. Use Layer via Copy (Ctrl/Command+J) to copy that section to a new layer.

3. Use the Move tool to slide the copy down over the girls.

4. Feather the edges of the copied area with the Eraser tool. Use a fairly large, soft-edged brush to provide a smooth transition. That section of the image now looks like the bottom portion of Figure 11.7. The unaltered section appears at the top of the figure.

Figure 11.7
The unaltered figure is
at the top; the feathered
version is at the bottom

5. Copy some areas containing grass on the slope, send them to new layers using Ctrl/Command+J, move them to cover up the remaining portion of the road, and then blend in with the Eraser tool, as before.

6. If the section of grass you select is significantly lighter or darker than the surrounding grass, use the Brightness/Contrast controls to darken or lighten the whole section until the copy matches its surroundings. The tonality of the patch should be similar enough that you probably won't need the control the Levels command provides.

7. Press Ctrl/Command+E to merge the grass patches with the image when you're satisfied.

8. Use the Clone Stamp tool, if necessary, to blend the grass in further. As you work, the image starts to look like Figure 11.8. We've managed to cover up most of the road. Keep cloning until all of the road is gone.

Figure 11.8
Keep cloning until all of the road is gone

9. Repeat Steps 5–8 to cover up the floodlights, too.

10. Enter Quick Mask mode, and select all the turrets except the first two. Then exit Quick Mask mode, and use the Levels command to darken the turrets.

11. Enter Quick Mask mode again, and use small and large brushes to select the sky down to the horizon. Exit Quick Mask mode, and darken the sky with the Levels command.

12. You might want to return to Quick Mask mode a third time, and select the lower part of the slope and darken it a little. When you're finished, the photo should look similar to Figure 11.9.

Figure 11.9
A more medieval look for some ancient walls

CHAPTER 11

Straightening Images and Improving Perspective

Before you can correct perspective problems in your composites, you need to understand how they occur in the first place. This next project shows you one of the most common perspective ills that can befall a photograph. After you learn to correct this kind of distortion in its simplest mode, you'll be better equipped to match your composited objects from a perspective standpoint. I'll show you more perspective tricks in Chapter 13, "Invisible Compositing."

Most photographs are taken head-on, with the back of the camera parallel to the plane of the subject. This puts the key parts of the subject roughly the same distance from the plane of the camera's film or sensor. When you tilt the camera up or down, the part of the subject that's farthest away from the camera appears to fall away. If you've ever leaned back to photograph a tall building, you know what I mean.

The photo of the Roman arch at the top of a tall hill in Medinaceli, Spain, shown in Figure 11.10, demonstrates the difficulty. Because the camera had to be tilted back to take in the top of the arch, the sides of the arch appear to converge. The effect may not be obvious in the figure, but after we've fixed the problem, you'll see what I mean.

Figure 11.10
The arch appears to be
falling over

Professional photographers use special cameras or lenses that let them raise and lower the view of the lens (or move it from side to side; perspective control can involve wide subjects as well as tall) while keeping the camera back in the same plane as your subject. Fortunately, Photoshop handles perspective fairly well. Just follow these steps using the file medinaceli.pcx on the CD-ROM bundled with this book.

1. To give yourself a little working space, choose Image > Canvas Size, and change the width of the image to 1700 pixels and the height to 1400 pixels. Zoom out to make the image fit on your screen, if you need to.

2. Create two vertical guides to let you judge the perspective of your image. Choose View > New Guide, and make sure the Vertical radio button is selected. Click OK to create the guide.

3. Press V to activate the Move tool, and drag the guide line onto the image, positioning it next to one of the sides of the arch.

4. Repeat Steps 2 and 3 to create a second vertical guide for the other side of the arch. Your image will look similar to Figure 11.11.

Figure 11.11
Apply guides to help line up your image as you change its perspective

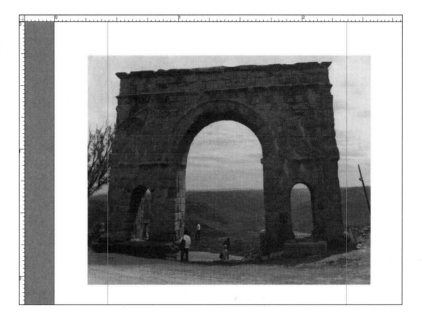

5. Use the Rectangular Marquee tool to select only the image of the arch, not the blank space you created around it.

6. Choose Edit > Transform > Distort to activate Photoshop's Distort feature.

7. Hold down the Shift key and drag the upper-left and upper-right corner handles of the selection outward, using the guides to gauge the position of the sides of the arch. You'll broaden the top of the arch as you do this.

8. Hold down the Shift key and drag the lower-left and lower-right corner handles of the selection inward, narrowing it, and providing some fine-tuning as you straighten the sides. Your image should now look similar to Figure 11.12.

9. Press Enter/Return to apply the transformation.

10. If you want, use your retouching skills to remove those pesky tourists. I left them in my photo to show the scale of the massive Roman arch.

Figure 11.12
The arch looks straight—all you need to do is crop

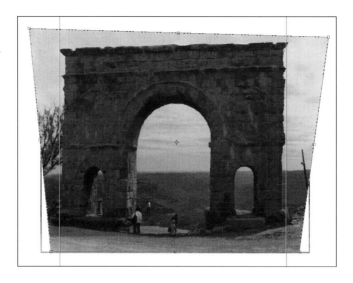

11. Crop the image to arrive at the final version, shown in Figure 11.13.

Figure 11.13
Here's the straightened arch

A Stitch in Time

You'll often find it necessary to combine two or more photos not by pasting parts of them on top of each other but, instead, by stitching them together to provide one larger photo that encompasses both images. This technique can help you supply missing image area where none was available before, or, more commonly, to create panoramic wide-angle photos.

There are special panoramic cameras that take an extra-wide photo on one piece of film. Ordinary Advanced Photo System cameras from Kodak and others perform the same trick simply by cropping the top and bottom of your picture using a mask built into the camera. The photofinisher's equipment recognizes this wide-angle mode and gives you extra-wide 4 × 10-inch prints from the narrow slice of negative. Of course, you could do the

same thing by ordering an 8 × 10-inch print and clipping off the top and bottom, but that costs more and you'd have to compose the narrow image in the camera using only your mental powers.

The easiest way is to take several full-frame photos and then stitch them together in Photoshop to create one extra-wide picture. The most important thing about creating such pictures (at least, if you're able to plan ahead), is to have the photos overlap enough that you can combine them easily. If all the exposures are similar, so much the better, but you can usually fix tonal values in Photoshop as long as the original photos are close enough in brightness and contrast.

This next exercise introduces you to the basics of stitching, using only three pictures of a very long and winding road. Find the road01.pcx, road02.pcx, and road03.pcx photos on the CD-ROM that accompanies this book. These shots were taken after I spent about an hour traversing a mountain pass over a route that measured roughly 3 kilometers as *el cuervo* flies, but a good 20 kilometers of a winding, twisting, panic-inducing road in a country that seems to feel that guardrails are not *macho*.

The images are shown in Figures 11.14, 11.15, and 11.16.

Figure 11.14
The left side of a panorama

Figure 11.15
The middle of the panorama

CHAPTER 11

Figure 11.16
The right side of the panorama

1. Create a large, empty document, approximately 2400 pixels by 700 pixels, and then copy and paste the left, middle, and right versions of the photos into the new document, as shown in Figure 11.17.

2. Try to align them so they overlap. You'll have a little trouble matching them, because the middle image *doesn't* overlap the image on the left. In fact, there's a slight gap. The image on the right does overlap, by quite a bit. That's because these photos were taken handheld, without the benefit of a tripod. We lucked out, though, in that the photos aren't rotated compared to one another. Your overlapped photos are shown in Figure 11.18.

OVERLAP EASILY

To simplify overlapping your photos, make the uppermost layer of a pair partially transparent by using the Opacity slider in the Layers palette. You'll be able to easily see when features that should coincide are on top of each other. Use the cursor arrow keys to nudge the layer being moved a pixel at a time; hold down the Shift key to nudge 5 pixels at a time.

Figure 11.17
Paste the three photos down in a single image document

Figure 11.18
Line up the images so their edges overlap (if possible)

3. Use the Clone Stamp tool to fill in the blank area between the left and middle photos.

4. Use the Eraser tool to blend the overlapping area of the middle and right photos.

5. If you're working on your own photos instead of mine, use the Levels command and Photoshop's color balancing tools to match the pictures tonally and by color, if necessary.

6. Crop the image to exclude the extraneous image area. The final photo looks similar to Figure 11.19.

Figure 11.19
The final image provides a wide-angle view

Next Up

I went easy on you in this chapter. We're going to dive off the dock and sink or swim with compositing in the next chapter, as you learn to remove large objects, replace objects with elements of your own choosing, and merge images with abandon.

12

Compositing to Improve a Picture

There is a school of photographic thought that proposes photographs ought to be created in the camera—that the photographer's vision should be manifest only after much contemplation, careful examination of every element in the photograph, and the precise arrangement of every component within the photographic frame.

This sort of thinking produces those "arty" pictures you see in which the edges of the photographic film, maybe even some 35mm sprocket holes, appear in the print as "proof" that the image wasn't subjected to some dastardly cropping in the darkroom. These are produced, apparently, by photographic artists who are able to envision every subject within, for example, a perfectly square 2 1/4 × 2 1/4-inch frame (a standard size for some kinds of professional cameras) or, perhaps the more flexible, but still stringent 2:3 aspect ratio (proportions) of the 24mm × 36mm frame of a 35mm camera. I'm still wondering what happens when these folks switch to a digital camera with, for example, 2048 × 1536-pixel resolution. Does their artistic vision have to suddenly conform to a 3:4 aspect ratio?

For most of us, pictures are rarely perfect at the moment of exposure. That's why books like this one are so popular. I'm particularly enamored with shooting *photos* quickly, and then assembling the *photograph* later. Much of my work in Photoshop consists of fixing errors I made, but a lot of it involves collecting together pieces of pictures that I deliberately shot in order to create a particular image later.

That's what we're going to cover in this chapter: using compositing to improve pictures. If your photo was framed incorrectly, or includes superfluous subject matter, or could benefit from the addition of an object or two, you'll learn how to perform these miracles here.

CHAPTER 12

Room for Improvement

As you learned in the retouching chapters in Part II, many pictures can be improved simply by removing defects. Retouching consists largely of taking stuff out that doesn't belong there, such as dust, scratches, holes in the background, bad complexions, your

brother-in-law, and so forth. Compositing is a lot more versatile. Here are some of the things you can do with compositing techniques:

▶ **Remove large objects**. Do you have a mountain vista in which an ugly old house squats smack dab in the middle? No problem. You'd be hard pressed to *retouch* such a large object out of your photo, but you can certainly delete it by replacing it with something else, such as trees, a mountain, a lake, anything that might be more attractive to look at than the ugly old house. Your fix can be virtually invisible, blending in with the surroundings seamlessly.

▶ **Relocate objects in the photo**. One of the projects later in this chapter involves moving a pesky tourist from the center of a photograph to one side, where she doesn't dominate the composition quite so much. Using compositing to relocate objects gives you the opportunity to correct faulty compositions, change the center of interest in a photo, or make something else a little easier to see. Perhaps you have a photograph of the company bowling team and the captain, who happens to be your CEO, ended up in the back row. Compositing lets you move the chief up to the front where she belongs.

▶ **Replace components in the photograph**. I had a nice publicity shot of myself showing me proudly holding the first edition of my latest scanner book. Then, the second edition was published and it had a completely different cover. Should I reshoot the photo? Too much trouble, and, besides, I was much better looking two years ago in the original picture. Why not just grab an image of the new book (even a scanned copy will do) and then use Photoshop to fix the perspective and drop it into the original picture? Compositing to the rescue again.

▶ **Add new objects to a photo**. After you learn to blend objects into photographs, I guarantee you'll go nuts with the possibilities. Did all the department heads except for one show up for a group photo for the annual report? Add the straggler later. Could your beach scene use some palm trees? Plant some quicker than you can say "Arbor Day." Do you want to see the Eiffel Tower in the middle of downtown London? The only hard part is obtaining photos of *la Tour Eiffel* and Piccadilly Circus.

▶ **Squeeze things together, or stretch them apart**. If you have a picture that is too wide for your intended use, you can often take the left and right halves, overlap them, disguise the seam, and end up with a narrower photo that fits, but doesn't look distorted. Or, you can fit something into the middle of the picture (much like adding a leaf to your dining room table when company comes) to make it fit a wider composition.

You'll find even more things you can do with compositing as you work through the projects that follow. Unlike some digital retouching texts you may have seen, I concentrate on showing you some techniques you can apply across the board to many different situations. Keep in mind as we work with particular photos and follow particular sets of steps to achieve a

particular effect that what you really should be learning is how the process *really* works so you can apply these skills to your own pictures.

Removing Large Objects

I'm not exactly sure why people insist on putting things in photos that they don't want there. Perhaps they are too shy to ask the big guy in the Hawaiian shirt to move to the left so he's not obscuring half the Lincoln Memorial. Maybe they spent thousands of dollars to fly to Paris and want everybody to know they went to Europe, so they refuse to come home with even *one* picture that doesn't have a family member in it. I happen to have the opposite problem: family members who refuse to pose for pictures, leaving future generations to wonder why Grandma never went on vacation with the rest of the family.

That's why it pains me to face the prospect of removing Grandma from the photo shown in Figure 12.1. It's a beautiful vista, but there she is perched on the stone wall, obscuring a rocky crag that's probably been there for six billion years. I'm going to feel even more pain when Grandma finds out this section is titled "Removing Large Objects," but I think we can make it up to her in the section that follows this one, which I've tentatively titled, "Relocating Petite Objects to the Side of the Photo."

Figure 12.1
Nice scenery, if it weren't blocked by Grandma

If you want to play along, locate rockwall.pcx on the CD-ROM that accompanies this book, and follow the easy steps I'm going to outline.

First, examine the photo carefully and see what can be used to cover up the unwanted large object. Part of the solution is easily discerned: She's seated on a rock wall, so we'll need to copy part of the wall to fill in the area where she won't be sitting once she's been

removed. Behind her is some greenery. We can probably cut and paste bits of the trees and bushes over part of the image, at the risk of ending up with too much plant life and not enough of the interesting rock formation. But there may be a way to fix that, as well.

If you look at the shadows in the photo, you'll see that the sun is coming from almost directly overhead, if a bit to the left. This makes our job easier, because there won't be long shadows to conform to as we assemble bits and pieces of the composite.

1. Select the upper-right corner of the rocky crag using the Lasso tool, and then press Ctrl/Command+J to copy it to its own layer.

2. Choose Edit > Transform > Flip Horizontal to flip the crag piece from left to right, producing the chunk shown in Figure 12.2. I've moved the piece up into the sky area and dimmed the rest of the image so you can see the size and shape of the area I selected.

3. Move the crag chunk down over the woman's face. You'll find that the brown vein in the rock matches almost exactly a similar brown vein lower in the crag, so the two blend quite well. There's a dimmed and undimmed version of the background in Figure 12.3 so you can see what we've done so far. Because the direction of the light is mostly overhead, the rock section blends quite well even though it's been reversed side to side. The light still appears to be coming from overhead.

Figure 12.2
Copy the piece on the right side of the rock and flip it horizontally

4. Next, copy the foliage in the foreground (just to the left of the gray post that has the orange digital numbers—another unwanted distraction—superimposed on it). Paste the plants on top of the woman, as shown in Figure 12.4. You can see what's been done fairly easily because the plants form a duplicating pattern that we'll get rid of later on.

Figure 12.3
Move the piece of rock
down to cover the
woman's face

5. Grab another section of plant life (it doesn't matter where as long as the tonal values are close) and finish covering up the woman, except for her leg.

6. Behind her is a section of wall. Select it and press Ctrl/Command+J to copy the wall section to its own layer.

7. Use Edit > Transform > Scale and elongate the wall section, making it different from the section you copied.

8. Use the Eraser tool and a hard-edged brush to erase around the edges of some of the rocks in the wall section you pasted down, so the section blends as if the rocks were laid on top of each other.

9. Select a few individual rocks and paste them down on top of the others. This gives the rock wall a random appearance so it doesn't look as if you've copied or cloned the pieces. You can see the results so far in Figure 12.5. Don't worry that the top of the rock wall doesn't look right. We'll fix that shortly.

10. Copy the top of the rock wall to the right of the area you're working on, and paste it down over the area where the woman formerly sat.

11. Trim the edges of the rock wall so it's even.

12. Choose Layer > Flatten Image to combine all the layers you've been working with so far.

13. Use the Clone Stamp tool to copy pixels from appropriate parts of the image to cover up the obviously duplicated portions, and to cover the partial fence rail at the left side of the photo. Don't forget to clone over those stupid digital numbers at the right side, too. Resample frequently to ensure a random appearance.

Figure 12.4
Add some plants to
cover her almost
completely

Figure 12.5
A new piece of rock
wall finishes the
disguise

14. Finish up by darkening the top of the stone wall, using the tonal controls
 you learned in Part II. (*Hint*: I entered Quick Mask mode, and painted a
 fuzzy selection that I darkened using the Levels command.) Your image
 should look similar to Figure 12.6.

Figure 12.6
Nothing but scenery
left in this version

Relocating Objects in an Image

Moving an object around within an image can be a piece of cake. In many cases, you'll simply want to put the object somewhere close by, so it's very likely that the size, proportions, and lighting of the object being moved will already match the rest of the image. Things only get tricky when you want to move something from the foreground to the background (or vice versa) or intend to flip the object horizontally and/or vertically so the lighting no longer matches. For this next part of the project, we're simply going to relocate the woman to the far left side of the wall.

When you're relocating instead of removing an object, the process is only slightly different. Ordinarily, you don't have to worry about removing or retouching the part of the photo that will be covered by the relocated object. Because we were removing our tourist from the scenic photo in the last section, we did a little extra work (that is, removing the fence railing from the part that she will now cover), but it was good practice. To work on this section, you need the copy you saved of rockwall.pcx with the woman removed, plus the original photo that had her perched in the middle. Follow these steps to give her a new home in the photo:

1. Use the Lasso tool to select the woman from the original picture. Include a little of the area around her so you can blend her in with the background. Press Ctrl/Command+J to copy the selection to its own layer. You can see the approximate size of the selection I made in Figure 12.7.

2. Switch to the new version of the image in which the woman had been removed. Paste the woman to the far left side of the rock wall.

3. Use the Eraser tool with a fuzzy brush to remove part of her surroundings and blend her in with the background. As she was seated on the rock wall, with foliage behind her, you'll find she already blends in quite well. The only part I really had to touch up was the area around her left foot.

4. Flatten the image to end up with the version shown in Figure 12.8. The scenery is a little more prominent in this version, but we've still got some documentation that actual humans were along on the trip.

Figure 12.7
Using the original photo, copy the woman from her perch atop the rock wall

Figure 12.8
Set her down in her new location, blend the edges, and flatten the image

Adding New Objects to a Photo

One of the most important skills you can acquire in becoming an adept photo compositor is the ability to deftly add objects to your photos in such a way that they don't look pasted in. Placing an object in a photo so it blends in smoothly with its surroundings can be tricky, but I'm going to show you your own set of tricks, including a selection method you may not have tried before.

We're going to work with the file moat.pcx on the CD-ROM that accompanies this book. You'll also need a fresh copy of rockwall.pcx, used in the last couple exercises, because we're going to extract part of that image and drop it into a new one. The moat photo can be seen in Figure 12.9. It's an old castle-type residence surrounded by a very cool-looking, moat-type body of water, and with a background of very blah-type sky. The photo would look much better if the sky had some clouds in it and the image in the moat were a little more dramatic. There's a right way and a wrong way to provide this fix. I'm going to show you both.

Figure 12.9
This photo has interesting subject matter, but it needs some pizzazz

Adding Clouds and Reflections—The Wrong Way

The wrong way to "fix" the photo doesn't involve compositing at all. It uses more of what you'd consider retouching techniques. The results actually aren't all that bad, if you're looking for that horrid 1950s postcard look. If you're not, you'll be looking for a better way. You don't have to actually follow these steps, unless you really do want an awful-looking photo.

1. Choose the Magic Wand and set a Tolerance level of 32.
2. Click in the sky behind the castle. Most of the sky will be selected.
3. Choose Select > Similar to grab any stray pixels in the sky. Select Similar tells Photoshop to look for noncontiguous pixels elsewhere in the picture that have similar values to those you've already selected. It's useful for

grabbing, for example, sky pixels between the branches of a tree or inside the links of a chain-link fence. Sometimes, Select Similar grabs unwanted pixels in an image. You can switch to Quick Mask mode and erase them from the selection.

4. Press D to make sure that Photoshop's default colors are black and white, and then double-click in the foreground swatch in the Tool palette. Choose an appealing sky blue, and then click OK to apply that color as the foreground color.

5. Choose Filter > Render > Clouds. The sky area you selected is instantly filled with glorious, 50s-era blue sky dotted with clouds that are instantly recognizable as Photoshop fake clouds by anyone who's ever used Photoshop.

6. Use Image > Adjustments > Levels and adjust the black point slider to the true black point of the image. Then, you can play with the midtone slider to change the appearance of the clouds to suit you. You won't be fooling anyone that these aren't Photoshop clouds, but go ahead. Click OK to apply the tonal change. The image now looks like Figure 12.10.

7. Deselect the clouds (press Ctrl/Command+D).

8. Enter Quick Mask mode, and paint a selection that encompasses the water in the moat, as shown in Figure 12.11. Then exit Quick Mask mode.

9. Use the Levels command as shown in Figure 12.12 and lighten the water in the moat.

You'll end up with an image similar to the one shown in Figure 12.13. Of course, the clouds you added in Step 5 won't appear in the reflection, so you'll have to repeat Steps 1–6 to finish the photo off, only using the reflected section instead of the original scene. But why bother? We can do much, much better.

Figure 12.10
Anyone who's used Photoshop will spot these Photoshop clouds a mile away (or from inches away)

Figure 12.11
Select the reflection so
you can lighten it

Figure 12.12
The Levels command
can brighten the
reflection

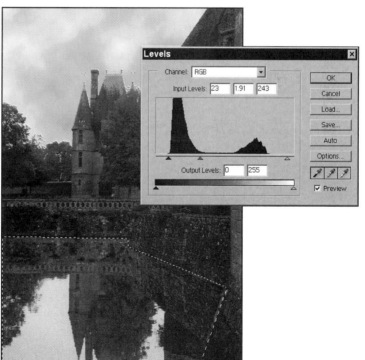

Figure 12.13
Our first effort to
"improve" the photo
(the wrong way) looks
like this

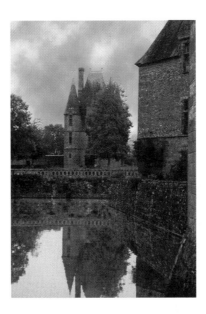

Adding Clouds and Reflections—The Right Way

Compositing can produce a much more interesting photo. There's a bit more work involved, but it's worth it. The effect is more realistic, too. Start with the moat.pcx photo and have the rockwall.pcx picture handy, too. First, we'll do the sky.

1. Choose Layer > Duplicate layer to create a copy of the background layer.

2. Choose Image > Adjustments > Levels, and bring the midtone and white point sliders very close together, as shown in Figure 12.14, producing a very high-contrast image on the background layer. Click OK to apply the tonal change. We're not going to use this stark, high-contrast layer for anything except to make an accurate selection of the sky area. Boosting the contrast makes it easy to differentiate between the sky and the rest of the scene.

3. Choose the Magic Wand, set the Tolerance to 4, and click in the sky area of the high-contrast area.

4. Make the high-contrast layer invisible by clicking its eyeball icon, and then switch to the unaltered, background layer of the image. The selection you made in the high-contrast area remains.

5. Press Shift+Ctrl/Command+I to invert the selection so that everything *except* the sky is selected.

6. Press Ctrl/Command+J to create a copy of everything except the sky in its own layer. With all the other layers invisible, your new, sky-less layer looks like Figure 12.15 (the checkerboard pattern represents the transparency in the sky area, of course).

Figure 12.14
Create an ultra-high
contrast version of the
photo to make selecting
the sky easier

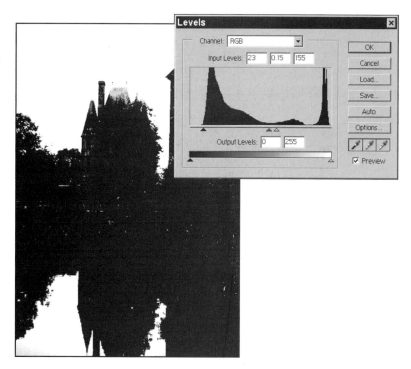

Figure 12.15
Copy the scene, sans
sky, to its own layer

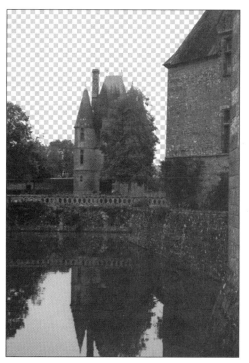

7. To make things easier to track, double-click in the new layer's name in the Layers palette and call it Castle Upright.

8. In the Layers palette, right-click (Control-click on the Mac) on the high-contrast layer you made and choose Delete Layer. We don't need this high-contrast layer any more.

9. Switch to the rockwall.pcx photo and copy an area of sky like the one shown in Figure 12.16. Paste it down in its own layer in the moat.pcx photo. Name the layer something like Clouds, as you did previously.

Figure 12.16
Add some clouds from the scenic photo we worked with earlier in the chapter

10. Use Edit > Transform > Scale to stretch the clouds so they fill the upper third of the castle/moat photo. The picture now resembles Figure 12.17. The moat still needs a little work, but we're getting somewhere.

11. Move the Clouds layer so it resides underneath the Castle Upright layer.

WATCH THAT FRINGE

There may be a bit of a white fringe around the edges of some of the trees as they blend into the sky behind, but the white fringe blends fairly well with the clouds. You could have eliminated the fringe by choosing Select > Modify > Expand and enlarging the selection by a pixel or two when you made the original sky selection, but that step isn't critical for this project. I'll show you several ways to blend these edges more smoothly in the next chapter.

Figure 12.17
With the clouds behind
the castle, the sky looks
a lot more interesting

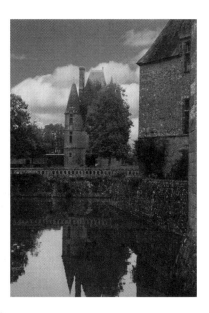

Adding clouds to the sky is fairly easy compared to improving the reflection in the moat, but I'll lead you through the process step-by-step. The important thing to learn from this next exercise is that you need to look carefully at your images to see how the pieces fall together. Only then can you drop new components into the scene in a realistic way. Next, we'll create a reflection in the moat. As you work, you may have to move layers around so that things that need to be "on top of" or "behind" other objects are in the right order. For example, you'll want to make sure the sky layer is always behind the castle layer, that the portions of the wall you copy are on top of the reflected layers, and so forth.

1. Merge the Castle Upright and Clouds layers. With the castle layer active, press Ctrl/Command+E.

2. Select only the castle and sky in the left two-thirds of the image (leaving out the building on the right side of the foreground and everything below the circular edges of the wall), and then copy to a new layer using Ctrl/Command+J.

3. Switch to the new layer and choose Edit > Transform > Flip Vertical to invert the image of the castle, as if it were a reflection in the moat.

4. In the Layers palette, set the Opacity of the new layer to about 40 percent so you can see both the image of the new layer as well as the original reflection in the water, which shows through the transparent layer easily, as shown in Figure 12.18.

5. Press V to choose the Move tool, and click in the new reflection layer. Use the cursor arrow keys to nudge the reflection until it more or less coincides with the original reflection that can be seen underneath. The match won't be exact, because the actual reflection is distorted slightly. However, you can get close.

CHAPTER 12

Figure 12.18
Make the new
reflection semi-
transparent so you can
position it accurately
using the original
image as a guide

6. Enter Quick Mask mode and use a hard-edged brush to create a selection around the edges of the reflection, to trim any part of the reflection that isn't in the water itself. Exit Quick Mask mode and delete everything that doesn't belong in the moat, producing a reflection layer that looks roughly like Figure 12.19.

Figure 12.19
Trim the flipped
version so it looks
more like a reflection

At this point, the photo looks fairly dramatic, compared to the original, which you can see in the side-by-side version in Figure 12.20. That vivid reflection in the moat is a real eye-catcher. The problem, when you compare the original and new version, is that the reflection isn't realistic. First, there's no reflection of the *wall* in the moat. In addition, the "water's" viewpoint is a little different. The building at the right side of the image doesn't appear that way in the reflection at all. We'll fix this problem in the next exercise.

Figure 12.20
Compare the modified image (right) with the original (left), and you can see how the reflection is still faulty

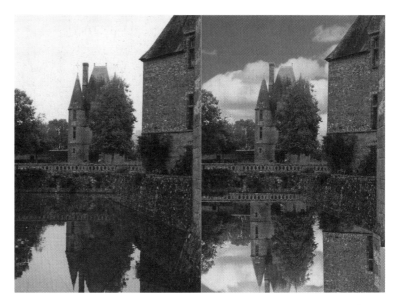

The reflection now needs to be trimmed and made more reflection-like so it, er, reflects the actual behavior of images cast on the water. We'll trim away some excess image, and darken the reflection to make it look deep and a little murky.

1. Use the Eraser tool with a hard-edged brush to trim away the part that would be obscured by the reflection of the wall at the right side of the image.

2. Use the Levels command to darken the reflection so that it's no longer a mirror image, so to speak, of the original view above. That makes it look more like a reflection rather than an upside-down castle. The lower part of the image should look like Figure 12.21. At this point, the original reflection of the wall at the right side of the image shows. It looks fairly good. However, if you want, you can create your own wall reflection, which you can then manipulate as you want.

3. Copy the wall above, flip it vertically, and then use Edit > Transform > Distort to reshape it so it fits the shape of the reflected portion of the wall. You may find it easier to change the Opacity of the shape in the Layers palette so you can view the original underneath as a guide.

Figure 12.21
Darken the reflection
to add some realism

4. Trim the wall reflection with a hard-edged Eraser. It should look similar to Figure 12.22.

5. Adjust the transparency of the right wall so it fades into the water.

6. We're still missing the reflection of the wall immediately under the castle in the water. Switch to the layer containing the castle, select the wall, copy it to its own layer using Ctrl/Command+J, and then invert it.

7. Move the layer so it is above the reflection of the castle in the Layers palette.

8. Trim the inverted wall segment so it looks like a reflection in the water.

9. Use the Brightness/Contrast control to reduce the contrast to about -25, and the brightness by about -8.

Figure 12.22
Create your own
reflection of the
wall at right

The image is virtually finished at this point, and looks similar to Figure 12.23. However, if you want, you can add additional effects to the reflection in the water, such as applying some of Photoshop's filters. For example, in the Distort menu, you'll find the Zig Zag filter with a Pond Ripples mode, which you can use to produce some ripples in the moat. In Figure 12.24, you'll see my "fairy-tale" version, in which I applied the Diffuse Glow filter to the reflection only, making the reflection look like a fairy-tale land. Or, you can apply Diffuse Glow to everything *except* the reflection, making another statement altogether.

For a real mind-bender, look at the version shown in Figure 12.25 for a minute and try to figure out what I did. For the answer, just turn the book upside down.

Figure 12.23
You may be happy
with this final image,
but there are more
effects you can add

Figure 12.24
Apply the Diffuse Glow
filter to the castle, or
its reflection, to create
a fairy-tale look

CHAPTER 12

Figure 12.25
How'd this view come about? For the answer, turn the book upside down!

Next Up

You're not done removing, relocating, or adding objects to a photo by a long shot. Believe it or not, these chapters are intended to build upon one another. You added some more basic skills to your repertoire, and are ready to use them in even more diabolical compositing adventures in the next chapter, in which I reveal the secrets of making your blended compositions virtually seamless.

13

Invisible Compositing

Completely invisible compositing is something like a perfect crime. If anyone ever pulls either off, we'll never know it happened, because they're *perfect*. If a melding of images is detectable, then it's not truly invisible. If you can't tell how the images were merged, then how can you prove they were, in fact, merged and the picture wasn't simply a straight photograph someone is trying to pass off as a perfect composite?

Even common sense and logic are no help. That photograph of a young Elvis out on the town with Cameron Diaz *could* be a fiendishly clever composite. Or, it might be a legitimate photo of the best-ever Elvis impersonator on a date with the most astounding Cameron Diaz look-alike. As Spock (the Vulcan, not the baby doctor) once said, "A difference that makes no difference is no difference."

In our work, the goal is not to create a completely invisible composite, but, rather, to merge images in ways that pass casual or even intense inspection. If you're trying to fool a forensics expert who can examine the pixels up close and look for obvious mismatches, you're wasting your time, unless you're trying to commit the perfect crime rather than the perfect composite. Instead, you should be trying to create plausible mergers that can be enjoyed within the context of the image they create. Instead of spending months trying to match every possible detail, you may want to devote an hour or two generating an image that doesn't scream FAKE! the moment it's seen.

This chapter explores a little more thoroughly some of the basic consistencies I outlined at the beginning of Chapter 11, "Simple Cropping and Fix-up Techniques," the matching of colors, lighting, textures, angles, and other details.

You're in the Driver's Seat

We're going to start off working with a particular image with a lot more attention to detail than we applied with some of the earlier projects in this book. We're trying to make this next assemblage *invisible*. I'm not going to make things especially easy for you. Several of the components will be a little on the challenging side.

We're going to start with the photo convertible.pcx, found on the CD-ROM bundled with this book. It's an old digital photo of a 1995 model-year white convertible, taken with a super-high-resolution digital camera of the time at an amazing 1024 × 768-pixel resolution—more than 3/4 of an entire megapixel! Moreover, the photo, shown in Figure 13.1, has an unfortunate overall reddish cast, along with some bad color in the upper half of the photo caused by the limitations of the antique sensor. Fortunately, we can fix the red cast, and we don't really need any part of the photo other than the car itself. I'm going to break down each step of the project into individual tasks that you can work on independently.

Figure 13.1
This isn't a DeLorean, but we're going to transport this 1995 car photo back to the future and 21st Century surroundings

Extracting the Car

The first step is to extract the car from its surroundings. There are many different Photoshop tools you can use; the Extract filter would work fairly well, because the edges of the car are fairly well-defined. I decided to extract the car the old fashioned way, with the Eraser tool.

1. Choose the Eraser tool and select a small, hard-edged brush. I used the 9-pixel brush.

2. Erase carefully around the edges of the car, as shown in Figure 13.2. Don't worry about removing every last nonautomotive pixel. You can touch up the edges when the image has been pasted down in its new home.

Figure 13.2
Erase around the edges
of the car to extract it

3. Continue erasing. Don't worry about getting the portion of the front car antenna; we're going to "shorten" it. Ignore the cell phone antenna mounted on the trunk, too.

4. When you get to the underside of the car, include some of the ground underneath. It will be easier later on to blend that ground in with the ground in the new photo, than to blend the car with the ground.

5. We've clipped off the top part of the antenna, so the best thing to do is use the Clone Stamp tool to clone pixels of the convertible top over most of the antenna, truncating it just above the windshield, as shown in Figure 13.3. Use a 3-pixel brush to put a few gray pixels at the top of the antenna to show where it stops.

6. Continue erasing around the car until it's been completely extracted.

7. If you haven't erased all of the background, select the remaining background with the Lasso tool and then delete it. The finished car will look like Figure 13.4.

Figure 13.3
Truncate the antenna
to simplify the outline
of the car

The mostly extracted car is shown in Figure 13.4.

Figure 13.4
Mostly extracted, the
car looks like this

USE SIMILARITIES TO YOUR ADVANTAGE

When extracting images for compositing, use similarities in backgrounds to your advantage. You can usually blend the old background with the new more easily than you can blend a sharp-edged subject with a new background. This works especially well when merging human figures; viewers tend to examine the transition between a person and his/her background more closely than other transitions in a composite.

Matching Perspective, Size, and Angle

Next, locate ksucampus.pcx on the CD-ROM. It's a sun-spattered photo of an idyllic college campus outside the building where I attended journalism classes eons ago. The photo is shown in Figure 13.5. The sun-spackling is what is going to make our composite so challenging, but we'll worry about the shadows later. Right now, we have to paste in the car at a realistic size.

As I noted in Chapter 11, our brains use the relative size and proportion of objects and how they relate to their surroundings to help us gauge distance. This photo has all the right cues, which is why it was chosen. Notice the large streetlamp at the right edge of the photo, and the smaller one farther away near the center of the picture. Why do we assume that it's farther away? Because the second streetlamp is smaller. If two similar objects are arranged in an image and one is smaller, our minds automatically assume the smaller one is farther away.

Figure 13.5
National Guardsmen
once took aim from this
spot; we're going to put
a car here

CHAPTER 13

Converging lines, like those of the sidewalk, remind us that objects not only seem smaller, but have a certain perspective as they approach a vanishing point at the horizon, as shown in Figure 13.6, which shows how the sidewalk would get smaller and smaller until the two edges merge in the distance at an imaginary "horizon." Notice how the bases and bulbs of the streetlamps converge on the same point. Sometimes, it helps to actually draw converging lines on an empty, transparent layer to help you visualize the arrangement of objects you're compositing together. And keep in mind that breaking the rules of perspective and size can help produce visual paradoxes or visual puns—good when done intentionally, and not so good when done accidentally.

We need to follow these rules to merge the car with our image:

1. Switch back to the convertible.pcx photo and copy the extracted car. Select the car's layer and press Ctrl/Command+C.

2. Press Ctrl/Command+V to paste the car down in a layer of its own, as shown in Figure 13.7. Clearly, the car's image is too small. When compared to the visual cues provided by the sidewalk and streetlamp, the car looks like a toy. Moving it farther back in the image, as in Figure 13.8, provides a more plausible size, but it's still not what we're looking for.

Figure 13.6
You need to take the converging lines into account when scaling a composited component

Figure 13.7
Clearly, the car is too small in its present size

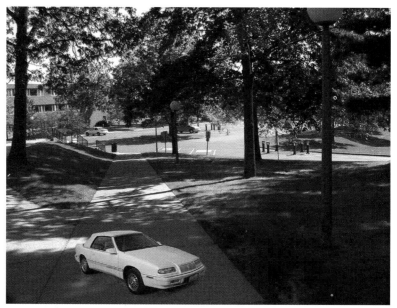

Figure 13.8
Moving it farther
back in the image
helps a little

3. Choose Edit > Transform > Scale and enlarge the car so it's roughly the
 size shown in Figure 13.9. Assuming the streetlamp is fairly tall and the
 sidewalk is broad (they are), the size is more realistic.

Figure 13.9
Enlarging the car to
more closely match its
surroundings works
even better

4. The last thing to do in positioning the car is to check out the angle and perspective. Could this automobile have been photographed in this camera position at the same time as the background? Here are the two most important things to look for:

▶ **Apparent shooting angle**. Was the camera tilted down or up at the subject and its background by roughly the same amount? Don't count on merging a low shot of an object with a background taken from much of an elevation. You'll be lucky most of the time. For example, the car photo was taken by a photographer standing on flat ground with the camera just a little under six feet from the ground (the photographer is 6'2" tall). The same photographer took the campus photo, also with the camera at eye-level. The sidewalk slopes a tiny bit, but not enough to make much of a difference in the shooting angle.

▶ **Distance from camera**. Objects closer to the camera look larger in proportion than objects farther away, as you'll recall from the wide-angle/telephoto portrait pair in Figure 7.1 in Chapter 7. To get the most realistic proportions, the objects you're merging should be taken using the same zoom setting on your camera (or with the same lens, if you're using interchangeable, nonzoom lenses) and at the same distance. Both the campus and car were photographed with the normal lens, so by placing the car in the photo at roughly the same distance it was when its picture was taken, the angle and perspective look natural.

Matching Color and Tone

In Chapter 11, I reminded you that if you're inserting an object in a photo that has a known color, or if its color can be compared to another object in the composite, the colors should match. Grass should be green, and the sky should be blue, and, moreover, mixtures of these components from different photos should be of similar greens and blues.

However, those concerns are only the most noticeable factors in blending color and tone. Our car had a reddish tone, whereas the illumination found in shadows or open shade is much bluer. Shade lighting is also softer and less harsh. We need to fix both those defects next.

1. With the car's layer selected, choose Image > Adjustments > Color Balance.

2. Click the Highlights button in the Tone Balance area. We need to change the white body metal and white cloth roof of the convertible.

3. Move the Yellow/Blue slider towards the blue, using a value of about +15, as shown in Figure 13.10. Click OK to apply the modification.

4. The car is too bright and contrasty. We need to lower the overall brightness and contrast evenly, so this is another one of those situations in which the Image > Adjustments > Brightness/Contrast control is a legitimate tool. Set the Brightness slider to -9 and the Contrast slider to -17. Click OK to apply the change, as shown in Figure 13.11.

Figure 13.10
Add some blue to
correct the color

Figure 13.11
Reduce the brightness
and contrast to match
the tones

DOING YOUR LEVELS BEST

Remember that the Levels command is the fastest and easiest tool to use when
you want to correct *bad* tonal problems with an image. It allows you to tailor
your changes to the shadows, midtones, or highlights as required. However, in
this case, the tonal relationships in the car are OK; we just needed to make some
overall changes in contrast and brightness, so Photoshop's most maligned com-
mand can be appropriately brought into play here.

Matching Sharpness and Edges

Parts of your image should match the sharpness of the components in the same plane, unless
you've applied a special-effects blurring filter or something when the photo was taken. So,
too, the components in your composites should have the same sharpness. That doesn't mean
that you can't adjust the sharpness of *other* objects in the image for special effects.

Sharpness in a photo is determined by the quality of the lens and film or sensor. A para-
meter called *depth of field* is also important. When a camera is focused on a particular
plane, only objects in that plane are in sharpest focus. Several factors are involved here:

▶ **The aperture (the lens opening or f-stop, such as f4, f5.6, and so forth) is
important**. The wider the aperture (the smaller the number, because an
f-stop can be thought of as the denominator of a fraction), the less depth
of field. So, f4 has a smaller range of sharp focus than f5.6 or f8.

▶ **Focus distance**. Although the relative range of sharp focus remains the same at a particular lens opening, how it's applied varies with the focus distance. That is, if you focus on something two inches away from the camera, you might find that only things from 1.5 inches to 3.5 inches are in reasonable focus. With the same lens opening and the camera focused on an object 2 feet from the camera, you might find that everything from 1.5 feet to 3.5 feet is fairly sharp. At 20 feet, everything from 15 feet to 35 feet might be sharp. This is just a rough example, but you get the idea.

▶ **Focal length of the lens**. Longer lenses (or longer zoom settings/higher magnifications) produce less depth of field. A wide-angle photo may allow everything to be in fairly sharp focus, whereas zooming in for a telephoto shot may sharply limit the depth of field. One good thing about digital cameras is that their lenses have relatively short real focal lengths, so you'll find most digital photos have adequate depth of field at any lens opening, most subject distances, and at virtually any zoom setting.

Finally, I'm lumping in the merger of an object with its surroundings in the "sharpness" category. This means that the edges of components pasted into a composite must blend in naturally with their surroundings. In many cases, that means soft edges. We'll apply these rules to our working image. Because the car photo was taken with a lower-resolution camera, and we've already enlarged it a bit to match scale, it could use some sharpening. We'll tackle that first.

1. Choose Filter > Sharpen > Unsharp Mask to produce the dialog box shown in Figure 13.12.

2. Set the Amount slider to about 34 percent. You can leave the Radius and Threshold sliders at their default values.

3. Click OK to apply the sharpening.

4. Choose the Eraser tool and outfit it with a fuzzy-edged brush. I started with a 65-pixel brush.

5. Erase around the edges of the car's outline anywhere that the transition is rough. The ground underneath the car actually looks a bit like leaves or something, so I didn't delete all of it. Instead, I set the Eraser to 50 percent Opacity in the Options bar, and gently erased the edges of the ground.

Don't obsess over the underside of the car. We're going to darken that area when we begin making adjustments for shadows in a bit. The image now looks like Figure 13.13.

Figure 13.12
Sharpen the car a
little to match the
background image

Figure 13.13
Touch up the
outlines of the car

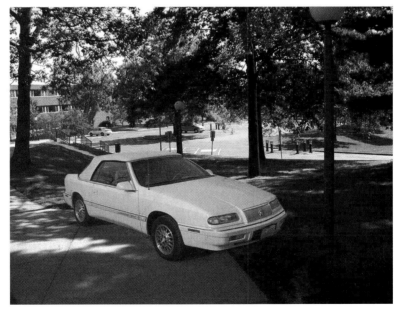

Matching Lighting and Shadows

This is the tricky one. Mismatched lighting, shadows, and illumination-related components such as reflections are one thing that viewers will quickly notice in a photo. I've deliberately chosen a challenging photo for this composite, in order to give you an immediate sink-or-swim introduction to the problems involved. We're going to duplicate the sun-spattered look of the shadows in the sidewalk on the surface of the car.

In this case, it's not important whether the shadows that fall on the car exactly duplicate those that would be produced by the trees overhead. The actual shadows are obscured, and the leaves that cast the shadows are out of the picture area, so no one really knows exactly how the shadows look. However, the simplest way to produce realistic sunshadows on the car is to duplicate the shadows on the sidewalk.

We also need to adjust the other lighting on the car. For example, the underside of the car would typically be much darker than in the original photograph taken in full sunlight. We can fix that, too. Let's get started.

1. Enter Quick Mask mode, and use a large (100-pixel or larger), fuzzy-edged brush to select the underside of the car, as shown in Figure 13.14.

2. Exit Quick Mask mode and press Ctrl/Command+J to copy the selected area to a layer of its own. We could have just used the Levels command on the selection to darken the underside directly, but working with a copy of the selection gives us greater flexibility in how we merge the darkened area with the original version of the car.

3. Use the Levels command to darken the underside of the car by moving the gray slider towards the right. Because the darkened underside is in a layer of its own, you can adjust it to suit your own tastes. For example, if you want slightly less shadows, reduce the Opacity of that layer in the Layers palette. Or, you can partially erase sections, as I did with the right front fender in Figure 13.15.

4. Now, we're going to apply some dappled sun and shadow effects. Click the eyeball icons next to all the layers except the underlying background to make them invisible. This gives us access to the shadows.

Figure 13.14
Select the underside
of the car

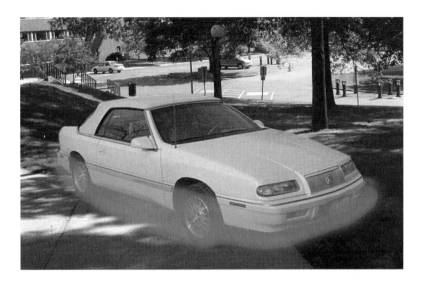

Figure 13.15
Darken the
underside to match
the surrounding
illumination

5. Choose the Magic Wand tool and set the Tolerance for 32 in the Options bar. With the background layer active, click in the shadows on the sidewalk, as shown in Figure 13.16

6. Make the car's layer visible again and switch to it.

Figure 13.16
Use the Magic Wand
tool to select the
sidewalk shadows

7. Because the Magic Wand tool is still active, you can drag the selection up
 and to the right so it covers the hood and passenger side of the car, as you
 can see in Figure 13.17.

8. Switch to Quick Mask mode and use the Eraser tool to remove the selec-
 tion from the underside of the car, tires, and other areas that shouldn't be
 affected by the shadows, as shown in Figure 13.18.

Figure 13.17
Drag the selection up
to the hood and side
of the car

Figure 13.18
In Quick Mask mode,
erase the unwanted
shadow selection

9. Exit Quick Mask mode and press Ctrl/Command+J to copy the "shadow" area to its own layer.

10. In the new layer, use the Levels command, as shown in Figure 13.19, to darken the area of the car struck by the shadows.

11. Soften the edges of the shadows by applying Filter > Blur > Gaussian Blur to the shadow layer. I used a Radius setting of 2 pixels.

12. Select the main car layer and choose Layer > Duplicate Layer to make a copy of it.

13. The new layer will be on top of the original layer. Switch to the original layer. We're going to use it to make a general shadow under the car.

14. Press D to make sure black and white are Photoshop's default colors, and then choose Edit > Fill. Fill the layer with black, making sure the Preserve Transparency check box is selected.

15. Press the V key to select the Move tool, and nudge the shadow down five or so pixels so it is beneath the car.

16. Use Filter > Blur > Gaussian Blur to make the shadow fuzzy. I used a Radius of 27 pixels.

17. Set the Opacity of the new shadow to about 40 percent so it's semitransparent and the sidewalk shows through.

18. Flatten the image. The finished photo looks like Figure 13.20.

Figure 13.19
Darken the shadows on
the hood and sides of
the car

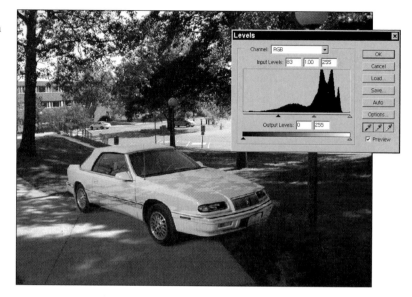

Figure 13.20
Our finished image
looks like this

Nobody should watch sausage being made. Because you worked on the image every step
of the way and know exactly how the illusion of the car parked on the sidewalk was
made, you might not be 100 percent convinced, but I think you'll find that "invisible"
composites made using the techniques you've learned will fool all of the people some of
the time, and some of the people all of the time.

Next Up

The photos we worked with in this chapter produced a composite of an image that could actually exist in real life. In the next chapter, we're going to create images that exist only in the imagination—yours.

14

Fantasy Compositing

Have you ever noticed how many horror flicks kick off with a particularly brutal scene very early in the movie? Maybe an alien bursts out of a guy's chest, or a careless teenage camper's head is chopped off and rolls around alarmingly, like a bowling ball wobbling towards the gutter? That's the filmmaker's way of saying, "Be afraid; something like this *or worse* may happen at any moment!" You spend the rest of the movie in terror, not of what you've just seen, but of what your imagination is saying you *might* see. The lesson here is that your imagination has a much more powerful hold over you than anything a moviemaker might dream up.

This chapter is designed to spark your imagination. Fantasy compositing is all about creating pictures that *might* be, even if they seem to be impossible under the currently understood laws of physics. So, I'm going to pull a variation on the filmmaker's trick and start off this chapter with a patently absurd image that would make even legendary space artist Chesley Bonestell cringe. The point of the science-fiction image in Figure 14.1 is that, if you can imagine it, you can create it with Photoshop. Perhaps a Deathstar-like moon couldn't possibly zoom down and irradiate a hillside castle on a planet that has magenta-colored skies, but we can make a picture that documents this nonevent.

Later in this chapter, we visit another sci-fi scenario with the Attack of the Giant Cat. Then, we travel to Samoa and drop a postcard to our friends.

Figure 14.1
Forbidden Planet?

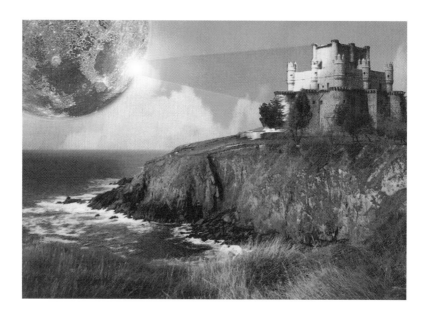

Castle in the Sky

This first project begins with a harmless, almost realistic composite, and gradually progresses from the sublime to the ridiculous. You'll see how fantasy compositions can always be taken one step further. The secret, I guess, is knowing when to stop.

We'll start with cliffs.pcx and cocacastle.pcx, shown in Figures 14.2 and 14.3. You'll find them both on the CD-ROM bundled with this book. The emphasis is on new techniques, not things you've already learned to do in previous chapters, so some of the steps are described only generally.

1. Open the cocacastle.pcx photo. First, select the castle portion. We don't need the sky, and we don't need most of the surrounding hillside. (Refer to Figure 14.1 to see just how much of the castle we're going to use.) One possible method for selecting the castle is to create a high-contrast layer, as you did in Chapter 12, "Compositing to Improve a Picture," and shown in Figure 14.4. Use the Magic Wand to select the high-contrast sky, invert the selection, and then snip away parts you don't want with the Eraser tool while in Quick Mask mode. Or, you could simply paint a mask in Quick Mask mode. A small, hard-edged brush works well for the sharp outlines of the castle. After the selection border is tidied up, switch to the normal contrast layer and select the castle image.

Figure 14.2
Start with this photo
of some rugged cliffs
in Ireland

Figure 14.3
Then combine it
with this castle in
Coca, Spain

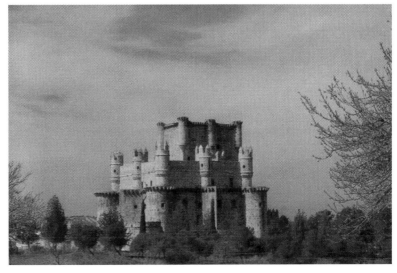

CHAPTER 14

Figure 14.4
A high-contrast layer
makes selecting the
castle easier

2. Copy the castle image, and then open the cliffs.pcx file and paste it down
 on top of the cliff. Don't let it teeter off to crash into the ocean below.

3. Resize the castle a bit using Edit > Transform > Scale so its proportions
 dominate the cliff (and so the castle can cover up those houses at the right
 side of the image).

4. The castle has a slightly yellow cast, so use Image > Adjustments > Color
 Balance, and move the yellow/blue slider a bit towards the right to add
 some blue. The image now looks similar to Figure 14.5.

5. Of course, correcting the color of the castle only made the reddish cast of
 the cliffs more obvious. Switch to the background layer (the cliffs) and use
 Image > Adjustments > Color Balance again, this time moving the cyan/red
 slider a little towards the cyan. The amount of correction to make in both
 this step and the previous step is a little subjective, and may depend on
 how your monitor is calibrated, so use your eye in both cases to make the
 corrections.

6. In the castle layer, use the Eraser tool to trim the excess area of the castle.
 Use a fuzzy, Eraser brush along the bottom to blend it in with the rest of the
 cliff. You can see how I blended the castle in the top image in Figure 14.6.
 I dimmed the background so you could see this better, but the full image is
 shown at the bottom of the figure. Note how the lighting of the castle and
 the cliffs matches closely enough that the blended images are fairly realistic.
 Adding the dramatic clouds in the next step makes this image look even
 more as if it were a bright day, so the lighting looks even more realistic.

Figure 14.5
First, color-balance
the castle

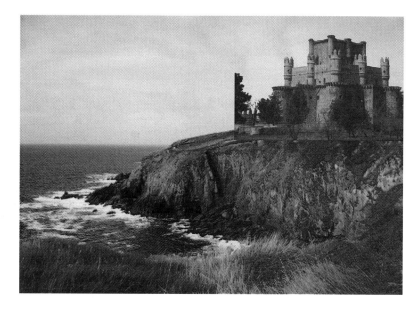

Figure 14.6
See how the castle is
blended with the
hillside?

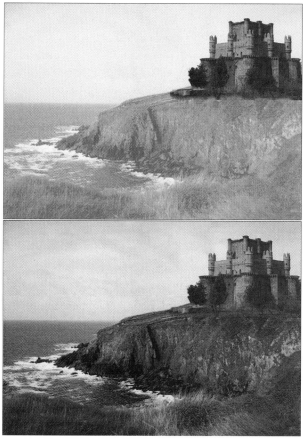

7. The clouds are pretty blah in this photo, but as a dedicated compositor, you should see such a defect as an opportunity by now. There are some interesting clouds in the photo irishcloud.pcx on the CD-ROM. Open the photo, shown in Figure 14.7, and select only the cloud area with the Lasso tool.

8. Copy the clouds and then switch to the castle/cliffs image. Select the background layer and paste the clouds down. The cloud layer should be between the background (cliffs) and the castle layer.

9. The clouds are a little too small for the area they must cover, so use Edit > Transform > Scale to widen them horizontally and stretch them vertically. You want the clouds to extend a little below the horizon.

10. Adjust the Opacity slider in the Layers palette to make the cloud layer partially transparent, so you can clearly see the horizon. Then use a hard-edged Eraser to erase the clouds below the line where they meet the horizon, follow the horizon line to the right, and continue erasing carefully up the slope of the cliff so the clouds disappear behind the edge of the cliff.

11. Adjust the Opacity slider in the Layers palette once more for the cloud layer, setting the clouds to about 55 percent opacity. This allows them to blend in with the blue sky in the background layer underneath, producing a more realistic effect, as shown at the top of Figure 14.8.

If you'd rather have extremely dramatic clouds, use less opacity. The image looks something like the bottom example in Figure 14.8. The choice is yours.

Figure 14.7
Here are some decent clouds for our composite

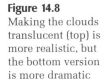

Figure 14.8
Making the clouds
translucent (top) is
more realistic, but
the bottom version
is more dramatic

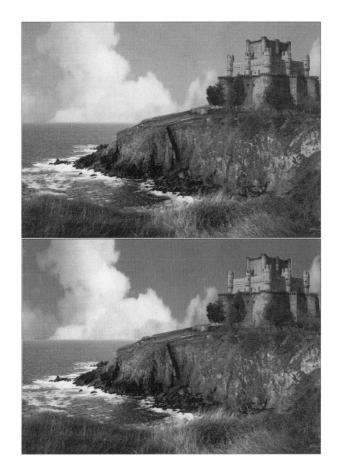

CHAPTER 14

If you want, you can stop at this point and admire your eye-catching composite. If you're willing to jump off those cliffs of the imagination, however, continue with the next exercise.

Voyage to Another Planet

The image so far looks decidedly Earth-like. We can fix that by changing the color scheme a little and adding a few otherworldly components. This section gives the photo a science-fiction look.

1. First, we need to change the color of the sky. Select the clouds layer and choose Image > Adjustments > Hue/Saturation. Move the Hue slider to the right, to roughly the 110-degree point on the color wheel, and boost the Saturation slider up to +35 percent, as shown in Figure 14.9. It's not necessary to select the Colorize check box.

2. Find the moon.pcx file on the CD-ROM and open it. Use the Elliptical Marquee tool to choose only the moon itself. Click approximately in the

center of the moon and hold down the Shift and Alt/Option keys while dragging to create a perfectly circular selection radiating outward from the point where you clicked. Release the keys and the mouse button when the size of the selection is right. You may have to use the cursor arrow keys to nudge the selection so it takes in the precise area you want.

3. Copy the moon and paste it down in the cliffs/castle image above the cloud layer.

4. Choose Edit > Transform > Flip Vertical, followed by Edit > Transform > Rotate 90 Degrees CCW. This brings a more interesting sector of the moon to face the castle.

5. Use Edit > Transform > Scale to enlarge the moon so it's roughly twice as tall as the castle.

6. A green-cheese moon would be nice. Choose Image > Adjustments > Hue/Saturation and set the Hue control to +90 and Saturation to +40.

7. Next, choose Select > Load Selection and choose Layer Transparency from the drop-down list. This is a good trick to remember when you want to quickly select the area of an image that doesn't contain image pixels. If Invert is checked in the Layer Transparency dialog box, you will select everything *but* the moon. If that's the case, then choose Shift+Ctrl/Command+I to invert the selection so only the moon is selected.

8. Choose Select > Modify > Border. When the Border dialog box appears, type a value of 32 in the box. This creates a selection border around the edge of the moon that includes a band 16-pixels wide of the orb itself, and 16-pixels of the area outside the moon.

9. Now choose Filter > Blur > Gaussian Blur, and set the Radius slider to 44 pixels. Click OK to apply the blur. This applies a positronic force field to the moon—at least, that's what they tell me. This effect differs from a drop shadow, because the blurring extends into the object itself as well as around it. For our purposes, this is a much cooler effect. The image now looks like Figure 14.10.

You can also stop now, if you want. You've got a composite that will have a lot of people scratching their heads, and, perhaps, wondering if you're still taking your medication. If you're still teetering on the edge of the cliff, move on to the next section to jump off.

Figure 14.9
Don't want a
plain-vanilla sky?
Make mine magenta

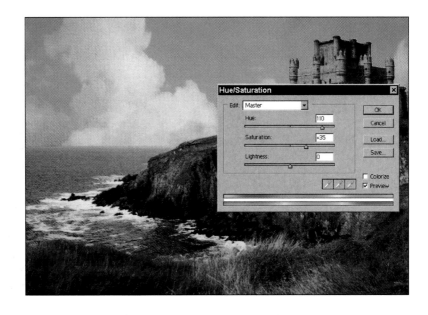

Figure 14.10
The moon is
surrounded by a
force field

CHAPTER 14

Attack of the Anti-Clones

The photo can be made a little more freaky, if you want. The Clone Stamp tool is one of the few tools you won't use in the next couple sections.

1. Move the moon to the upper-left corner of the image, so it appears to be looming above the sea and castle.

2. With the moon layer still active, choose Layer > Duplicate to create a copy.

3. Press D to make sure Photoshop's default colors are black and white, and then choose Edit > Fill to fill the copy with black. The Preserve Transparency check box should be checked.

4. Choose Edit > Transform > Scale, squish the black circle down to a squat oval, and then move it down so it's below the moon, as if it were a shadow on the water.

5. Then apply Gaussian Blur, using a value of at least 50 pixels to fuzzy the circle up a lot. Change the Opacity of the layer to 45 percent so the ocean shows through. The image should look like Figure 14.11.

6. Create another copy of the moon layer. Use Edit > Fill and fill it with yellow, with the Preserve Transparency check box still selected. Apply a stiff dose of Gaussian Blur. The yellow blur will look a little like a giant, yellow sun. Move the layer underneath the moon to add an ominous yellow glow to our force field, as you can see in Figure 14.12.

Figure 14.11
Smoke on the water?
No, it's just a shadow

Figure 14.12
A yellow glow makes
the force field appear
more ominous

Adding an Eerie Spotlight Effect

I'm going to show you how to create a cool, stark spotlight effect you can apply to many different images. Here, it will look as if an enemy base on the moon is using a laser or other weapon to attack the castle.

1. Switch to the layer with the castle on it (the poor castle has been neglected so long, it's feeling lonely) and enter Quick Mask mode. Use a fuzzy brush to paint a diagonal selection of the castle that's facing the moon. The area you need to grab is shown in Figure 14.13.

2. Exit Quick Mask mode and press Ctrl/Command+J to copy the selected area to its own layer.

3. Here's the secret behind the spotlight trick: In the Layers palette, change the blending mode of the newly pasted layer to Color Dodge. This creates a stark, washed-out look that closely resembles a harsh spotlight, as you can see in Figure 14.14.

4. You can add the spotlight beam itself. Choose Layer > New Layer to create another layer at the top of the Layers palette stack.

5. Enter Quick Mask mode and paint a wedge-shaped beam using a brush. Use Edit > Fill and fill it with yellow. Reduce the Opacity of the beam's layer to about 50 percent, so the sky shows through.

6. We need a source for the death-beam. To do this right, we need to operate on the whole image, so you'll need to flatten the layers together. Save a copy of the image under another file name so you can play with it more later, if you want. Then choose Layer > Flatten Image.

CHAPTER 14

7. Next, choose Filter > Render > Lens Flare to access the Lens Flare dialog box, shown in Figure 14.15. Choose the 50-300 Zoom setting and click OK. Flip back to Figure 14.1 to see once again what our final effort looks like.

Figure 14.13
Paint a diagonal section of the castle facing the moon

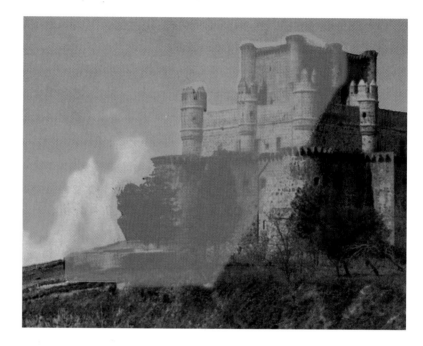

Figure 14.14
Color Dodge creates a stark, washed-out effect

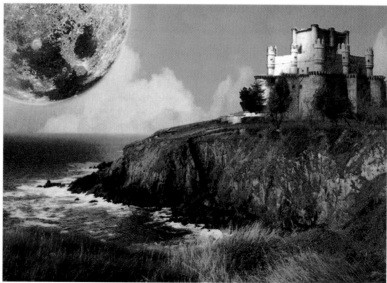

Figure 14.15
The preview box in this dialog box shows the image now has a bit of panache and flare

Attack Cat

Even though physicists of the early 1950s felt that nuclear reactions could be harnessed to create cheap energy, or perhaps, revolutionize mining, the most common public perception of atom splitting was its potential to create giant lizards to stalk Tokyo, ants the size of an Airstream trailer, and 50-foot tall women who would suddenly make things a little more equal in the battle of the sexes. Virtually all the movies of that era (that didn't star John Wayne) included either flying saucers or mammoth creatures of some type, or, perhaps, both.

Now's your chance to create a giant avian's worst nightmare—a giant cat. The serious side of this exercise is to show you how scale can be manipulated to produce fantasy landscapes of gargantuan proportions. We start with a kitten photo, sunshine.pcx, found on the CD-ROM bundled with this book, and shown in Figure 15.16. The first step is to extract the cat from her non-sci-fi surroundings.

Figure 14.16
This harmless kitten is
about to be mutated to
enormous size

Extracting the Kitten

It's time to use the useful Extract command again. It's especially appropriate for this image because the Extract command works best with fuzzy (as in texture, not sharpness), hairy, wispy, or furry images. You can use it to carefully paint a mask around the edges of your object, adjust the borders, and preview your result before extracting the object. Follow these steps:

1. The Extract command operates best with images that are sharp, so the first thing to do is sharpen the kitten image using Filter > Sharpen > Unsharp Mask. Use a setting of 100 percent to make every hair on the kitten's body stand out. Use the default values of 1 and 0 for the Radius and Threshold sliders.

2. Activate the Extract command by choosing Filter > Extract, or by pressing Alt/Option+Ctrl/Command+X. The dialog box shown in Figure 14.17 appears.

3. Zoom in on the portion of the image you want to extract. In this case, focus on the upper edge of the kitten. Zooming within the Extract dialog box is done in exactly the same way as within Photoshop. Use the Zoom tool (available from the dialog box's Tool palette at the left edge) or simply press Ctrl/Command+space to zoom in or Alt/Option+space to zoom out.

4. Click the Edge Highlighter/Marker tool at the top of the Tool palette. Choose a brush size of 20 from the Tool Options area on the right side of the dialog box.

5. Paint the edges of the kitten with the marker, so the green stroke overlaps both the edge and the background around it. Use the Eraser tool to remove markings you may have applied by mistake, or press Ctrl/Command+Z to undo any highlighting you've drawn since you last clicked the mouse. The Hand tool can be used to slide the image area within the preview window.

6. When you've finished outlining the kitten (don't worry about the whiskers; they won't show up in the composite, anyway), click the Paint Bucket tool and fill the area you want to preserve.

7. Click the Preview button to see what the kitten will look like when extracted, as shown in Figure 14.18.

8. If necessary, use the Cleanup tool (press C to activate it) to subtract opacity from any areas you may have erased too enthusiastically. This returns some of the texture of the kitten's fur along the edge. Hold down the Alt/Option key while using the Cleanup tool to make an area more opaque.

9. Use the Edge Touchup tool (press T to activate it) to sharpen edges.

10. Click OK when satisfied to apply the extraction to the kitten.

Figure 14.17
The Extract command is useful for selecting fuzzy objects

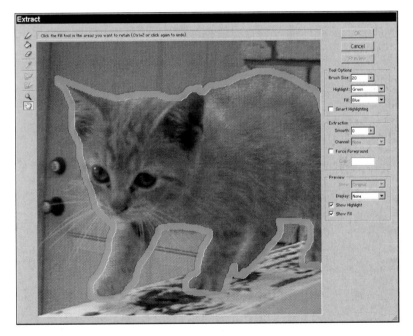

Figure 14.18
You can preview your
image, and touch it up
if necessary

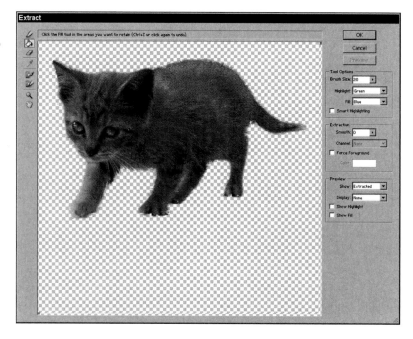

A Day at the Shore

We can take the kitten to the North Atlantic coast of Spain simply by accessing the
shore.pcx image, tucked away on the CD-ROM that accompanies this book, and shown in
Figure 14.19.

Figure 14.19
The coast of Spain

1. Open the shore.pcx file.

2. Switch back to the sunshine.pcx file and copy the kitten image from the sunshine.pcx file and paste it down a little offshore.

3. Reduce the size of the kitten so she's merely gargantuan, as shown in Figure 14.20. Position her right front paw so it's resting on the small island.

4. Switch to the background layer, and use the Lasso tool to copy the patches of water that would cover the kitten's paws if she were really standing in the sea. Copy the water and paste it down in a new layer above the kitten.

5. If necessary, use the Eraser tool to adjust the upper edges of the water patches. Then set the opacity of the water to about 69 percent, so the kitten's paws can be seen under the water. Now, she no longer looks as if she's floating above the sea, as you can see in Figure 14.21.

6. The kitten needs a shadow under her, or a reflection, or both. Use Layer > Duplicate Layer to create a copy of the kitten layer.

7. Choose Edit > Transform > Flip Vertically to flip the kitten layer upside down.

8. Choose Edit > Transform > Scale and squish the reflection vertically.

9. Use the Eraser tool to remove the parts of the reflection (chiefly the legs) that don't remain under the kitten. Then adjust the Opacity slider for the reflection layer in the Layers palette so the water shows through. I used a value of about 20 percent. With the other layers hidden, the kitten and its reflection look like Figure 14.22.

10. Make a copy of the reflection layer, and fill it with black using Edit > Fill. Make sure the Preserve Transparency check box is checked. This creates a shadow under the cat.

11. Blur the shadow using Gaussian Blur and offset it slightly so the reflection and shadow are distinct components. The photo now looks like Figure 14.23.

CHAPTER 14

Figure 14.20
Position the kitten
on the island

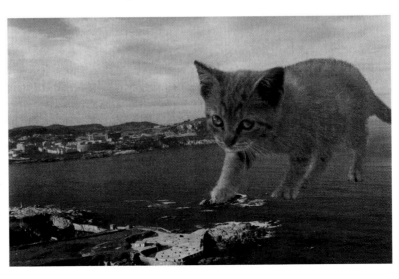

Figure 14.21
Submerse her paws
in the water so she
doesn't look like
she's floating

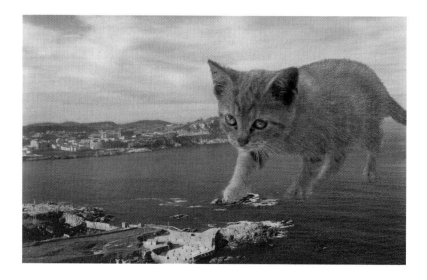

Figure 14.22
A reflection adds
some realism

Figure 14.23
The reflection and shadow appear to be separate on the water

Emphasizing the Scale

The only real problem with the photo is the gigantic scale of the cat doesn't really hit you in the face as it should. We need some teensy object in the photo to show that the kitten is really *big*. I've got a plethora of castle pictures on file, so we'll use one now. Find hillcastle.pcx on the CD-ROM bundled with this book, shown in Figure 14.24, and open it.

Figure 14.24
This castle can be added to provide some contrast in scale

1. Select the castle using your favorite selection method, and copy it to the shore photo containing the kitten.

2. Resize the castle and move it to the jut of land (actually a parking lot) in the lower center of the image.

3. Trim away the excess portions so the castle fits in with its surroundings, and then flatten the image. Your result will look like Figure 14.25.

Don't forget to use your imagination! You can come up with additional variations on this theme, perhaps like the one pictured in Figure 14.26.

Figure 14.25
This is the end result of our science-fiction nightmare. Or is it?

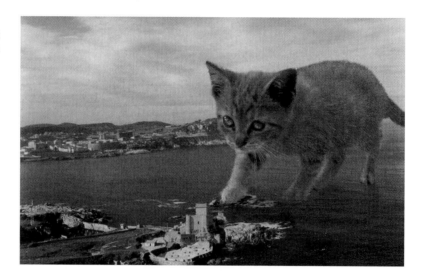

Figure 14.26
You never know what's going to hop up next

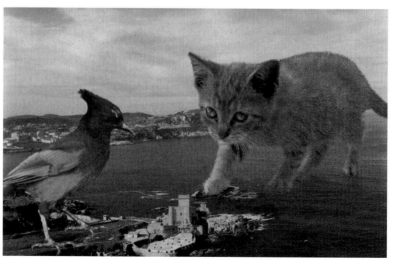

Create a '50s Era Postcard

Here's a quickie. I'm going to show you how to create one of those postcards from the 1950s—the ones where the colors were so strange and the greetings a little weird. ("Wish you were here?" Then who would you send the card to?) Use samoabeach.pcx, found on the CD-ROM bundled with this book, or create your own.

The original photo, shown in Figure 14.27, is a bit dull; the sky is overcast and the colors are not of the vibrant sort you'd expect on a visit to Samoa. That's the secret behind these postcards: The destinations all looked this way until someone applied some deceptive tricks to them, as we're going to do. The chief difference is we're going to use Photoshop.

Figure 14.27
You never guessed Samoa was this bland-looking

CHAPTER 14

1. The trick to producing the weird color schemes found in postcards is to increase the saturation *too much*. Choose Image > Adjustments > Hue/Saturation, and move the Saturation slider up to about 75 percent. Don't worry if the colors look strange. That's our goal.

2. We need some greeting text. Choose yellow as Photoshop's foreground color, and choose the Text tool.

3. Type a greeting (I used "Greetings From Samoa!") in an appropriate type-face. I selected Arial Narrow in 36 pt size, and applied the Bold attribute from the Options bar.

4. Click the Warp Text icon (it's to the immediate right of the Color patch in the Options bar when the Text tool is active), and choose Rise from the text warping options list. Set the amount of rise to 50 percent.

5. Click the Confirm button (the check mark in the Options bar) to create the text.

6. Choose Layer > Duplicate Layer to create a copy of the greeting text.

7. Choose Layer > Layer Style, and then select Stroke. The default options (3 pixel size, Outside Position, and so forth) will work fine. Click in the Color patch and choose red as the outline color. Then click OK to apply the stroke to the outside of the text.

8. Choose the other copy of the greeting text and use Edit > Fill to fill it with black. Make sure the Preserve Transparency check box is checked.

9. Move the yellow text above the black text, if necessary, and then switch to the black text and use the cursor arrow keys to nudge the black layer down and to the right, creating a sharp-edged shadow.

10. Flatten the image, and then print out and mail your postcard, shown in Figure 14.28.

Figure 14.28
Your postcard will really make them wish they were there

Next Up

I hope you had as much fun with this chapter as I did. It's time for the final chapter in this book, in which we explore a world that's a bit more serious: advertising, public relations, and other publication destinations. Although the subject is a broad one, we focus on making people and products look their best in print.

15

Compositing and Retouching for Print and Advertising

If you stop to think about it, compositing and retouching are nothing more than creating a new photograph from raw material that ranges from pixels to prints. We modify photos to convey a message or to improve the way something looks. The goal is similar to that of advertising, which futurist Marshall McLuhan called "the greatest art form of the twentieth century." When you reshape an image using Photoshop, you're trying to better sell an idea, whether that idea is "look at this beautiful place I visited!" or "doesn't this distinguished-looking guy inspire confidence?"

Or, perhaps our goal with both digital manipulations or advertising is simply to improve an image. George Santayana (the philosopher, not the brother of the Grammy-winning guitarist) said, "Advertising is the modern substitute for argument; its function is to make the worse appear the better." That's what we're doing when we touch up errors or create a composite by moving or replacing an object in a photo.

There's no reason why any of the techniques described earlier in this book can't be used both for personal photos, such as our vacations or family pictures, as well as for professional publishing, public relations, and advertising use. However, in this chapter, we're going to focus more closely on publicity and product photography and other types of pictures used in print, whether for advertising, public relations, or other nefarious purposes. You'll learn how to create knockouts, assemble several products into one photograph, and perform other magical effects.

Because this is the last chapter of the book, you've already developed virtually all the skills you need to create any of the images discussed, so not all the examples will be step-by-step, follow-along exercises. Instead, I'll provide a few more examples and simply tell you how they were created, with whatever details you need to duplicate the effects with your own images. You're probably sick of working with my vacation and family photos, anyway.

Honesty is the Best Policy

When manipulating photographs for publication, an additional constraint accrues that we don't have to worry about when we're simply trying to amaze or mislead our family, friends, and colleagues. Overly fussy people, such as the news media and the judiciary, tend to freak at the thought of a photograph's being changed in ways that will lead people to the wrong conclusion. The media have even established a set of guidelines about how retouching, compositing, and other photo tricks can or cannot be used for news photos (erring mostly on the *cannot* side). The legal establishment has its own directives, most of which fall under the rules of evidence and can result in rather severe sanctions if you break them.

Advertising, as well, is governed by rules and laws about what you can or cannot do when a photograph is made, or afterwards. For example, it's illegal to put marbles in a bowl of soup to make all the toothsome ingredients rise to the top for a photograph. On the other hand, it's OK to use a professional photographer to create "amateur" snapshots for a print ad, as long as the resulting photos, after they've been subjected to halftoning and the printing process, look *no better or sharper* than photos an amateur might produce with typical amateur equipment.

Although photo manipulation is more or less ruled out for news editorial use and for courtroom evidence, it's winked at for advertising and other print applications as long as you don't mislead anyone, or the image is openly presented as a manipulation. If you remember the ads Adobe had for Photoshop in which various landmarks were transplanted from one country to another, you'll know what I am talking about. No one was misled: Photoshop was indeed capable of the feats shown, and no viewers of the ads seriously thought the Eiffel Tower had been moved.

I sometimes bend the rules a tiny bit. I write two or three short articles a month for our local daily publicizing our kids' school, and frequently "fix" the photos that accompany them. I'm not an employee of the newspaper, and they can't detect my fixes anyway, so what's the harm if the three smiling faces in a group shot didn't all come from the same original photograph?

You, however, will be working in different circumstances. It's best to keep the rules in mind when you manipulate any photograph intended for print.

Fix That Bad Expression

When I'm photographing groups for publication, invariably the person in charge wants to include every possible warm body in the photograph. I carefully explain that picturing 37 people in a two-column newspaper photo means that each person's face will probably end up in print roughly the size of a halftone dot. With only two or three people in the photo, each person will appear large, lifelike, and recognizable for their moment of fame. Moreover, publications prefer tight, intimate photos over those that appear to be documentation for the most recent reunion of the Royal Air Force.

Of course, the real reason for limiting the number of people in a publicity photo is that the more people pictured, the greater the chance that one of them will have one or more eyes closed or some horrid facial expression. Case in point is the photo shown in Figure 15.1. The young man has just received an autographed photo from the author of the Harry Potter book series, but he looks like he's swallowed a lemon. Figure 15.2 shows him in a better mood, but the little girl really looked better in the first photo. This is no problem for the Photocomposition Brigade. We can do a simple head transplant.

Figure 15.1
Does this young man look happy? Can we fix that?

Here are some things to keep in mind when moving a face or an entire person from one photo to another.

▶ You'll do best when as many things are similar as possible between the two (or more) source photos. Your best bet is to use a picture from the same shooting session. Your subject should be wearing the same clothing, and the lighting should be the same. If possible, the background should be the same, but that's not essential.

▶ You must choose a shot taken from roughly the same angle. The photo in Figure 15.2 was taken from a slightly higher angle, but it doesn't really matter because the boy tilted his head to look at the camera full-face anyway. We can use the second photo with no problem.

Figure 15.2
We can use his
expression from this
photo, instead

▶ Copy more of the person from the donor photo than you plan to use. Even if all you're going to replace is the head, it's easier to resize the face, if necessary, using more of the body as a guideline. This is the chief problem with all those Britney Spears photos you see on the Internet with her head seemingly the size of a prize-winning pumpkin. Correct proportion is essential when making any composite involving a human being.

▶ If the backgrounds are similar, include a lot of the background from the donor photo. It's easier to blend in the edges of a background, which nobody is interested in anyway, than it is to blend the edges of a human, which everyone will be examining closely.

To fix up our publicity shot, find kids01.pcx and kids02.pcx on the CD-ROM accompanying this book, and follow these simple steps:

1. Copy the boy's head from kids02.pcx. Include some of the background in your selection, as well as a chunk of his shirt down below the button.

2. Switch to the kids01.pcx photo and paste the boy's visage into a layer of its own, as shown in Figure 15.3.

3. Make the layer semitransparent by adjusting the Opacity control in the Layers palette to about 50 percent.

4. Move the pasted face over the original face and try to line up the eyes, as shown in Figure 15.4. This is simply to see if the size is correct, not to align the pasted image. In this case, the size of the eyes match. If they didn't, you'd need to resize the pasted layer using Edit > Transform > Scale.

Figure 15.3
The pasted head and shoulders will replace the original version

Figure 15.4
Make the new layer transparent and see if the eyes of both versions match in scale

THE EYES HAVE IT

The easiest way to see if a face is scaled properly is to make one layer semitransparent and then compare the size and distance between the eyes. That's because there is usually some "blank" space (called "cheeks") immediately below the eyes that don't contain detail that will interfere with the comparison. If the eyes don't match, you can use Edit > Transform > Scale and resize the pasted piece until it's the proper size.

5. The scale for the donated piece seems OK, so the next step is to align the shoulders of the boy in both images. Why the shoulders rather than the face? Because the second photo was taken from a slightly higher angle, if we matched up the faces, we'd find that the boy's neck is too short to reach to his shirt collar. Instead, it's better to match his clothing in a natural way. No one will notice the difference in angle.

6. When the shoulders match, use the Eraser tool with a fuzzy-edged brush to blend the shoulders and shirt of the pasted piece in with the shirt in the original photo. You may want to increase the opacity of the pasted layer to 100 percent to help you see just how the images are merging. Follow the lines of clothing folds and wrinkles to create a smooth merger. Figure 15.5 shows the image as it looks after erasing, at left. At right, I've dimmed the background layer so you can see exactly what I've removed so far.

7. One of the reasons I've left so much of the shirt in the composite is that we can use the shirt to match tones. Use Image > Adjustments > Levels to access the Levels dialog box, shown in Figure 15.6.

Figure 15.5

Erase part of the shirt to merge it with the underlying layer

Figure 15.6
The Levels command
can match the tonal
values of the shirt with
the original layer

8. Move the white point slider at the far right of the histogram towards the left to the point at which white tones begin to show detail (the base of the "mountain").

9. You can move the gray point slider towards the left to brighten the boy's face a little.

10. Use the Eraser tool with a fuzzy brush to trim away the background around the boy's head so it blends in with the rest of the photo.

11. Flatten the image.

12. Use the other retouching and cropping skills you've mastered in this book to fix any dust spots or adjust tones. I made the boy's shirt and the girl's blouse a little darker, and trimmed the picture. The finished shot is shown in Figure 15.7, and as published in Figure 15.8.

CHAPTER 15

Figure 15.7
The composited image with the new face looks like this

Figure 15.8
Now, the two kids are famous

Third-graders have 'write' stuff

What makes a really great children's story?

Third-graders at Immaculate Conception School in Haven are trying to find the answer to that question.

All students in Linda Ruff's class have been writing to their favorite authors, asking them how and where they get their story ideas, create characters and set the mood for an exciting tale.

Harry Rowline has already heard back from his favorite British author, J.K. Rowling.

The creator of the Harry Potter series sent Harry an autographed picture and a letter outlining the latest Harry Potter adventure, which is to be called "Harry Potter and the Order of the Phoenix."

Other students have written to authors such as Judy Blume, who created the "Fudge-A-Mania" books.

"Authors entertain us with vivid imaginations and their talent for writing," Ruff said, "but what do we really know about them?"

She challenged her students to think of the things they would really like to ask their favorite

authors and to write to them for advice on how to improve their writing skills.

The class members will use the ideas they receive from the authors to prepare for the writ-

ing section of the proficiency exams they will be taking in the spring.

Harry Rowline left, and Chelsea Bowling, third-graders at Immaculate Conception School, admire an autographed picture and letter sent by J.K. Rowling, author of the Harry Potter series. Harry wrote to Rowling as part of the class project asking authors advice on how to write well.

Knock Yourself Out

Quite a few advertising photos use some sort of knockout technique to isolate The Product so it can be presented against a plain background, or perhaps dropped into another image to create a composite. I'm almost ashamed of how casually I apply this technique. When I worked as a commercial photographer, I spent hours carefully posing items ranging from product boxes to truck clutches on white seamless paper, carefully lighting them and choosing the exact angle that would make the product look exciting and glamorous. Of

course, one of my clients' idea of "glamorous" was any photo of his company's beloved clutches illuminated by a spotlight, so the work wasn't as challenging as I just tried to make it sound.

Today, digital photography and Photoshop have made me lazy. Our first exercise is an actual example of a photo I created for an earlier book. I discovered that I suddenly needed a photograph of an external, FireWire-compatible hard disk drive to illustrate a chapter on archiving photos. The only tricky part of the task was that I needed a "generic" disk drive with no logos or other identifying material. I could have set up some seamless paper or another backdrop, lit the drive as if it were a still life, and spent, say, a whopping 10–20 minutes producing a photographic masterpiece.

Instead, knowing the finished photo was going to be reproduced as a two-inch-wide figure in the book, I took a shortcut. I unhooked a spare FireWire drive from one of my computers, set it down on top of my scanner, and halfheartedly put a piece of paper snatched from my printer under it. I grabbed the digital camera that always resides on my desk and snapped the monstrosity shown in Figure 15.9, using direct flash. I had my product shot, and I didn't even have to get up from my chair. Of course, there was a bottle of window cleaner, the scanner, and some cabinets visible in the photo, but that was no problem. If you want to follow along with this quickie, you can use the harddrive.pcx photo included on the CD-ROM bundled with this book. Here's all I had to do to create my illustration:

Figure 15.9
The original photo looks haphazard and sloppy for a reason: The photographer was haphazard and sloppy

1. Enter Quick Mask mode.

2. Select a hard-edged brush. I chose the 19-pixel brush, the largest in Photo-shop's default set, then moved the Master Diameter slider to enlarge it to 40 pixels.

3. Paint around the edge of the hard drive to create a selection that encom-passes everything *except* the hard drive itself, as shown in Figure 15.10. Don't worry about being extra precise around some of the curves.

Figure 15.10
Select everything
except the hard drive

4. After you've outlined the hard drive, use the Lasso tool to select the rest of the surrounding area, and choose Edit > Fill to fill it up with the red Quick Mask tint.

5. Use smaller, hard-edged brushes with both the Eraser and Brush tools to touch up the edges.

6. Exit Quick Mask mode and press Shift+Ctrl+I to invert the selection you just made so that only the hard drive is selected.

7. Press Shift+Ctrl/Command+J to copy the hard drive to its own transparent layer.

8. I needed to obscure the drive maker's logo, as well as the hard drive itself that was visible under the translucent case, so copy the clean section of case at the far left and paste it multiple times over the visible drive and logo. A little work with the Clone Stamp tool blends the edges invisibly.

9. To check how well we've knocked out the drive, create a new layer and fill it with black. The hard drive in its transparent layer shows any light-colored fringes that needed to be fixed, as you can see in Figure 15.11.

Figure 15.11
A temporary dark background will help you spot any fringing

10. Use the Eraser tool to remove those light fringes.

11. For this illustration, I just needed the hard drive to look vaguely three-dimensional, so we can use Photoshop's Layer Styles to add a drop shadow. Chose Layer > Layer Style > Drop Shadow to produce the dialog box shown in Figure 15.12. Use the following settings:

 ▶ Leave Blend Mode at Multiply.

 ▶ Set Opacity to about 34% so the shadow won't be excessively dark.

 ▶ The default angle of 125 degrees works well. This value represents the direction of the light that casts the shadow.

 ▶ Set Distance to 18 pixels to move it away from the hard drive slightly. This value is the apparent distance that the object being shadowed is suspended above the surface the shadow is cast on.

 ▶ Set Spread to 8 percent to feather the drop shadow.

 ▶ Select 21 pixels for the Size to make the shadow medium-sized.

 ▶ Leave the other values at their defaults.

CHAPTER 15

Figure 15.12
Layer Styles includes
a Drop Shadow option

LAYER KNOCKOUT

One cryptic control in the Drop Shadow dialog box is the Layer Knocks Out
Drop Shadow check box. Mark this check box when you're adding a drop
shadow to a partially transparent object and you *don't* want the drop shadow to
show behind the transparent object. Our hard drive is opaque, so the control
makes no difference, but if you were working with an object that is transparent
in real life (say, a photographic filter), you might want to turn off this feature so
the shadow *does* appear. The check box is marked by default.

12. Create a new transparent layer above the disk drive.

13. Choose the Elliptical Marquee tool and create a selection around one of
the drive indicator lights on the right front edge of the drive case.

14. Fill the selection with green.

15. Activate any selection tool (the tool doesn't matter; just press M, for exam-
ple) and use the cursor arrow keys to move the selection (only) over to the
other indicator light. Fill it with red.

16. In the Layers palette, choose Overlay as the blending mode for this col-
ored layer. The indicator lights are colored, but the texture is still visible,
as you can see in Figure 15.13.

17. Flatten the image and your generic external hard drive illustration is
finished.

Figure 15.13
The indicator lights
are an added touch
of realism

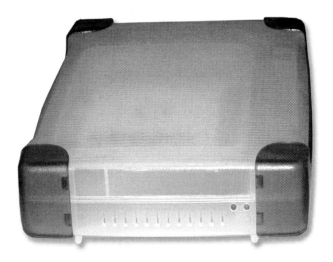

Combining Knocked-Out Images

Knocked-out images are great for assembling photos used on Web sites, either your own, or those of online auction services such as eBay. You can assemble images that are clear and easy to understand, surrounded by a white background that blends in with the rest of the page seamlessly. I'm going to show you several examples in this section, all taken from real life.

Creating a Picture Diagram

To coin a cliché, a picture is worth a whole bunch of words, especially when you have people zooming past your Web page looking for something that makes sense. Composites can be used to create picture "diagrams" that communicate a message at a glance. Figure 15.14 is an example of this kind of photo, created for an online auction ad to show how a particular electronic converter component is used, without muddying up the waters with line drawings or photos of the item actually in use. The dimmed components at left and right represent the buyer's equipment and cabling; the item for sale is the widget in the center of the photo.

Figure 15.14
This is a kind of simple
pictorial diagram

You don't need to follow along and do this exercise yourself; the following steps tell you exactly what I did so you can apply the technique to your own products.

1. I put the converter gadget shown in the center and a cable on my scanner and grabbed an image of each of them at about 800 samples per inch.

2. In Quick Mask mode, I painted a selection around each of the components, knocking out the background (which was actually the lid of the scanner). I pasted each in a layer of its own.

3. The plug on the converter gadget plugs into a jack on a video component (at left), but I didn't have such a component easily accessible (without venturing into the rats' nest of cables behind my DVD player, anyway). So, I took a digital photo of the S-Video jack end of a different converter, and extracted the jack portion.

4. Then I created a gray "panel" in Photoshop, used the Edit > Transform > Perspective control to give it a slant, and then filled it with some random noise (using the Filter > Noise > Add Noise feature). Then, I duplicated the layer, filled it with black, and put it behind the front of the "panel" to give some three-dimensional thickness. At this point, the image looked like Figure 15.15.

5. I made the panel and cable layers semitransparent, added the text, and flattened the layers to produce the image shown in the previous Figure 15.14.

Figure 15.15
The basic components
are all in place

Showing the Product in Use

Other times, you really do want to show the product being used, especially if it is an unusual application that the viewer might not have thought of. Many laptop computer owners don't know they can link their S-Video ports to a composite monitor or television to view DVDs they play on their computers on a big screen. You can also do this with a desktop computer that has a video card with S-Video output, but the intent of this particular ad was to grab laptop owners. They've already spent big bucks on their portable computer, and are desperate to find something to do with it to justify their expenditure.

The first attempt at a photo didn't come off very well, as you can see from the quickie shot (Figure 15.16) made (on the desktop again), using an old IBM laptop and taping the converter gadget to a piece of white paper. Observant types will notice that the jack the item is being plugged into isn't even an S-Video jack; it's a PS/2 *mouse* port. I don't own a laptop with an S-Video jack. No problem. Here's what I did:

Figure 15.16
The initial shot was even sloppier than usual

1. I took the best photo I had of the laptop and used the Levels command to lighten it up.
2. I used the Clone Stamp tool to remove the icon for the mouse port.
3. Next, the bottom edge and right edge of the laptop were squared off using the Eraser tool, and the laptop (only) was copied to a transparent layer of its own.
4. I took a photo of the converter gadget, knocked it out of its white background, and put it in a layer on top of the laptop image in the correct position (as if it were being plugged into the mouse port).
5. After adding drop shadows using Layer Styles, I inserted the text and some handy arrows to point out where everything goes, ending up with the version shown in Figure 15.17.

CHAPTER 15

Figure 15.17
The final version looks a little more professional

Showing Other Views

Compositing is a great way to show the inside of a product, using a cut-away or X-ray view. You can also use it to show several views of the same product without resorting to three-dimensional virtual reality.

For example, in Figure 15.18, the intent was to show that the device is a *converter* not an adapter, in response to endless questions from potential buyers. The X-ray view conveys the idea without the need for tons of wordy text (wordy text is the worst kind). The image was produced by combining a photo of the converter and another photo of the circuitry, and making the circuitry semitransparent. Another frequent question was, "Where does this plug into?" The two photos of the ends of the converter composited into the lower-left and lower-right explain this fairly clearly.

Figure 15.18
An X-ray view clearly provides a hint of what the product consists of

How do you show both ends of a 25-foot cable, without showing the entire length of the cable? Compositing helped create a view of both ends, although not, perhaps, in the way you might think. I'm going to describe a handy technique for creating a good-looking image of an object that is very high in contrast, and almost impossible to correct tonally using ordinary methods. You can follow along if you want, using cable.pcx, shown in Figure 15.19, from the CD-ROM, or simply read through the instructions.

Figure 15.19
It's difficult to show the light and dark portions of this cable clearly, no matter how much you use the Levels command

1. Make a copy of the background layer.
2. Use the Brightness/Contrast controls to make it even more contrasty.
3. Select the Magic Wand and select the white background around the cable. Don't forget the background that shows through the gaps in the center.
4. Press Shift+Ctrl/Command+I to invert the selection, so that only the cable is selected.
5. Press Ctrl/Command+J to copy the cable to a transparent layer of its own.
6. You can discard the high-contrast layer now, if you want.
7. Make a copy of the cable layer.
8. Work with one of the cable layers, using the Levels command to produce a lighter version, like the one shown at the top of Figure 15.20. The goal is to make the highlights brighter and deepest blacks of the cable less dark. Note that the colors of the very darkest portions may shift, and the cable plugs will be completely washed out. That doesn't matter.

CHAPTER 15

9. Switch to the other cable layer and the Levels command to create a version in which the lighter plug ends of the cable are tonally pleasing, as shown at the bottom of Figure 15.20. When you're finished, move this layer (if necessary) so it's above the extra-light cable layer in the Layers palette.

10. Now, using the Eraser tool with a soft-edged brush, and an Opacity of about 50 percent, you can lightly erase parts of the top, darker layer in areas of the cable that are too dark.

11. When you're happy, flatten the image. The finished ad is shown in Figure 15.21.

Figure 15.20
At the top, a lighter layer showing the detail of the cable; at the bottom, the emphasis is on the ends of the cable

Figure 15.21
Combining both layers lets all the detail show

Next Up

At this point, the next step is up to you. I've tried to pass along some of the tricks I've picked up over the years for retouching photos and combining them to create new images. Although this book contains just about everything I know about these topics (plus a lot of related stuff I hope you found interesting), it doesn't contain everything I *will* know, or that *you* will know, either. Photoshop, in its dozen-plus years of life, hasn't yet been fully explored by its millions of devotees. And as long as the good folks at Adobe keep piling on useful features, its boundaries never will be approached. My goal is that this book will encourage you to explore Photoshop further, and that the chapters have held lots of nuggets and idea starters that will help you come up with the kind of images that evoke those, "Wow! How was that photo created?" comments we all secretly yearn for.

Glossary

Pictures are worth a thousand words, particularly when you try to sort out the jargon involved to describe how they are made, edited, and printed. This list includes all the really tough words in this book, and more than a few that are not. Whether you're working with an associate who likes to pretend he knows more than you do, or you plan to impress the boss at the next company meeting, this glossary will help you understand the terms used in image editing, retouching, and compositing.

additive primary colors
The red, green, and blue colors used alone or in combinations to create all other colors you view on a computer monitor or capture with a digital camera or scanner. Photoshop's default RGB mode uses these colors, even when you're working in other color modes, such as CMYK (Cyan, Magenta, Yellow, Black). See also *CMY(K) color model.*

airbrush
Originally developed as an artist's tool that sprays a fine mist of paint, an airbrush is used both for illustration and retouching. Photoshop includes an airbrush tool.

ambient lighting
The diffuse, nondirectional lighting that doesn't appear to come from a specific source but, rather, bounces off walls, ceilings, and other objects.

anti-alias
A process in Photoshop that smoothes the rough edges in images (called jaggies or staircasing) by creating partially transparent pixels along the boundaries that are merged into a smoother line by our eyes.

aperture-preferred
A camera setting that allows you to specify the lens opening, with the camera selecting the shutter speed automatically, based on its light-meter reading. See also *shutter-preferred.*

artifact

A type of noise in an image, or an unintentional image component produced in error by a digital camera or scanner. One of the goals of retouching is to remove these objects from photos.

aspect ratio

The proportions of an image. An 8×10-inch and a 16×20-inch photo each have a 4:5 aspect ratio. Your monitor set to 800×600, 1024×768, or 1600×1200 pixels has a 4:3 aspect ratio. When you change the aspect ratio of an image, you must crop out part of the image area.

autofocus

A camera setting that allows the camera to choose the correct focus distance for you.

background

The bottom layer of an image, according to Photoshop, whereas in photography, the background is the area behind your main subject of interest.

back-lighting

A lighting effect produced when the main light source is located behind the subject. You can use Photoshop to simulate this effect by selecting the subject and pasting it down in its own layer, and then creating a lighting effect behind it. See also *front-lighting, fill, and ambient lighting*.

balance

An image that has equal elements on all sides.

bilevel image

An image that stores only black-and-white information, with no gray tones; a bitmap in Photoshop terminology.

bit

A binary digit—either a 1 or a 0, now used to measure the color depth (number of different colors) in an image. For example, a grayscale 8-bit scan may contain up to 256 different tones (2^8), whereas a 24-bit scan can contain 16.8 million different colors (2^{24}).

bitmap

Within Photoshop, a bitmap is a bilevel black/white-only image. The term is also used to mean any image that represents each pixel as a number in a row and column format.

black

The color formed by the absence of reflected or transmitted light.

black point

The tonal level of an image where blacks begin to provide important image information. When correcting an image with a tool like the Levels command, you'll usually want to set Photoshop's black point at the place where these tones exist. (See Figure G.1.)

Figure G.1
The black triangle should be set to the point on the histogram where black pixels begin in the image

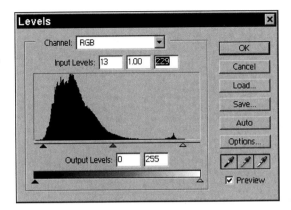

blending modes
Photoshop's calculations for combining pixels when merging layers or when applying pixels with any of the Brush-like tools.

blur
The process of softening an area by reducing the contrast between pixels that form the edges.

brightness
The amount of light and dark shades in an image, usually represented as a percentage from 0 percent (black) to 100 percent (white).

burn
A darkroom technique, mimicked in Photoshop, which involves exposing part of a print for a longer period, making it darker than it would be with a straight exposure. Photoshop's Burn tool darkens areas of the image.

calibration
A process used to correct for the differences in the output of a printer or monitor when compared to the original image. After you've calibrated your scanner and/or Photoshop, the images you see on the screen more closely represent what you'll get from your printer, even though calibration is never perfect.

cast
An undesirable tinge of color in an image. (See Figure G.2.)

CCD (Charge-Coupled Device)
A type of solid-state sensor used in scanners and digital cameras.

chroma
A term meaning color or hue.

chromatic color
A color with at least one hue and a visible level of color saturation.

Figure G.2
This photo has an
undesirable yellow
color cast

chrome

An informal photographic term used as a generic for any kind of color transparency, including Kodachrome, Ektachrome, or Fujichrome.

CIE (Commission Internationale de l'Eclairage)

An international organization of scientists who work with matters relating to color and lighting. The organization is also called the International Commission on Illumination.

close-up lens

A lens add-on that allows you to take pictures at a distance that is less than the closest-focusing distance of the lens alone.

CMY(K) color model

A way of defining all possible colors in percentages of cyan, magenta, and yellow, and frequently, black. Black is added to improve rendition of shadow detail. CMYK is commonly used for printing (both on press and with your inkjet or laser color printer). Photoshop can work with images using the CMYK model, but converts any images in that mode back to RGB for display on your computer monitor.

color correction

The process of changing the relative amounts of color in an image to produce a desired effect, typically a more accurate representation of those colors. Color correction can fix faulty color balance in the original image, or compensate for the deficiencies of the inks used to reproduce the image.

comp

A preview that combines type, graphics, and photographic material in a layout.

composite

In photography, an image composed of two or more parts of an image, taken either from a single photo or multiple photos. Usually, composites are created so that the elements blend smoothly together.

compression

The process of reducing the size of a file by encoding using fewer bits of information to represent the original. Some compression schemes, such as JPEG, operate by discarding some image information, whereas others, such as TIFF, preserve all the detail in the original, discarding only redundant data.

continuous tone

The images that contain tones from the darkest to the lightest, with a theoretically infinite range of variations in between.

contrast

The range between the lightest and darkest tones in an image. A high-contrast image is one in which the shades fall at the extremes of the range between white and black. In a low-contrast image, the tones are closer together.

crop

The process of trimming an image or page by adjusting its boundaries.

densitometer

An electronic device used to measure the amount of light reflected by or transmitted through a piece of artwork, used to determine accurate exposure when making copies or color separations.

density

The ability of an object to stop or absorb light. The less the light is reflected or transmitted by an object, the higher its density.

depth-of-field

A distance range in a photograph in which all included portions of an image are at least acceptably sharp. (See Figure G.3.)

Figure G.3
Depth of field
determines how much
of an image is in
sharp focus

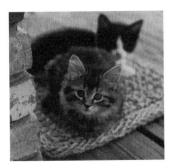

desaturate

The process of reducing the purity or vividness of a color, making a color appear to be washed out or diluted.

diffusion

The random distribution of gray tones in an area of an image, producing a fuzzy effect.

dither

A method of distributing pixels to extend the number of colors or tones that can be represented. For example, two pixels of different colors can be arranged in such a way that the eye visually merges them into a third color.

dodging

A darkroom term for blocking part of an image as it is exposed, lightening its tones. Photoshop's Dodge tool can be used to mimic this effect.

dot

A unit used to represent a portion of an image, often groups of pixels collected to produce larger printer dots of varying sizes to represent gray.

dot gain

The tendency of a printing dot to grow from the original size to its final printed size on paper. This effect is most pronounced on offset presses using poor-quality papers, which allow ink to absorb and spread, reducing the quality of the printed output, particularly in the case of photos that use halftone dots.

dots per inch (dpi)

The resolution of a printed image, expressed in the number of printer dots in an inch. You'll often see dpi used to refer to monitor screen resolution, or the resolution of scanners. However, neither of these use dots: The correct term for a monitor is pixels per inch (ppi), whereas a scanner captures a particular number of samples per inch (spi).

dummy

A rough approximation of a publication, used to evaluate the layout.

dye sublimation

A printing technique in which solid inks are heated and transferred to a polyester substrate to form an image. Because the amount of color applied can be varied by the degree of heat (and up to 256 different hues for each color), dye sublimation devices can print as many as 16.8 million different colors.

emulsion

The light-sensitive coating on a piece of film, paper, or printing plate. When making prints or copies, it's important to know which side is the emulsion side so the image can be exposed in the correct orientation (not reversed). Photoshop includes "emulsion side up" and "emulsion side down" options in its print preview feature.

existing light

In photography, the illumination that is already present in a scene. Existing light can be daylight or the artificial lighting currently being used, but not electronic flash or additional lamps set up by the photographer.

export

The process of transferring text or images from a document to another format.

eyedropper

A Photoshop tool used to sample color from one part of an image, so that color can be used to paint, draw, or fill elsewhere in the image. Within some dialog boxes, such as the Levels command, the eyedropper can be used to define the actual black points and white points in an image.

feather

The process of fading out the borders of an image element, so it blends in more smoothly with another component. (See Figure G.4.)

Figure G.4
A feathered edge, so to speak

fill

In photography, the lighting used to illuminate shadows. In Photoshop, fill is the process of covering a selected area with a solid, transparent, or gradient tone or pattern.

filter

In Photoshop, a feature that changes the pixels in an image to produce blurring, sharpening, and other special effects. In photography, a device that fits over the lens, changing the light in some way.

flat

An image with low contrast.

flatbed scanner

A type of scanner that reads a line of an image at a time, recording it as a series of samples, or pixels.

focal length

A measurement used to represent the magnification of a lens.

focus range

The range in which a camera is able to bring objects into sharp focus.

four-color printing

Another term for process color, in which cyan, magenta, yellow, and black inks are used to reproduce all the colors in the original image.

framing

In photography, the process of composing your image in the viewfinder. In composition, using elements of an image to form a sort of picture frame around an important subject.

frequency

The number of lines per inch in a halftone screen.

front-lighting

The illumination that comes from the direction of the camera.

f-stop

The lens aperture, which helps determine both exposure and depth of field.

full-color image

An image that uses 24-bit color; 16.8 million possible hues. Images are sometimes captured in a scanner with more colors, but the colors are reduced to the best 16.8 million shades for manipulation in Photoshop.

gamma

A numerical way of representing the contrast of an image. Devices such as monitors typically don't reproduce the tones in an image in straight-line fashion (all colors represented in exactly the same way as they appear in the original). Instead, some tones may be favored over others, and gamma provides a method of tonal correction that takes the human eye's perception of neighboring values into account. Gamma values range from 1.0 to about 2.5. The Macintosh has traditionally used a gamma of 1.8, which is relatively flat compared to television. Windows PCs use a 2.2 gamma value, which has more contrast and is more saturated.

gamma correction

A method for changing the brightness, contrast, or color balance of an image by assigning new values to the gray or color tones of an image to more closely represent the original shades. Gamma correction can be either linear or nonlinear. Linear correction applies the same amount of change to all the tones. Nonlinear correction varies the changes tone-by-tone, or in highlight, midtone, and shadow areas separately to produce a more accurate or improved appearance.

gamut

The range of viewable and printable colors for a particular color model, such as RGB (used for monitors) or CMYK (used for printing).

Gaussian Blur

A method of diffusing an image using a bell-shaped curve to calculate the pixels that will be blurred, rather than blurring all pixels, producing a more random, less "processed" look.

grayscale image

An image represented using 256 shades of gray. Scanners often capture grayscale images with 1024 or more tones, but reduce them to 256 grays for manipulation by Photoshop.

halftone

A method used to reproduce continuous-tone images, representing the image as a series of dots.

highlight

The lightest part of an image with detail.

hue

The color of light that is reflected from an opaque object or transmitted through a transparent one.

indexed color image

An image with 256 different colors, as opposed to a grayscale image, which has 256 different shades of the tones between black and white.

interpolation

A technique Photoshop uses to create new pixels required whenever you resize or change the resolution of an image, based on the values of surrounding pixels. Devices such as scanners and digital cameras can also use interpolation to create pixels in addition to those actually captured, thereby increasing the apparent resolution or color information in an image.

invert

In Photoshop, the process of changing an image into its negative; black becomes white, white becomes black, dark gray becomes light gray, and so forth. Colors are also changed to the complementary color; green becomes magenta, blue turns to yellow, and red is changed to cyan. (See Figure G.5.)

Figure G.5
An inverted image

ISO (International Standards Organization)

A governing body that provides standards, such as those used to represent film speed, or the equivalent sensitivity of a digital camera's sensor.

jaggies

The staircasing effect of lines that are not perfectly horizontal or vertical, caused by pixels that are too large to represent the line accurately. See also *anti-alias.*

JPEG (Joint Photographic Experts Group)

A file format that supports 24-bit color and reduces file sizes by selectively discarding image data.

landscape

The orientation of a page in which the longest dimension is horizontal; also called wide orientation.

lens aperture

The lens opening that admits light to the film or sensor. The size of the lens aperture is usually measured in f-stops.

lens flare

A Photoshop feature borrowed from conventional photography, where it is an effect produced by the reflection of light internally among elements of an optical lens. Bright light sources within or just outside the field of view cause lens flare. Flare can be reduced by the use of coatings on the lens elements or with the use of lens hoods. Photographers sometimes use the effect as a creative technique, and Photoshop includes a filter that lets you add lens flare at your whim.

lens hood

A device that shades the lens, protecting it from extraneous light outside the actual picture area that can reduce the contrast of the image or allow lens flare.

lighten

A Photoshop function that is the equivalent to the photographic darkroom technique of dodging. Tones in a given area of an image are gradually changed to lighter values.

line art

Usually, the images that consist only of white pixels and one color, represented in Photoshop as a bitmap.

line screen

The resolution or frequency of a halftone screen, expressed in lines per inch.

lithography

Another name for offset printing.

lossless compression

An image-compression scheme, such as TIFF, that preserves all image detail. When the image is decompressed, it is identical to the original version.

lossy compression

An image-compression scheme, such as JPEG, that creates smaller files by discarding image information, which can affect image quality. (See Figure G.6.)

Figure G.6
When carried to the extreme, lossy compression methods can have a serious impact on image quality

luminance

The brightness or intensity of an image, determined by the amount of gray in a hue.

LZW compression

A method of compacting TIFF files using the Lempel-Ziv Welch compression algorithm, one of Photoshop's optional compression schemes.

maximum aperture

The largest lens opening or f-stop available with a particular lens, or with a zoom lens at a particular magnification.

mechanical

The camera-ready copy with text and art already in position for photographing.

midtones

The parts of an image with tones of an intermediate value, usually in the 25 to 75 percent range. Many Photoshop features allow you to manipulate midtones independently from the highlights and shadows.

moiré

An objectionable pattern caused by the interference of halftone screens, or other regular patterns, frequently generated by rescanning an image that has already been halftoned. Photoshop can frequently minimize these effects by blurring the patterns.

monochrome

A single color, plus white. Grayscale images are monochrome (shades of gray and white only).

noise

In an image, pixels with randomly distributed color values. Noise in digital photographs tends to be the product of low-light conditions, particularly when you have set your camera to a higher ISO rating than normal.

negative

A representation of an image in which the tones are reversed: blacks as white, and vice versa.

neutral color

In Photoshop's RGB mode, a color in which red, green, and blue are present in equal amounts, producing a gray.

parallax compensation

An adjustment made by the camera or photographer to account for the difference in views between the taking lens and the viewfinder.

Photo CD

A special type of CD-ROM developed by Eastman Kodak Company that can store high-quality photographic images in a special space-saving format, along with music and other data.

pixel

A picture element of a screen image.

pixels per inch (ppi)

The number of pixels that can be displayed per inch, usually used to refer to pixel resolution from a scanned image or on a monitor.

plug-in

A module such as a filter that can be accessed from within Photoshop to provide special functions.

point

A measurement that is approximately 1/72 of an inch outside the Macintosh world, exactly 1/72 of an inch within it.

portrait

The orientation of a page in which the longest dimension is vertical, also called tall orientation. In photography, a formal picture of an individual or, sometimes, a group.

prepress

The stages of the reproduction process that precede printing, when halftones, color separations, and printing plates are created.

process color

The four color pigments used in color printing: cyan, magenta, yellow, and black (CMYK).

red-eye

An effect from flash photography that appears to make a person or animal's eyes glow red. It's caused by light bouncing from the retina of the eye, and is most pronounced in dim illumination (when the irises are wide open) and when the electronic flash is close to the lens and, therefore, prone to reflect directly back. Photoshop can fix red-eye through cloning other pixels over the offending red or orange ones. (See Figure G.7.)

Figure G.7
Oddly enough, animals don't seem to get red-eye—but yellow-eye can be just as bad!

red-eye reduction

A way of reducing or eliminating the red-eye phenomenon. Some cameras offer a red-eye reduction mode that uses a preflash that causes the irises of the subjects' eyes to close down just prior to a second, stronger flash used to take the picture.

reflection copy

The original artwork that is viewed by light reflected from its surface, rather than transmitted through it.

register

The process of aligning images.

registration mark

A mark that appears on a printed image, generally for color separations, to help in aligning the printing plates. Photoshop can add registration marks to your images when they are printed.

resample

To change the size or resolution of an image. Resampling down discards pixel information in an image; resampling up adds pixel information through interpolation.

resolution

In Photoshop, the number of pixels per inch, used to determine the size of the image when printed. That is, an 8 × 10-inch image that is saved with 300 pixels per inch resolution will print in an 8 × 10-inch size on a 300 dpi printer, or in a 4 × 5-inch size on a 600 dpi printer. In digital photography, resolution is the number of pixels a camera or scanner can capture.

retouch

The process of editing an image, most often to remove flaws or to create a new effect.

RGB color mode

A color mode that represents the three colors—red, green, and blue—used by devices such as scanners or monitors to reproduce color. Photoshop works in RGB mode by default, and even displays CMYK images by converting them to RGB.

saturation

The purity of color; the amount by which a pure color is diluted with white or gray.

scale

The process of changing the size of a piece of an image.

scanner

A device that captures an image of a piece of artwork and converts it to a digitized image or bitmap that the computer can handle.

selection
In Photoshop, an area of an image chosen for manipulation, usually surrounded by a moving series of dots called a selection border.

sensitivity
A measure of the degree of response of a film or sensor to light.

shadow
The darkest part of an image, represented on a digital image by pixels with low numeric values or on a halftone by the smallest or absence of dots.

sharpening
The process of increasing the apparent sharpness of an image by boosting the contrast between adjacent pixels that form an edge.

shutter-preferred
An exposure mode in which you set the shutter speed and the camera determines the appropriate f-stop. See also *aperture-preferred*.

SLR (single lens reflex)
A camera in which the viewfinder sees the same image as the film or sensor.

SmartMedia
A type of memory card storage for digital cameras and other computer devices.

smoothing
The process of blurring the boundaries between edges of an image, often to reduce a rough or jagged appearance.

solarization
In photography, an effect produced by exposing film to light partially through the developing process. Some of the tones are reversed, generating an interesting effect. In Photoshop, the same effect is produced by combining some positive areas of the image with some negative areas. Also called the Sabattier effect, to distinguish it from a different phenomenon called overexposure solarization, which is produced by exposing film to many, many times more light than is required to produce the image. With overexposure solarization, some of the very brightest tones, such as the sun, are reversed. (See Figure G.8.)

specular highlight
The bright spots in an image caused by reflection of light sources.

spot color
The ink used in a print job in addition to black or process colors.

subtractive primary colors

The cyan, magenta, and yellow colors, which are the printing inks that theoretically absorb all color and produce black. In practice, however, they generate a muddy brown, so black is added to preserve detail (especially in shadows). The combination of the three colors and black is referred to as CMYK. (K represents black, to differentiate it from blue in the RGB model.)

telephoto

A lens or lens setting that magnifies an image.

thermal wax transfer

A printing technology in which dots of wax from a ribbon are applied to paper when heated by thousands of tiny elements in a printhead.

threshold

A predefined level used by the scanner or Photoshop to determine whether a pixel will be represented as black or white.

thumbnail

A miniature copy of a page or image that provides a preview of the original. Photoshop uses thumbnails in its Layer and Channels palettes, for example.

TIFF (Tagged Image File Format)

A standard graphics file format that can be used to store grayscale and color images plus selection masks.

time exposure

A picture taken by leaving the lens open for a long period, usually more than one second. The camera is generally locked down with a tripod to prevent blur during the long exposure.

tint

A color with white added to it. In graphic arts, often refers to the percentage of one color added to another.

tolerance

The range of color or tonal values that will be selected, with a tool like Photoshop's Magic Wand, or filled with paint, when using a tool like the Paint Bucket.

transparency scanner

A type of scanner that captures color slides or negatives.

unsharp masking

The process for increasing the contrast between adjacent pixels in an image, increasing sharpness, especially around edges.

USB

A high-speed serial communication method commonly used to connect digital cameras and other devices to a computer.

viewfinder

The device in a camera used to frame the image. With an SLR camera, the viewfinder is also used to focus the image if focusing manually. You can also focus an image with the LCD display of a digital camera, which is a type of viewfinder.

vignetting

The dark corners of an image, often produced by using a lens hood that is too small for the field of view, or generated artificially using Photoshop techniques.

white balance

The adjustment of a digital camera to the color temperature of the light source. Interior illumination is relatively red; outdoor light is relatively blue. Digital cameras often set correct white balance automatically, or let you do it through menus. Photoshop can do some color correction of images that were exposed using the wrong white balance setting.

white point

In Photoshop, the lightest pixel in the highlight area of an image.

zoom

In Photoshop, the process of enlarging or reducing the size of an image on your monitor. In photography, the process of enlarging or reducing the size of an image using the magnification settings of a lens.

Index

INDEX